# METAL

## FORMING, FORGING, AND WELDING TECHNIQUES

**José Antonio Ares**

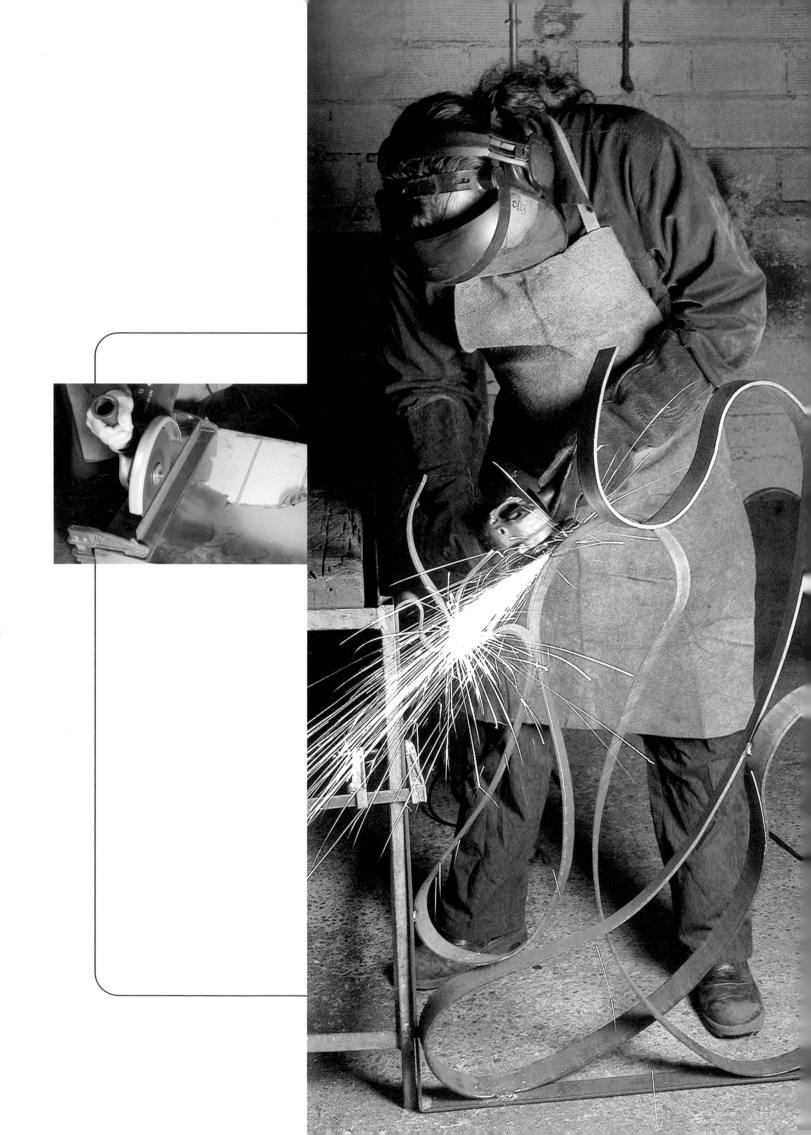

# METAL

## FORMING, FORGING, AND WELDING TECHNIQUES

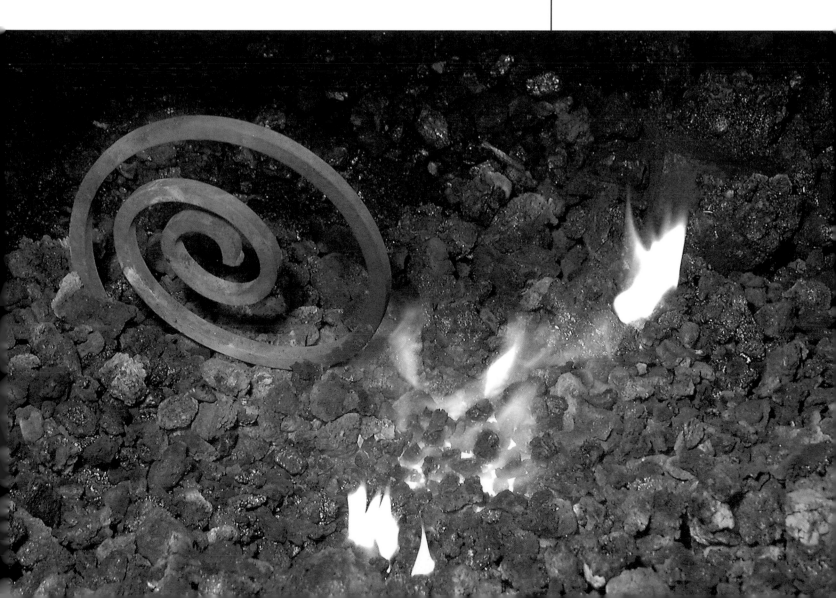

*Metal*

**Text:**
José Antonio Ares

**Photography:**
Nos & Soto, Ares, AISA, J.M. Barres,
Enric Rosàs, Museu Cau Ferrat, and
Resources Computing International, Ltd.

**Infographic Drawings:**
Jaume Farrés

Original title of the book in Spanish:
*El metal*
© Copyright 2004 Parramón Ediciones,
S. A.—World Rights
Published by Parramón Ediciones,
S. A., Barcelona, Spain.

Author: José Antonio Ares

© Copyright 2006 of English language
translation by Barron's Educational Series,
Inc., for the United States, Canada, and its
territories and possessions.

*All inquiries should be addressed to:*
Barron's Educational Series, Inc.
250 Wireless Boulevard
Hauppauge, New York 11788
**http://www.barronseduc.com**

Library of Congress Catalog Card No.:
2005922457

ISBN-13: 978-0-7641-5896-4
ISBN-10: 0-7641-5896-1

Printed in Spain
9 8 7 6 5 4 3 2 1

# INTRODUCTION, 6

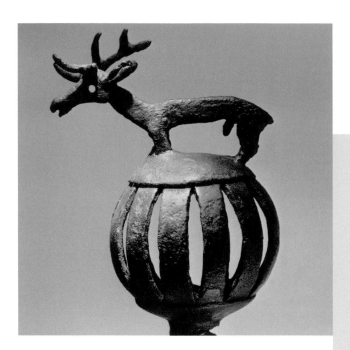

# PHYSICAL METALLURGY, 14

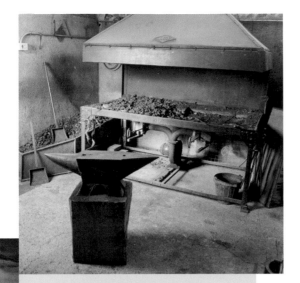

ents

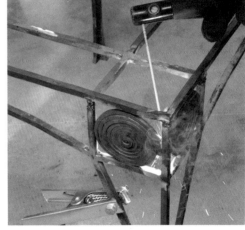

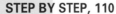

# Introduction

Often, the forms of certain objects and the materials with which they are made give people the impression that they are difficult or at least complicated to make. This book shows that working with metals can be simpler than it appears at first glance.

This book presents the basic techniques for working with metals directly using commercially available forms. Iron, copper, brass, and stainless steel are common metals, affordable and easy to find. They are products that have been elaborated in the factory, and that come to the market in various formats.

The reader will also find subjects related to the metallurgy of metals and alloys, in other words, the physical and mechanical characteristics, transformation into commercial forms, and so on. The reader will also find historical references to the relationship that different civilizations had with metals and how metals have influenced human progress. But the pages of this book do not include any foundry-related techniques, because these processes do not entail a physical and direct manipulation of the metal but rather of the molds and of the complex behavior of metals in them.

The reader will find information related to the mechanical transformation of metals, that is, the basic forming techniques, machining, and welding and soldering techniques for the permanent joining of metals. Also, a section will be presented on forging, an essential technique that could fill a book by itself due to its wide array of creative possibilities.

In addition, a chapter will be presented on the tools and machines needed for performing the techniques, and another one describing the different surface finishes for metals.

To finish, several practical exercises are explained step by step, with the goal of offering a hands-on approach to the use of the different basic techniques described as the object is being created.

In brief, this book presents the basic processes related to working with the most common metals in a clear, concise, and rigorous manner.

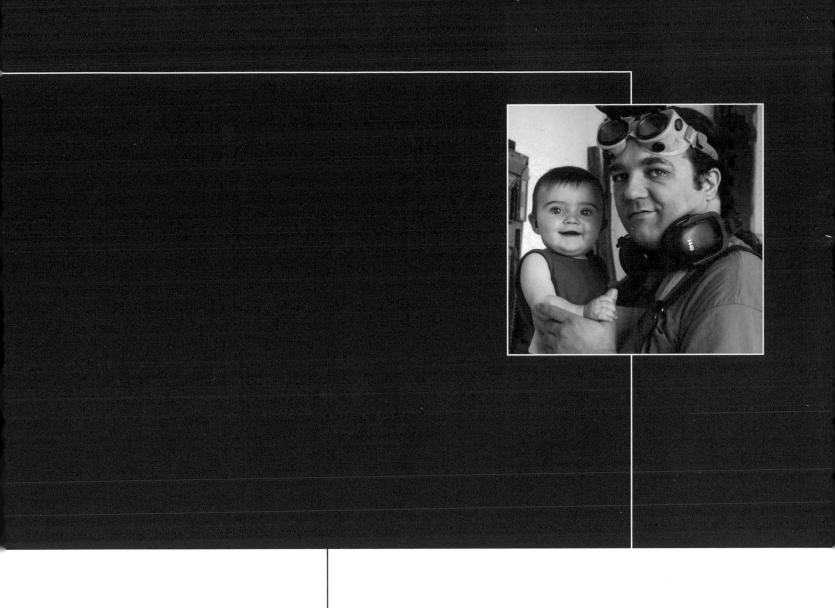

**José Antonio Ares i Río** (Villar de Golfer, 1968) has a degree in fine arts from the University of Barcelona with a concentration in sculpture. He has completed studies in printmaking at the Escola d'Arts i Officis de la Diputació Provincial de Barcelona and in sculpture at the Escola Massana, also in Barcelona. Since 1997 he has alternated the profession of sculptor with teaching sculpting techniques as head of the studio at the School of Fine Arts of the University of Barcelona. In 2003, while preparing this, his first book, for publication, he celebrated the immense joy of the birth of his daughter Ia.

# The Metal Ages

The knowledge of the techniques for modifying minerals and for converting them into metals is relatively new, taken from the perspective of human existence. From the use of simple elements such as stone, sticks, or bones as everyday utensils to the discovery of the first metal tools, which required technological knowledge for their transformation, thousands of years elapsed.

In the first half of the nineteenth century, the Danish archeologist C. J. Thomsen created a period table dividing the classification of archeological material found at the sites into three phases. This material was organized according to whether it came from the Stone Age, at the end of which the use of gold and copper is found, the Bronze Age, or the Iron Age.

These divisions are not chronologically exact. For example, it is known that China went from the Stone to the Bronze Age at about the same time as Great Britain, and that in Japan bronze and iron appeared at the same time. However, in the New World, metallurgy was not used to produce objects until the arrival of Spaniards, with the exception of gold, for which some civilizations showed great craftsmanship.

## Premetallurgy

From the earliest civilizations, ornamentation has had a special importance as a status symbol within a social group. Decorative objects were constructed with stones and minerals that stood out from the rest because of their bright colors. So, jet, pyrite, jasper, obsidian, and amber were used to produce adornments that were a symbol of status within the group and gave prestige to their owners.

From the use of these attractive stones, ancient civilizations learned about other minerals, some of which constitute the raw material for obtaining metals.

They familiarized themselves with them, learning to find them, to extract them, and to manipulate them until they got, for example, pigments of different colors. Also, learning that fire changes the color of some rocks and that if the heat is intense even their outer appearances could be modified.

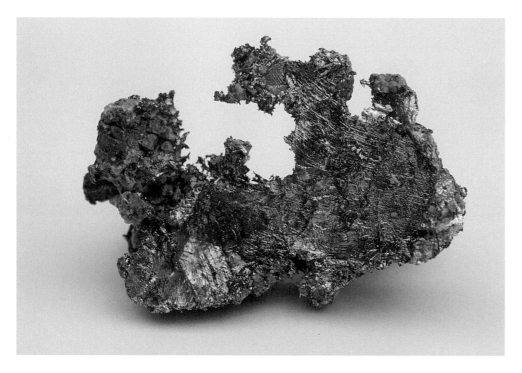

◄ In nature, in addition to gold nuggets, it is possible to find different native materials, that is, in pure form, usually precious and semi-precious ones like silver, platinum, and also copper. This sample is natural copper, which came from the Calcedonia mine (Ontonagon County, Michigan).

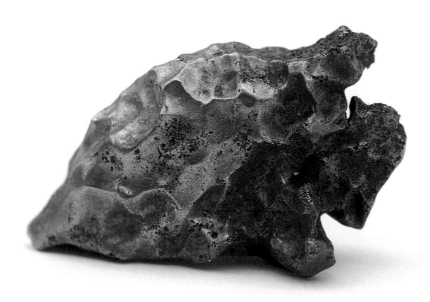

◄ Iron, shown here, and some other metals, can also be found in what is called a native state. This one comes from a meteorite found in Australia.

# Native Metals

The first metals that were used to produce objects in primitive societies are those that we call native. They are found in nature in pure form, without the combinations that form minerals. Gold, copper, and silver were the most common ones and the most sought after, and later iron from meteorites would be included.

The attraction of primitive societies to these metals is understandable. Their bright colors arouse curiosity. Furthermore, their forms could be modified by hammering them, unheated, with stones over stone anvils to make small decorative objects.

Native copper was the first metal to be worked, as evidenced by the objects found in Tell de Sialk (Iran) and in Coyönü Tapesi (Turkey) between the eighth and seventh millenia B.C.E. This metal was used for both practical or decorative purposes.

Gold, on the other hand, was used only for decorative and ornamental purposes. Its malleability allows the creation of thin sheets by hammering the nuggets found in the sands of gold-bearing rivers.

# Calcolithic

The Calcolithic period, also called the Copper Age, comprises the fourth and third millenia and is placed at the end of the Stone Age. The word *calco* comes from Greek and means "copper" and *lithic*, also from Greek, means "stone."

This period is considered the beginning of metallurgy. At the same time that they harvested and worked metals in their native form, some societies of this period extracted copper minerals from mines, like the one in Timna near the Dead Sea, and transformed them by melting them to extract the metal, which is a purely metallurgic process.

This allowed the liquid copper to be poured into molds of various shapes to create everyday utensils like hachet blades, arrow points, and hoes. These tools were very important for the progress of civilizations that were beginning to domesticate animals and to replace hunting with agriculture.

▼ Location of the first metallurgy production centers, especially copper, bronze, and iron, in eastern Europe and the Middle East.

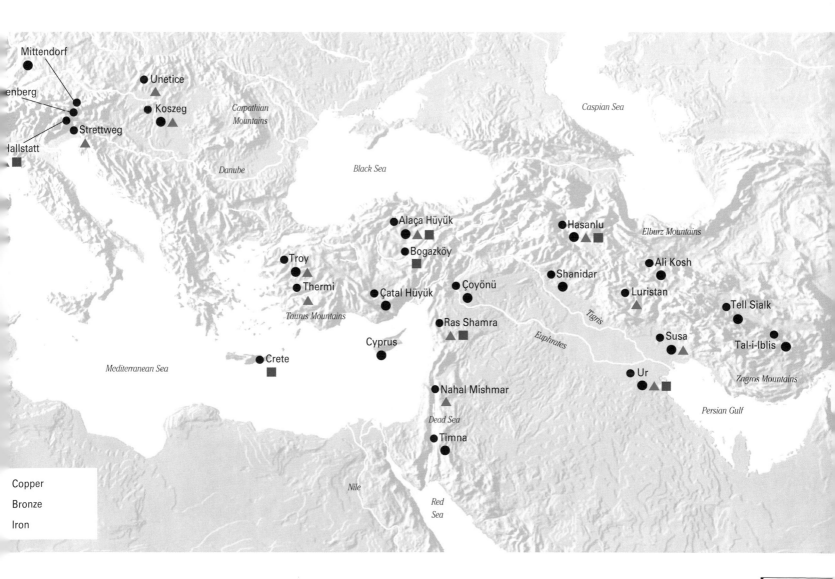

Copper

Bronze

Iron

# Bronze Age

The Bronze Age developed after the Calcolithic period. This era received its name from the use of this copper and tin alloy to make tools. The first bronze alloys were not mixtures produced by humans but were combinations of natural origin, such as copper and arsenic, which was very plentiful in the Middle East.

But the discovery of bronze as a result of mixing copper and tin revealed excellent advantages. This new metal was harder and less fragile than copper alloy with an arsenic base, and therefore much more durable.

Bronze allowed an improvement of the quality of the tools, because it made them more resistant to stress. The ease with which it was liquified and shaped allowed the use of molds to create many objects, like cups, cauldrons, and all kinds of utensils for daily or religious use. Another advantage of bronze was that it could be used to make tools like hachets, knives, and chisels.

Bronze utensils also revolutionized other endeavors like carpentry, making possible the creation of adzes, hammers, and chisels, and agriculture, with the production of hoes and scithes.

Also, the need for finding tin deposits to make bronze promoted the exploration of territories and of sailing, and with it, the discovery of new commercial routes.

▼ Wall decoration of a tomb in Sakkara, of the Ancient Empire in Egypt (c. 2330 B.C.E.), in which foundry scenes are represented on the upper row and forging on the lower.

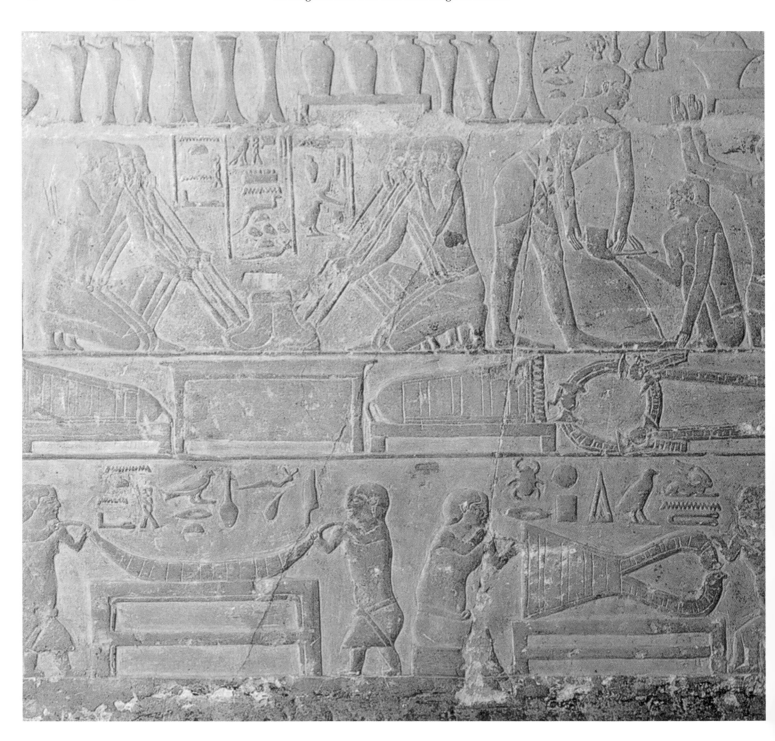

# Metallurgic Techniques in Antiquity

The different places around the world where metallurgy developed used techniques that were similar but that logically had some differences. The first metal work, still within the Stone Age, used stones for the forming process, so it is possible to imagine that the work was merely done through pounding, and that bending and even shearing was possibly done by the same method. In fact, this early work had little impact on the development of these societies due to the lack of raw material. The objects created were not so much functional as they were ornamental, making use of the shine and plasticity of the metal. Despite this modest production and with some reservation, we could say that these works were the beginning of metallurgy.

However, thousands of years would still have to pass before humans learned about the minerals that contained copper and then, once they were found, to separate the ore from the rock, the metal from the waste, through mechanical means and heat, a process that is called reduction. Remnants of this activity have been found in Iran dated to approximately 4000 B.C.E. However, a reasonable doubt persists among specialists about whether in a slightly earlier period, between 5000 and 4000 B.C.E., in Mesopotamia, they had been able to melt copper and to pour it into molds, an important technical milestone, since this metal has a melting temperature of 1,981°F (1,083°C).

Between 4000 and 2000 B.C.E., practically all cultures were aware of the existence of the foundry and also of alloys, first arsenic copper, which in reality was an impurity that improved the hardness of copper, and then of tin. From a technical point of view, metal founding—a great chapter in metallurgy that is not covered in this book—became perfected, and with it the production of molds and pouring, and the way the molten metal behaved inside the molds. But the use of metal tools also greatly influenced the invention and fabrication of all types of metal items for every use (armament, ornamentation, tools, and domestic implements, etc.), as archeologists have discovered. Around the year 2000 B.C.E., in what is considered the Old Bronze Age in eastern Europe, metal artisans were able to produce complex hammered work (sheet and thread), forming techniques, riveting, inlay, and stone setting. At the same time, they began to do embossing work—possibly the oldest decoration technique—as

well as engraving and perforating. From this, we can deduce that they had tools for hammering, for holding in place, for measuring, and for cutting that were not so different in shape from the current ones. From the middle of the period, known as mid-Bronze, soldering techniques were beginning to become known through working alloys with what we know as soft soldering.

It is also worth mentioning similar work with precious metals (gold and silver), which are not covered in this book because they belong to the world of goldsmithing and silversmithing, yet which share many of the techniques and tools of metallurgy. There are many important objects and jewelry that belong to many civilizations, including those of the Americas, and that demonstrate mastery of materials and finishes, beauty of design, and creativity. The embossed work in

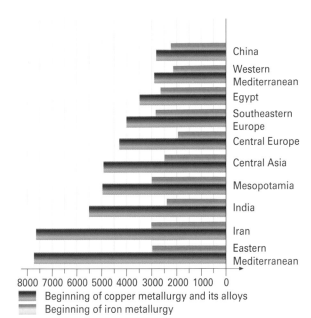

▲ Chronological diagram of the beginnings of metallurgy in various parts of the world.

gold produced by the Egyptians in funerary masks and cult objects are some outstanding examples of these.

Finally, metallurgy reached its pinnacle with the Iron Age, the most abundant and affordable metal. However, iron requires a temperature of 2,795°F (1,535°C) to reach its melting point, so humans had to perfect smelting techniques for minerals. Between 2000 and 500 B.C.E., all the civilizations of the Old World knew how to work iron, with the exception of tropical and equatorial Africa. In America, it was mainly the Spaniards and perhaps the Vikings who introduced the techniques for working iron.

Despite a wide and even sophisticated production of iron objects in the great civilizations of the Old World, it would still take centuries before metal was refined to fabricate steel, first in modest quantities and later on a large scale, after the nineteenth century.

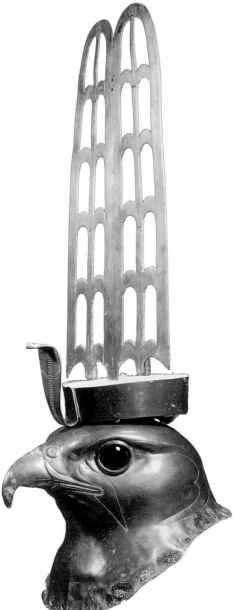

◀ Head of Horus, the Egyptians' falcon god, in which the crafstmanship of this civilization can be seen in the embossed work of the head, which in this case is made of gold. This head was made from a sheet by forming and stretching it, hammering even the smallest details, using no soldering whatsoever.

# Iron Age

The Iron Age began toward the second millenium B.C.E., and the Hittites, in a village in the area of Anatolia, were the first ones to use this material. Following them, the rest of the Old World entered this age centuries later. The technical difficulties presented by the smelting of iron minerals accounted for the delay in its use, keeping in mind that humans had already been in contact with metals for a period of five thousand years.

Copper, for example, can be melted down in a primitive oven operated with a torch or with a blower, and can reach temperatures of up to 2,012°F (1,100°C). To melt iron, on the other hand, a temperature greater than 3,092°F (1,700°C) is required, for which more complex ovens had to be invented.

Another difference is that copper and bronze can be worked cold, even with stone tools, thanks to its malleability at room temperature. However, iron is very hard and it must be heated until it turns red to make it malleable. Early metalworkers therefore had to develop tongs or pliers that would allow them to handle the incandescent metal, and anvils that were strong enough to work it. This represented a true technological innovation.

On the other hand, iron minerals are very abundant on the surface of the Earth's crust. This, together with the abundance of forests where natural coal was produced for working with iron, favored the expansion of the iron and steel industry throughout the Near East and the Mediterranean basin.

Iron metallurgy soon spread from the pioneer regions of the Near East, Cyprus, and the Aegean by Greeks in the eightth century B.C.E. to Sicily and Italy, and through the commercial activities of the Phoenicians throughout the Mediterranean.

In general, iron offers many advantages over other metals such as bronze and copper, one being that the mineral from which it is extracted is more abundant and easier to find. Iron tools and weapons are stronger and more durable than those made of copper or bronze, which broke on impact due to their fragility. Iron was used to make many objects and tools for agricultural activities, like plowshares, attachments for carts, scythes, and sickles. Stronger swords, lance points, shields, bits for horses, and helmets were also made. The knowledge of iron metallurgy contributed to a great extent to progress and socioeconomic expansion of ancient civilizations.

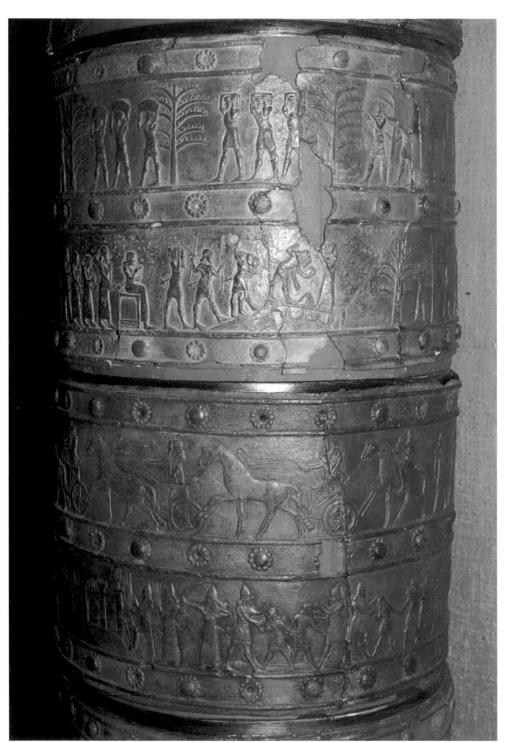

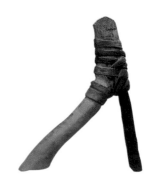

▲ Egyptians, in addition to making weapons, used iron to make tools, as evidenced by this adze.

◀ The civilizations of Mesopotamia were also notable for their knowledge of metal techniques. Bronze doors from the Salmanasar II palace in Balawat, dated between 858–824 B.C.E. British Museum (London).

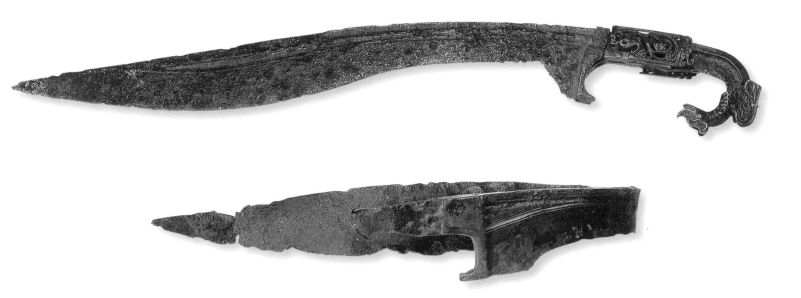

▲ Iberian iron swords found in Almedinilla (Córdoba, Spain). These wide and curved blade weapons were made by welding together three iron sheets. The middle one was extended to form a handle, which often had the shape of an animal, in this case a horse, that also protected the hand. The swords were produced between the fifth and first centuries B.C.E., although iron metallurgy was brought to Spain towards the eightth and seventh centuries B.C.E. by the Phoenicians. Museo Arqueológico Nacional (Madrid).

▲ Reproduction of a scene from a Greek cup showing the molten metal in a primitive foundry.

► This iron ornament from a war chariot, used by the people who lived on the hills of the north shore of the Dead Sea, reveals the art and mastery that they possesed in working this metal in the seventh and sixth centuries B.C.E. From the archeological site of Altái (Russia).

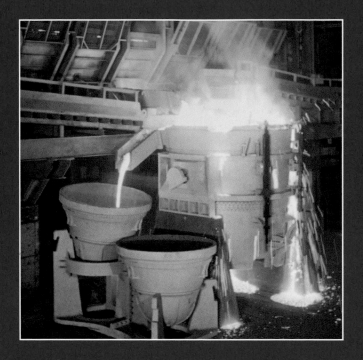

*M*etallurgy studies the range of procedures and techniques for the production of metals, as well as the way they are transformed and manufactured. The following chapters cover the subjects related to physical metallurgy, that is, the branch of science that studies the physical and mechanical characteristics of metals and their alloys, especially those that are used in this book.

The intention is to discuss and review concepts that are commonly used in the area of metalworking, like the properties and characteristics of metals and alloys, and the fabrication of commercial products directly from raw materials, among others. Also a brief passage is devoted to oxidation and corrosion, because these processes are important in the world of metals, although they do not belong strictly to this branch but to chemical metallurgy. The goal of this chapter is to serve exclusively as a tool for review and reference.

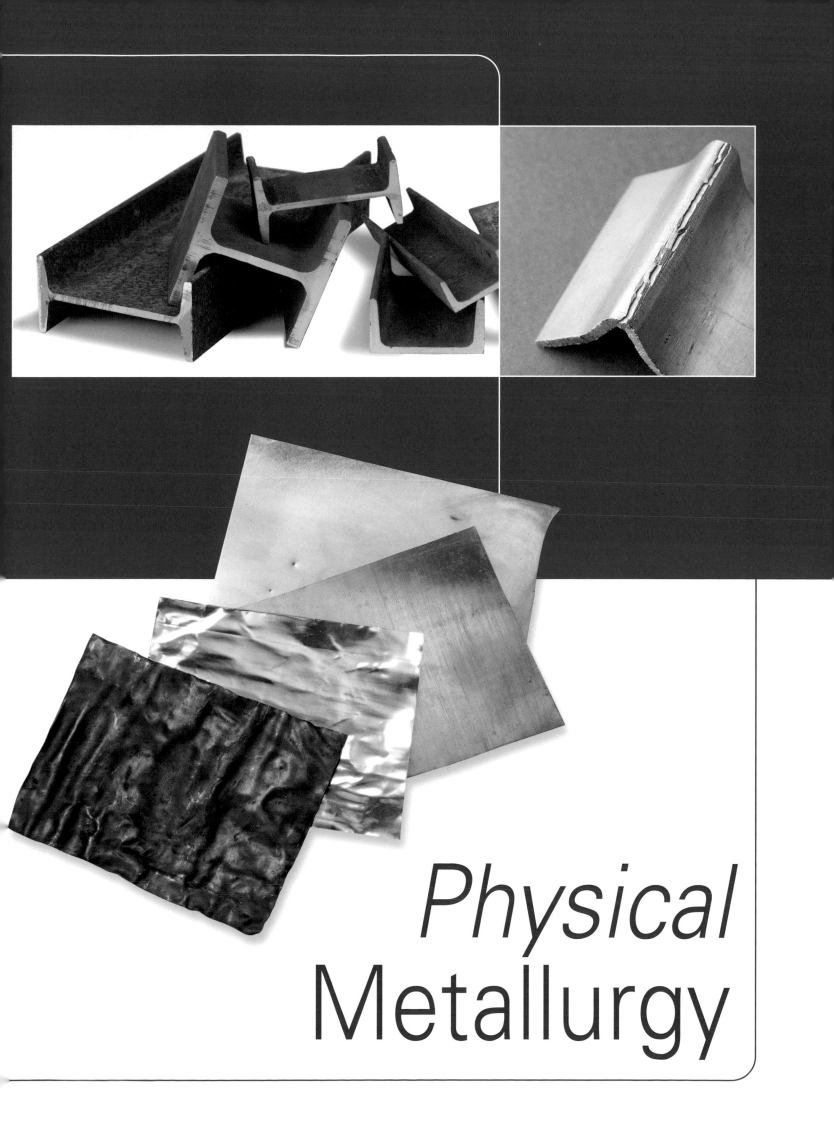

# Physical
# Metallurgy

# Metals and Alloys

Technically, a **metal** is an element that has a tendency to give up electrons. Its structure is a clear cubic or hexagonal crystal, that is, the geometric figure formed by the organized group of atoms, ions, and molecules, of which metal is made. Its surface has a characteristic shine when polished. Most metals have a gray or grayish and white color, except for copper, which has a unique red color, and gold, which is yellow. All metals are solid at room temperature, except mercury, which is liquid. They are good conductors of heat and electricity. In general, metals possess two of the most important characteristics for a material that is to be manipulated: malleability and ductility, because their shapes can be modified without breaking.

To improve the other properties of metals, like their strength and hardness, they are often combined among themselves to produce **alloys**. They can belong to a binary system, in other words, metal combinations with two components; for example, carbon steel, which is made of iron and carbon. Some alloys can have as many as seven components, like certain hardened steels made of iron, cobalt, and wolfram, among others.

Alloys are opaque, have a metallic sheen, and they are good conductors of heat and electricity. In general, they are harder than the metals they are made of but are less ductile and malleable. Alloys also have better fusibility than the least of the metals of which they are made.

There are two groups of metals: ferrous and nonferrous.

**Ferrous** metals, like the name indicates, are made of iron; for example, carbon steel (iron and carbon), stainless steel (iron, chromium, nickel, manganese, and silicon), gray iron (iron, carbon, and silicon), and white iron (iron, carbon, and manganese).

The rest of the metals and alloys that have no iron component belong to the **nonferrous** group; for example, copper, brass, bronze, aluminum, and zinc, among others.

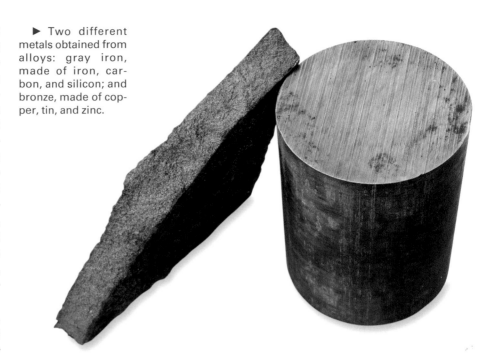

▶ Two different metals obtained from alloys: gray iron, made of iron, carbon, and silicon; and bronze, made of copper, tin, and zinc.

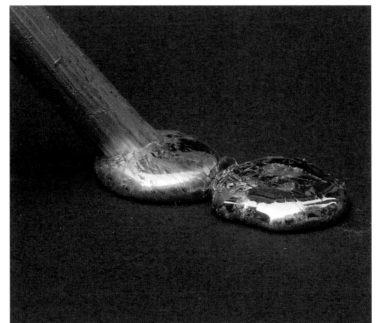

◀ The fusion point of alloys is always lower than any of their metal components. This property is used to our advantage for soft solder, whose metal component is generally formed by a 50/50 alloy of tin and lead, which is easy to melt with an electric soldering iron or gas torch.

A        B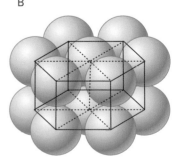

▶ Systems of metal crystallization: cubic structure characteristic of iron, copper, and aluminum (A), hexagonal structure corresponding to zinc and cobalt (B).

# The Concept of Corrosion

**Corrosion** refers to the spontaneous transformation of the natural free state of a metal to a combined natural state through a process of oxidation. Upon being exposed to weather conditions, metal tends to reach a chemically stable point, only to return to its previous state by combining with other elements.

The **oxidation** of metals is the combination of the metal with the oxygen in the air. During this process, a thin oxide layer is formed on the surface, which in many cases prevents more oxygen from entering, thus fulfilling a protective function. For example, aluminum produces a very compact layer of oxide that protects it permanently from corrosion.

**Corrosion** takes place in humid environments and is an electrochemical process. For corrosion to take place spontaneously, three factors must be present at the same time:

**anode**, **cathode**, and **electrolyte**. This group is called a **galvanic reaction**.

The electrolyte is a water solution that conducts electrical currents, for example, marine environments. In this environment, anodes repel positive ions while the cathode attracts them, creating an exchange of electrons between the anode and the cathode. Corrosion takes place in the anode areas; cathode areas remain unchanged.

Anode metals corrode in the presence of cathode metals. For example, such is the case of galvanized steel, which is a carbon steel covered with a thin layer of zinc; it is the latter metal, with a negative power superior to that of steel, that suffers the effects of corrosion. On the other hand, in tinplate, which is a carbon steel covered with a thin layer of tin, is the steel that corrodes because it has more negative electrons than tin.

▲ To protect the metal components of some vessels from marine corrosion, sacrificial metals are used. They are more electronegative than the metal that must be protected, producing corrosion from the effect of galvanic reaction of the anode metal.

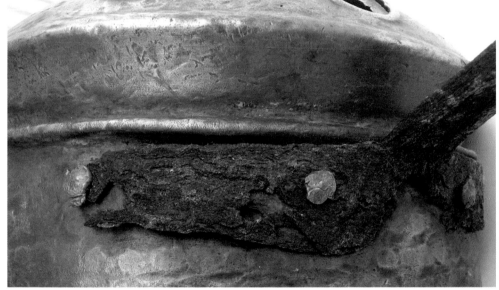

◀ The effects of galvanic reaction. The iron piece of the handle has been subject to a more intense process of corrosion compared to the unaltered copper piece.

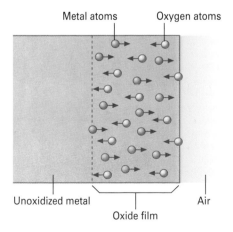

▲ Diagram of the exchange of electrons in the oxidation process of metals.

*Labels: Metal atoms — Oxygen atoms — Unoxidized metal — Oxide film — Air*

## CHART OF THE POTENTIALS OF SOME METALS

The greater the distance between metals, the greater the degree of corrosion between them, keeping in mind that the most electronegative metal always corrodes.

| ELEMENT | ELECTRONEGATIVITY |
|---|---|
| Mg (magnesium) | −2.37 V |
| Al (aluminum) | −1.66 V |
| Zn (zinc) | −0.763 V |
| Fe (iron) | −0.44 V |
| Cd (cadmium) | −0.403 V |
| Ni (nickel) | −0.25 V |
| Sn (tin) | −0.136 V |
| Pb (lead) | −0.126 V |
| H (hydrogen) | 0.000 V |
| Cu (copper) | +0.337 V |
| $O_2$ (oxygen molecule) | +0.401 V |
| Ag (silver) | +0.799 V |
| Au (gold) | +1.5 V |

# Properties of Metals

Metals possess a series of physical and mechanical characteristics that define them. These are the so-called properties of metals.

The *physical properties* of metals refer to the way metal behaves in situations that affect its interior structure. For example:

**Dilation** and **contraction** refer to the changes in the dimensions of the metal as a function of the temperature that is applied to it. The metal expands when heated (it dilates), and it shrinks when cooled (it contracts).

**Fusibility** indicates the temperature at which a metal turns into liquid through the absorption of heat.

**Thermal and electrical conductivity** refers to the capability of metals to allow heat or electricity to be transmitted through their molecules.

The **welding property** allows putting two metals together through fusion.

The **forging property** is the ability of heated metals to being forged by hammering or stamping.

The *mechanical properties* determine the behavior of metals subjected to efforts and manipulation that tend to change their shape. For example:

**Malleability** is the property that allows the form of the metal to be altered without cracking. This makes it possible to turn metal into sheets and into any number of forms.

**Ductility** is the property that allows the metal to be stretched to form threads without breaking.

**Tenacity** is the resistance of metals to breaking when subjected to forces of traction.

**Elasticity** is the property that allows metals to change their shape when being subjected to force and to return to their initial shape when the force subsides.

**Flexibility** allows the metal to bend or curve without breaking.

**Resiliency** is the resistance offered by metals to the action of striking or percussion.

**Hardness** is the resistance of metal to wearing out through rubbing.

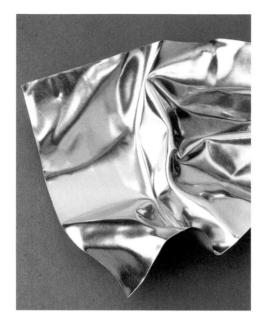

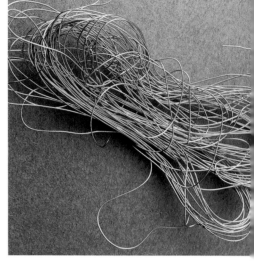

◄ Thanks to malleability, very thin sheets of metal can be created, in this case tin.

▲ Ductility allows the creation of very thin metal filaments, as is the case for copper.

◄ The fibers of some metals that are not very flexible, like this piece of aluminum, break under the pressure of bending force.

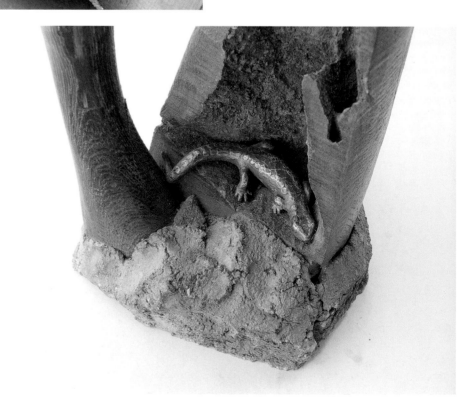

► Jordi Torras, *Salamander*, 1995. Bronze and wood.
Fusibility allows molten metal to be poured into a mold to create objects.

## Stainless Steel

This is an alloy of iron, carbon, and chromium as the main elements, to which nickel, molybdenum, titanium, or silicon, among others, can be added, which have an influence on the characteristics and properties of this metal. Stainless steel is divided into three large groups: martensite, ferrite, and the most commonly used, austenite.

They are all corrosion resistant when they come in contact with the air, humidity and some acids. Martensites and ferrites are magnetic, that is, they attract a magnet, while austenites do not.

## Carbon Steel

This is an iron and carbon alloy with a gray color most commonly known as iron. The amount of carbon in the alloy determines its properties and characteristics. The most commonly used is steel with a carbon content lower than 1.7%; at higher levels it is called cast iron.

Carbon steel is ductile and malleable, hard, elastic, and resistent, and melts at 2,795°F (1,535°C).

## Aluminum

This is a light metal that has a white color and is very resistant to corrosion when it comes in contact with air or humidity. It is a relatively soft metal, very ductile, malleable, and not dense, and melts at 1,220°F (660°C).

## Copper

A reddish metal that is very ductile and malleable, as well as a great conductor of heat and electricity. It is very resistant and its melting temperature is 1,981°F (1,083°C).

## Brass

This is a copper and zinc alloy with a yellow color. It is hard and very resistant to corrosion. It melts at temperatures between 1,472°and 1,877°F (800°–1,025°C), depending on its composition.

## Zinc

Zinc is a bluish-gray metal that is very resistant to corrosion. It is malleable, flexible, not very ductile, and fragile at high temperatures. It is a dense metal that melts at 450°F (232°C).

## Lead

A very soft and dense gray, lead can easily become scratched. It is firm, ductile, malleable and resistant to environmental corrosion. It melts at 621°F (327°C).

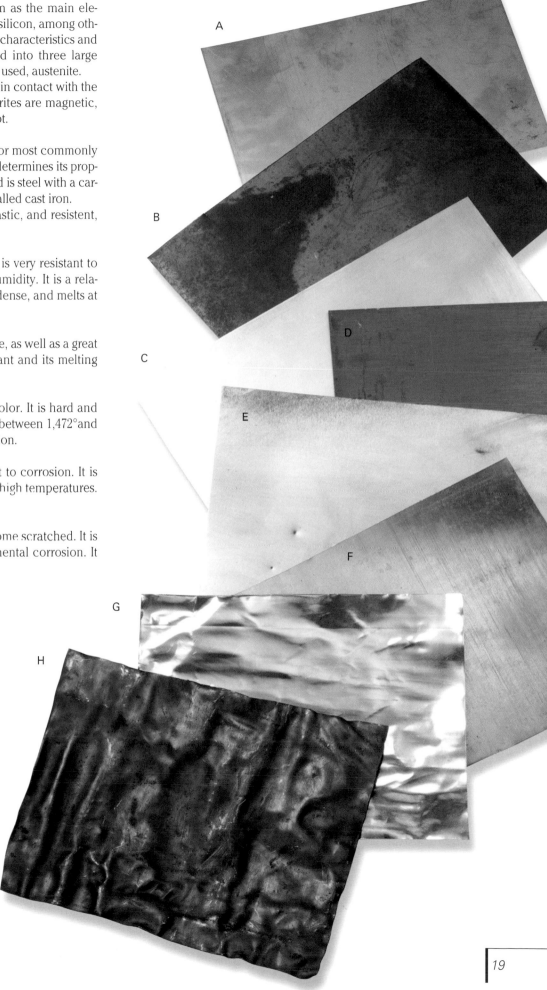

▶ Stainless steel (A), Carbon steel (B), Aluminum (C), Copper (D), Brass (E), Zinc (F), Tin (G), Lead (H).

# Manufacturing Steel

Iron is a metal with a percentage of carbon lower than 0.05%. Some of its characteristics, like hardness and elasticity, can be improved as an alloy combined with the right proportion of carbon, and it can also be subject to thermal treatments, like tempering. Such is the case of steel. On the other hand, if it is combined with carbon in a proportion greater than 1.7%, it turns into a fragile and brittle material that is neither very ductile nor malleable. Such is the case of cast iron.

Steel is an alloy made up basically of iron and carbon. The proportion of the latter is between 0.05% and 1.7%. Steel is produced from iron minerals like magnetite, and hematites, among others.

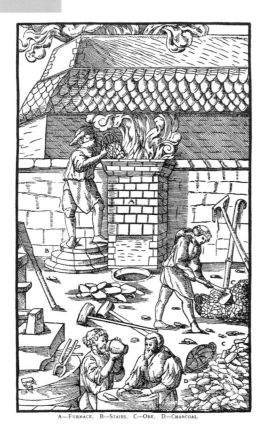

A—Furnace.  B—Stairs.  C—Ore.  D—Charcoal.

◄ Scene in the ninth book of De Re Metallica (1556), encyclopedic work by Beorgius Agricola (1494–1555), which represents all aspects of metalworking in the sixteenth century.

▼ Tapping of liquid iron in a foundry. The manufacturing and refining process of iron up to the moment it turns into steel consists of reducing the carbon content and other impurities. At the same time, according to its future use, other elements can be added to produce a steel with certain special characteristics.

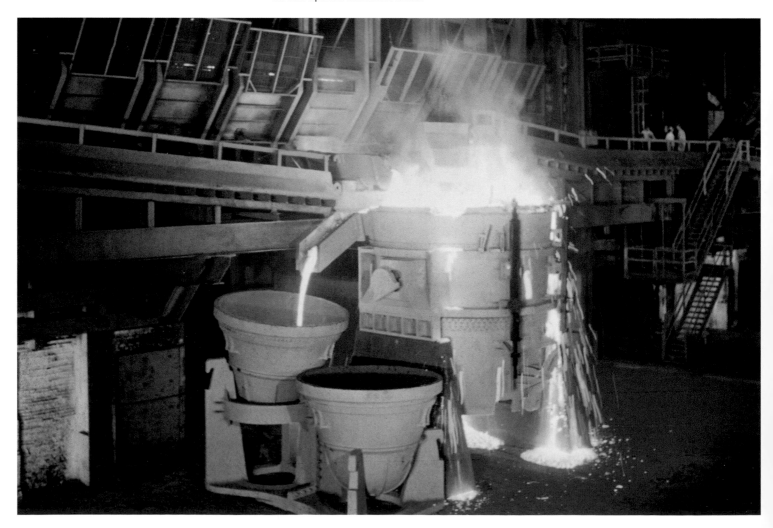

# Basic Oxygen Furnace

Beginning in the nineteenth century, blast furnaces were used to produce steel. And the production of this metal in large quantities begins with the Bassemer converter.

In general, the processing with basic oxygen consists of refining cast iron in a very tall cone-shaped furnace—a blast furnace—making the oxygen pass through the molten metal at high pressure. Oxygen is combined with carbon and with other elements as chosen, and an oxidizing reaction of the cast iron's impurities takes place.

At the same time, lime and other infusible materials are used to generate a chemical reaction that produces heat at an approximate temperature of 3,002°F (1,650°C). When the correct composition of steel, which is tested by sampling, is achieved, the molten steel is poured into a continuous casting furnace.

This process is used for the large-scale production of carbon steel, because a basic oxygen furnace can generate 300 tons of steel in only 45 minutes.

# Electric Arc Furnace

With this type of furnace, the heat needed for melting metal is obtained from electricity and not from carbon combustion. Inside an airtight chamber, a voltaic arc is formed between two electrodes. This arc generates very intense heat, up to 3,506°F (1,930°C), which melts the metal. At this moment, the exact quantities of the necessary alloyed materials are added to the molten mass.

The raw material used in this process is scrap metal, which has been previously analyzed and classified to make sure that its contents will not affect the composition of the refined metal.

The most important advantage of this furnace compared to others is the fact that the temperature can be controlled with great precision, automatically. This is very useful, especially in the production of special types of steel and stainless steel, since there is no combustible fuel involved that could create impurities in the metal.

▼ The process for the fabrication of steel and various other semi-elaborated products from minerals and scrap metal.

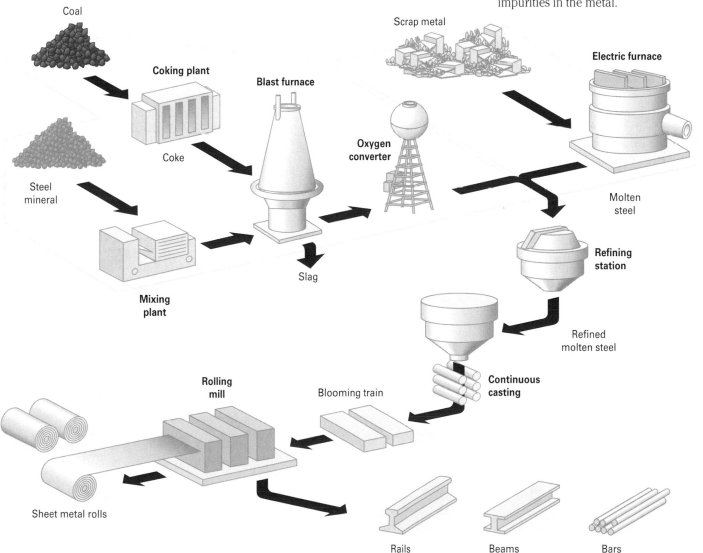

# Commercial Metals

Metals are sold as finished products. They are available in different shapes and sizes known as **commercial sections**. These products are classified according to their degree of transformation, their shape, and their finish and use. They can be sold as semi-finished products or finished products.

The semi-finished products include the steel blanks that are used as the base material to make the finished products. They are produced through a milling process of the product in bulk, obtained from the tapping extracted from the blast furnace.

These products include the square or rectangular bloom, the square bar, and the rectangular bar. All of them are produced without edges.

The finished products are obtained following different procedures, which may include **milling**, **extrusion**, **manufacture of tubes**, and **drawing**.

## Rolling

The rolling process consists of making a mass of metal pass through two rollers placed on top of each other and that turn with a reverse motion. This procedure can be executed cold or hot.

When the process is hot, a continuous forging effect is achieved. Hot rolling does not produce hardening, in other words, the material does not harden as a result of deformation. Besides, rolling can be as intense as needed if the material is maintained at a certain temperature, between melting and recrystallization. Also, the structural and chemical characteristics of the metal are improved with this process.

In cold rolling, the work is done at room temperature, which causes the metal to become hardened. This effect can be eliminated by annealing at the end of the process.

Of all the metals, steels are the most commonly used in the process of milling, either hot or cold. A variety of metal sections can be produced as well with copper and its alloys, aluminum and its alloys, magnesium alloys, zinc and lead.

The different products are manufactured in **roll stands**, which basically consist of two or more rollers placed one above the other. When these stands are arranged in such a way that the material can pass from one to the next continuously, they are called **continuous rolling mill trains**. There are trains for blooming, bars, sections of different shapes, and so on, which are classified according to the final product.

Commercial rolling trains are used for the fabrication of small and medium weight sections. They consist of various rollers arranged in groups, which resemble the shape of the finished product the closer they get to the end of the process. The semi-finished product is first put through the blooming group, followed by the preparatory one, and finally, through the finishing group.

## Pulling and Drawing

These are two forming processes used for ductile materials. Both methods shape the material by drawing it through openings of various diameters arranged in a draw plate.

The difference between both processes involves three essential aspects: the kind of material used, the object of the operation, and its execution.

The pulling procedure is applied to metal wire with a diameter greater than 0.040 inch (10 mm), while drawing is used for rounds of 0.20 to 0.30 inches (5 to 8 mm) in diameter, obtained through a milling process specifically designed for this operation.

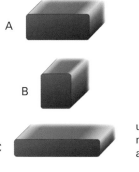

A

B

C

◄ Sections of the semi-finished products as they come out of the first hot milling phase. Bloom (A), square bar (B), and rectangular bar (C).

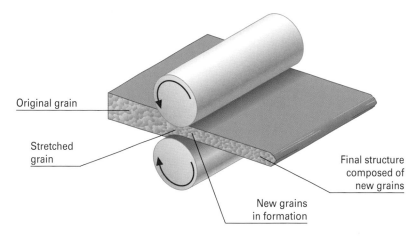

Original grain

Stretched grain

New grains in formation

Final structure composed of new grains

▲ The enormous pressure applied by the rollers produces variations in the structure of metals. When the rolling is carried out at room temperature, the metal hardens and loses plasticity and elasticity, becoming more fragile. It is therefore necessary to anneal it afterward to recover those properties.

If it is carried out hot, a continuous forging effect is achieved, which improves certain properties like the tenacity and ductility of the metal, making it more resistant to breaking, twisting, traction, and contraction.

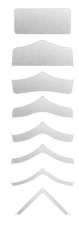

► Progression of the various forms obtained in each group of the roll stands, until a steel angle is created.

► Sections obtained in each group of roll stands to produce a bar in the shape of a rail.

The purpose of the pulling process is to change the diameter of the metal, to harden it by deforming, or to give it a specific shape, while the function of drawing is to make the material thinner. Also, pulling executes the operation in a single step, while drawing requires the material to pass through several times to make the metal thinner.

The materials that are drawn to make all kinds of wires are all the steels, copper, bronze, and aluminum. The filaments for light bulbs are obtained from drawn tungsten.

Only metals that are ductile and resistant to traction are used for drawing so they do not break. The most commonly used are carbon and alloyed steels, copper, tin, aluminum and its alloys, and magnesium.

# Extrusion

Extruding is a procedure used for forming metals and their alloys by making them flow under pressure, cold or hot. It allows the production of pieces and tubes with uniformly shaped sections and a good finish.

In **cold extrusion**, the material is placed within the die and forced to flow between its walls and the tool that presses on it with force.

The metals used for this procedure are very ductile, like lead, tin, zinc, and copper, and the pressure applied by the tool is very strong. The tool descends rapidly, so the energy released from the impact produces heat and encourages the extrusion.

Cold extrusion is used to make small containers with flexible walls to hold certain pastes like glues, paint, creams, and for the fabrication of casings for cylindrical batteries, condensers, and so on.

In **hot extrusion**, metals are made to flow at temperatures approaching the melting point, using molds with a die of the same diameter as the piece that needs to be fabricated.

This technique is used for forming a great number of metals and alloys, like lead, tin, zinc, copper, aluminum, nickel, manganese, and all their alloys. It is also applied in soft steels and stainless steels.

The hot extrusion method is used to make angles, tees, and double tee-shaped pieces, round or multi-shaped tubes, with flanges, with ridges, and molding of any shape.

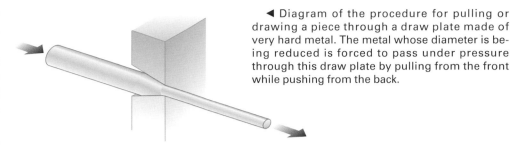

◀ Diagram of the procedure for pulling or drawing a piece through a draw plate made of very hard metal. The metal whose diameter is being reduced is forced to pass under pressure through this draw plate by pulling from the front while pushing from the back.

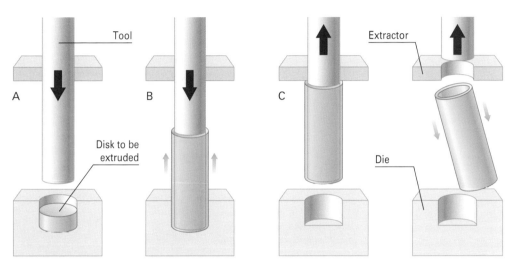

▲ Different phases of cold extrusion. The operation is carried out in a press. In (A) the metal disk that is to be extruded is placed inside the die, which is made of very hard metal. In (B) an impact applied with a specific pressure from a tool made of very hard metal forms or extrudes the metal disk, and in (C), when the tool recedes inside the extractor, the piece is dislodged. The pressure with which the impact is applied is calculated based on a series of variables, such as the characteristics of the metal that is to be extruded, its shape, and the thickness of the disk, among others.

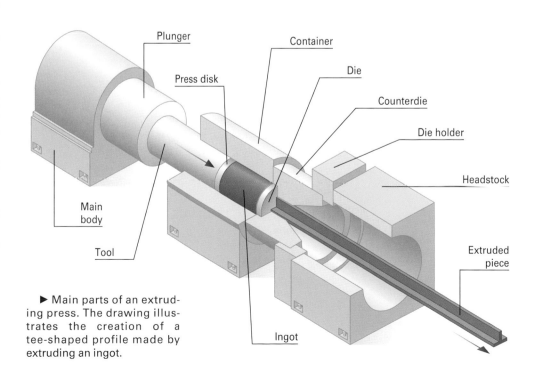

▶ Main parts of an extruding press. The drawing illustrates the creation of a tee-shaped profile made by extruding an ingot.

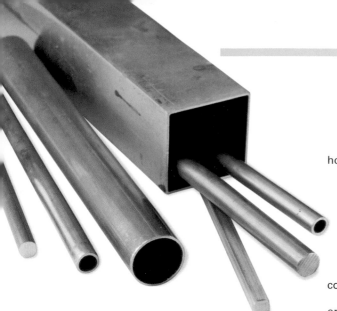

◀ Copper and brass pieces (right), solid and hollow with square and round sections.

▼ Aluminum extruded pieces. Extrusions of this metal are available commercially in many complex designs.

These pieces are used very often in the construction of window frames and enclosures in general. They are also very prevalent in the aeronautic, automotive, and railroad industry for their light weight and durability.

## Manufacturing Tubing

Tubing is manufactured using a great variety of procedures according to the different types that are sold for different uses. There are open, clamped, electronically welded with a seam, arc welded, and oxyacetylene welded. Tubes can also be cast, hollow formed hot, extruded hot, or fabricated by perforating with a drill. There are tubes that are used in construction, for conduction of fluids, and to make scaffolding. Others are used in the automotive industry, for domestic applications, or to manufacture metal furniture.

▶ Different phases of tube construction through forming and arc welding with a seam.

The sheet metal is shaped using a system of rollers until a complete circle is formed, at which time the edges are sealed together automatically by arc welding.

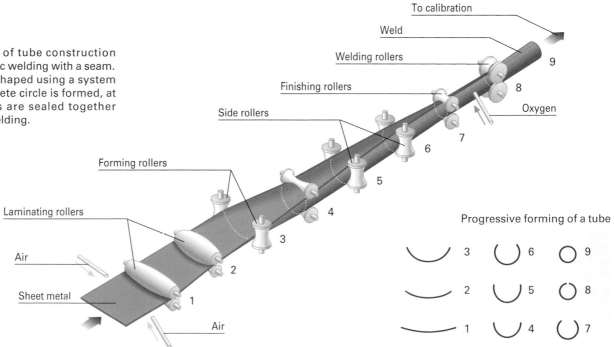

To calibration

Weld

Welding rollers

Finishing rollers

Side rollers

Oxygen

Forming rollers

Laminating rollers

Air

Sheet metal

Air

Progressive forming of a tube

## Hollow Steel Sections

The variety of finished steel products available on the market can be classified as pieces made by cold forming and pieces made by hot rolling.

The first group is made of a thin sheet, between 0.040 and 0.24 inches (1 and 6 mm) thick, in forming machines that bend and curve while cold, which means at room temperature. In general, in cold forming there is

no rolling involved because the last part of the sheet metal made to conform to the desired shape does not vary from the initial section.

These types of pieces are generally used for making metal furniture and light structures, for example, door and window frames and elements used in construction, such as railings and fences.

▼ Different types of hollow pieces made by cold forming, from thin sheet metal of various thicknesses in automatic forming machines: open channels used for sliding doors (A), special tubes for making frames and doors (B), tubes used to make handrails (C), rectangular tubes (D), square tubes (E), round tubes (F), tube fabricated by perforating an iron ingot while hot (G).

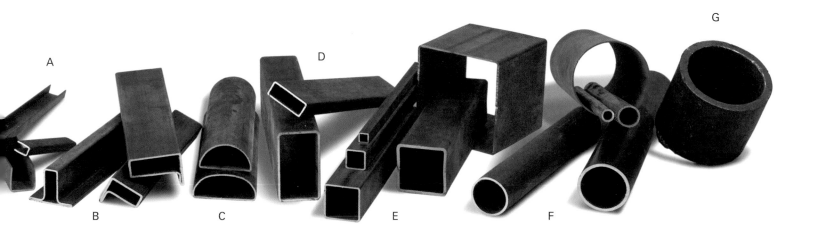

Hot rolled, or the process in which the metal is brought up to a certain temperature, improves the characteristics of the metal by eliminating any possible porosity that occurred during the foundry process. It also eliminates certain irregularities in the metal, in its chemical composition and in its structure, removing the metal's impurities or traces of slag that could have also occurred during casting.

In general, the products created on a hot rolling table are used for structural functions due to their optimum mechanical qualities, their resistance to twisting, traction, and compression. They are commonly employed in the construction of civil engineering structures like bridges, electrical towers, or gates for dams; in architecture, for the structural skeletons of buildings; and in the shipbuilding industry.

▼ Different metal shapes formed by hot rolling: the typical I-beam (A), Grey profile (B), typical channel (C), typical T-profile (D), steel angle with equal sides (E), squares (F), rounds (G), hexagonal (H), plates (I).

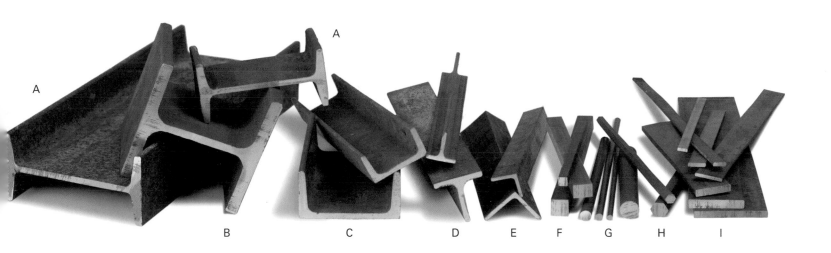

On the following pages the reader will find different objects for doing the most diverse types of metal work. Some of these tools and machines are little different from those used centuries ago, like hammers, stakes, files, and so on.

However, others emerged during the progress and advances of the twentieth century; such is the case of welding machines and plasma cutting machines.

In any case, these are not simple instruments, but extensions of the hands, ways of applying the most varied of creative approaches.

It is therefore very important to care for your tools and maintain them in perfect condition, not forcing them past the limits suggested by the manufacturer, to ensure that they work well.

This also goes for the use of the personal safety equipment required for each situation.

# Tools and
# *Machines*

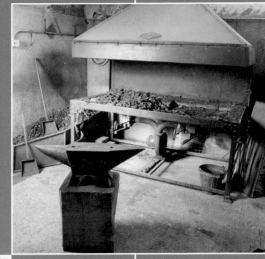

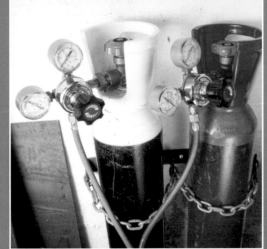

# Instruments for Measuring and Marking

When beginning the fabrication of any object, it is important to be able to draw straight lines and accurate curves on the material so it can later be precisely cut, bent, and folded. To help with this there are tools and instruments for measuring, verifying, making lines, and marking for comparing and determining length, angles, and surfaces.

## Different Kinds

### Vernier Gage or Sliding Calipers

This instrument precisely measures exact length greater than 0.020 inch (0.5 mm), with graduations as small as 0.00008 inch (0.002 mm) depending on the caliper. It consists of a steel ruler, usually stainless, divided into millimeters and inches with a large jaw at one end and a smaller one facing in the opposite direction, at a 90° angle to the rule. This rule slides along another fixed ruler that also has a large and small jaw at the end, and has graduated marks engraved along its edge.

The calipers are used for taking outside measurements using the large jaws and inside measurements with the smaller ones, and it also will measure depth using the rod at the opposite end of the calipers.

### Metal Rulers and Tape Measures

Rectangular metal rulers are made of stainless steel, and are very useful for drawing lines on metal. Wood and plastic rulers are easily damaged by contact with the metals and scribers.

Tape measures are very practical for measuring both flat surfaces and three-dimensional objects. The flexible steel tape is very thin and slightly curved, and rolls up into a small plastic case. It is usually from 36 to 72 inches (1 to 5 m) long. It should not be confused with longer tapes made of fabric or steel that are used for measuring lengths greater than 30 feet (10 m).

### Squares and Sliding Bevel

These instruments allow us to draw and verify angles between perpendicular surfaces. It is a good idea to have squares of different sizes, since a large surface should never be checked with a small square. This way there will be no risk of missing an error that could be past the contact surface of the square.

The sliding bevel is useful for transferring and marking specific angles on the work sur-

---

### HOW DO YOU USE THE VERNIER GAUGE?

When taking a measurement with the Vernier gauge, the 0 on the sliding rule may exactly coincide with one of the marks on the fixed rule of the calipers, for example the 7 mm (about ¼ inch). But it is also possible for the 0 to not coincide with any mark. This conflict is resolved by resorting to the divisions on the sliding rule.

Let's imagine that when we take the measure of an object the sliding 0 stops between two divisions on the fixed rule, 2 and 3 for example. We must note the number that appears to the left of the sliding 0, this will be the whole number, 2 mm; and the line on the sliding ruler that coincides with a division on the ruler, any one of them, signifies the decimal, in this example 3. This gives us a final measure of 2.3 mm. A nonmetric gauge is used the same way, but the divisions indicate inches and divisions of tenths, hundredths, and thousandths of an inch.

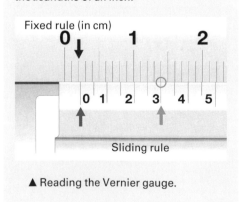

Fixed rule (in cm)

Sliding rule

▲ Reading the Vernier gauge.

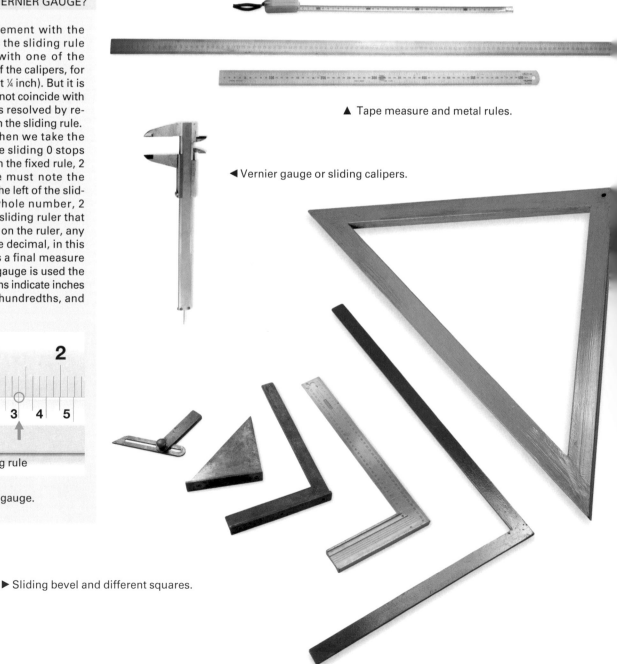

▲ Tape measure and metal rules.

◀ Vernier gauge or sliding calipers.

▶ Sliding bevel and different squares.

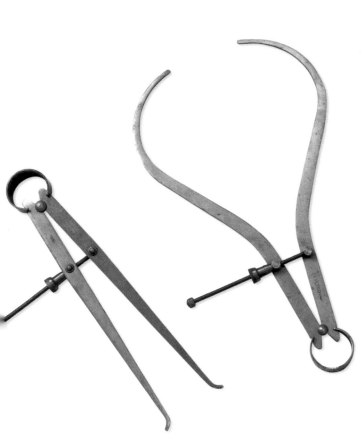

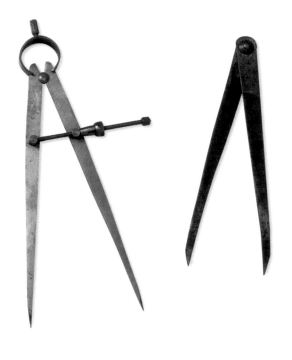

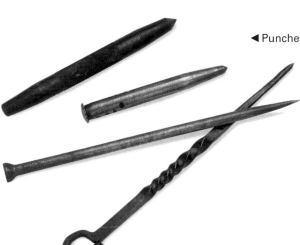

▲ ▶ Measuring calipers for inside and outside surfaces, marking compasses, and a beam compass (right).

face, as well as for verifying and comparing some angles. It consists of two pieces, usually of steel, attached at an axis that allows it to be set at any angle.

### Marking Compasses and Measuring Calipers

Marking compasses are made of two steel legs that end in a hardened point. They can be simple or have a spring. The latter are opened by turning a screw that applies pressure to one of the legs. A beam compass is used for marking an arc or a circle with a large radius; it consists of a graduated ruler with two sliding mounts with scribing points. These mounts are positioned at the distance that marks the radius of the arc or circumference that you wish to scribe.

Marking compasses are also useful for transferring lengths and making equidistant marks.

Measuring calipers are used for comparing and checking the exterior and interior dimensions of objects and parts. They have concave legs, in the case of calipers for measuring exteriors or thickness, and convex legs for measuring inside dimensions.

◀ Punches and scribers.

### Punch and Scriber

The punch is a steel tool with a round section and a tempered point at one end. It is used for marking points that will serve as guides for tracing arcs and circumferences. It is also used for guiding the bit when drilling holes in metal.

The scriber is a steel rod with a very sharp, tempered point. It is used for making straight lines guided by metal rulers and squares.

# Templates

When we speak of templates or patterns we are referring to auxiliary elements made exclusively for each project as guides for its construction. Their use makes it easier to make several identical pieces or to create other more complicated ones. Sometimes their use is limited to transferring a specific shape to a single metal piece for later cutting. Others are used for checking and comparing shapes as they are being made. Some patterns are even used for making prototypes, acting as templates for cutting parts with an electronic pantograph. Making patterns, whether cardboard, wood, or metal, allows us to approach a project from the perspective of an open dialogue in which the design idea, the material, and the technique interact. In any case, the templates or patterns help us carry out the project, allowing us to modify the aesthetic criteria as the piece is being constructed.

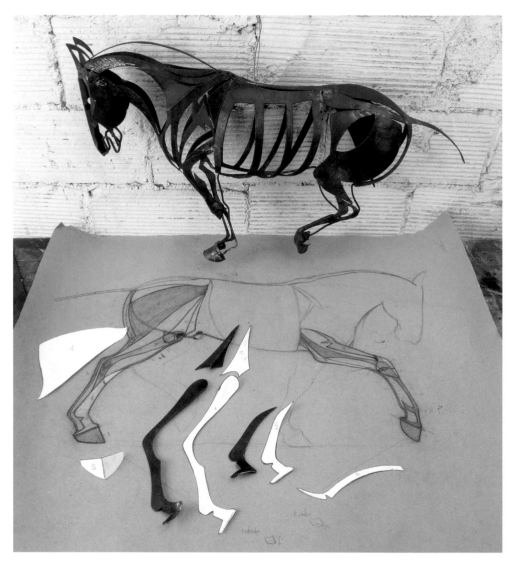

▶ Two systems have been combined to carry out this project: an exact drawing, in which color has been used to highlight the parts that will make up the sculpture, and the cardboard templates that will be used to transfer the form to the sheet metal. This pattern also will help illustrate the volume that the form will have. Work by Marta Martínez.

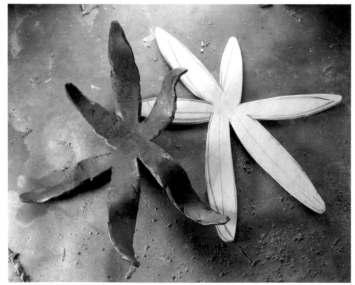

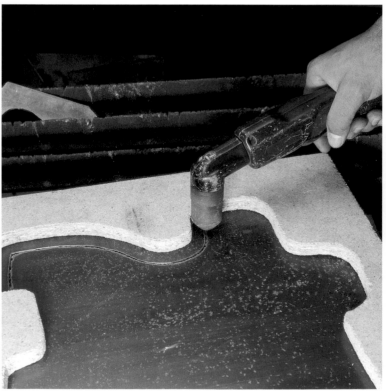

▲▶ A wood template is another way to transfer a drawn shape to metal so it can be cut out. In these photographs we see two forms. In the first case we see a star-shaped pattern that serves as a prototype that can be used with a cutting torch controlled by an electronic pantograph, which was later shaped on an anvil by Gemma López. In the second case, the thickness allows the outline to be easily followed so it can be traced and cut out of metal.

▼ ▶ Metal templates are mainly used for forging operations. They are very useful for reproducing the same shape several times or faithfully copying a complex one. It consists of a pattern of the desired form mounted to a metal plate with tack welds; this gives it durability and keeps it from becoming deformed during the process of forming the piece on the template.

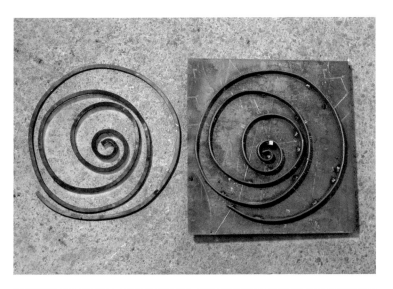

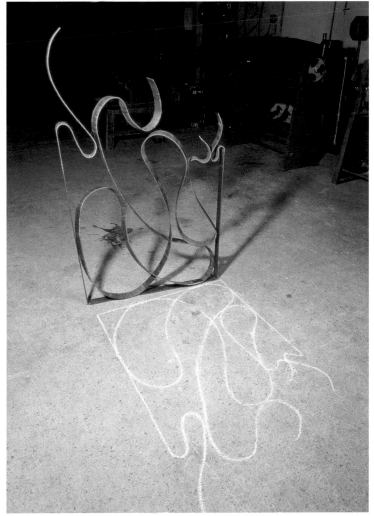

◀ ▼ A full-size drawing on the floor also aids the assembly of the work. It is helpful to compare the different parts with the drawing as they are being made, assuring that the final results are similar to the original idea.

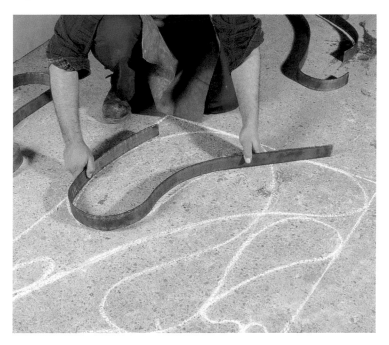

# Holding Tools

Holding tools are used to fix and immobilize objects. They are designed to adapt to pieces of a wide range of sizes and shapes. These tools make the work of filing, polishing, cutting, and drilling easier. Using holding tools assures the correct positioning of pieces when welding, brazing, or soldering; it is very important to keep the parts you are trying to join from moving. Sometimes these tools are needed simply because it is difficult to hold the pieces in our hands.

Most important, by attaching the pieces to the workbench we avoid possible personal injury.

## Different Types

### Bench Vise

This tool is made of cast or forged steel. It is an important and basic shop tool. Pieces can be firmly held in it for filing or cutting. The jaws are textured to better hold the objects. However, this texture can create marks on the surface of the pieces being held; to avoid this, L-shaped metal pieces can be placed over the jaws of the vise, and should be made of metals that are softer than steel, like lead or aluminum. There are fixed and swivel bench vises, the latter allowing the pieces to be positioned by rotating them.

### Hand Vises

These are also called hand screws, and they are very practical for pieces that are difficult to hold because they are small, for handling pieces that tend to get hot when being worked, and so on. They consist of two small jaws attached at the base by a pin that allows them to be articulated, and moved by a wing nut to better grasp the pieces.

### Vise for 90° Angles

This cast metal tool is used for joining metal sections, ensuring that they form a 90° angle. It has two separate fixed jaws that are perpendicular to each other and a movable jaw with sides parallel to each fixed jaw. The movable jaw has a screw for adjusting the pieces. In addition to moving forward and backward, the screw can pivot to better adjust to uneven pieces.

### Clamps

Clamps are the most common tools designed for holding. They can immobilize pieces of different sizes, and their portability makes them indispensable in the metal shop.

They are made in different sizes and shapes, usually consisting of a steel bar with a fixed jaw at one end. Another jaw that can be moved up and down the bar has a screw for tightening against the pieces.

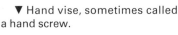
▼ Vise for 90° angles.

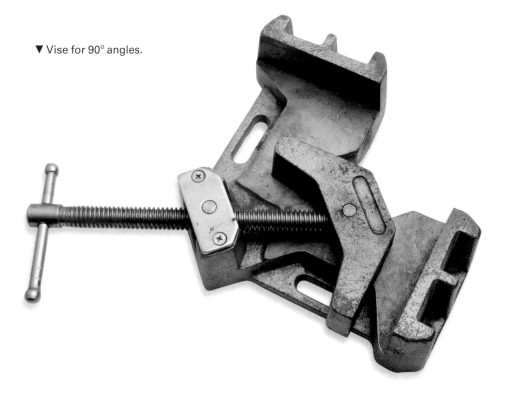

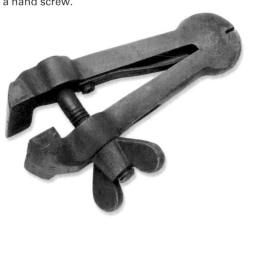
▼ Hand vise, sometimes called a hand screw.

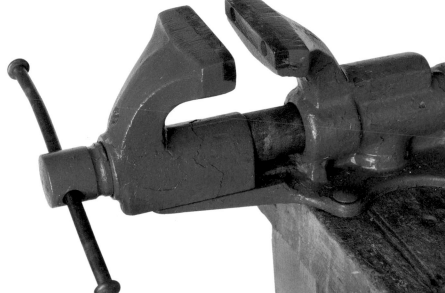
▼ Bench vise.

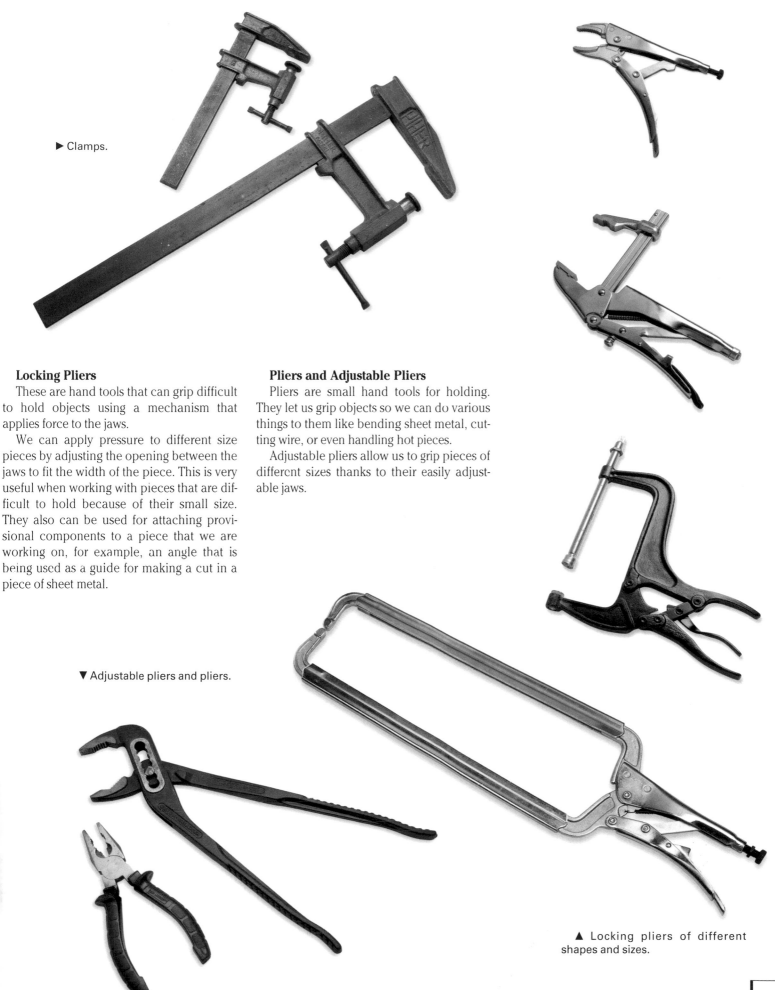

► Clamps.

## Locking Pliers

These are hand tools that can grip difficult to hold objects using a mechanism that applies force to the jaws.

We can apply pressure to different size pieces by adjusting the opening between the jaws to fit the width of the piece. This is very useful when working with pieces that are difficult to hold because of their small size. They also can be used for attaching provisional components to a piece that we are working on, for example, an angle that is being used as a guide for making a cut in a piece of sheet metal.

## Pliers and Adjustable Pliers

Pliers are small hand tools for holding. They let us grip objects so we can do various things to them like bending sheet metal, cutting wire, or even handling hot pieces.

Adjustable pliers allow us to grip pieces of different sizes thanks to their easily adjustable jaws.

▼ Adjustable pliers and pliers.

▲ Locking pliers of different shapes and sizes.

# For Striking, Bending, and Shaping

## Hammers

The hammer is the most popular and necessary tool in any metal shop. It helps us form and deform pieces by striking them, whether against an anvil or a forming stake, or even hammering directly against the piece of metal. They consist of a forged metal head and a strong and flexible wood handle. Only the faces of the metal piece have been hardened by tempering; this helps avoid breaking the middle part, where it attaches to the handle.

Hammers are generally easy to handle. Their weight ranges from ½ to 4½ pounds (250 to 2,000 g), which allows them to be used with one hand, leaving the other free to control the piece. There are hammers of different shapes, depending on the function they are designed for.

### Ball Peen and Forming Hammers
These are the most common in any metal shop. The ball peen heads have a hemispheric shape; the forming hammer has a slightly rounded wedge-shaped head.

### Mallets
These have flat heads used for flattening operations.

### Planishing Hammer
This hammer has a square face and a round face. The latter is slightly rounded for doing finishing work.

### Raising Hammer
These hammers can have one or two heads. They are used for shaping work.

### Forming Hammer
Mainly used for light hammering work, this lightweight hammer has two slightly rounded faces.

### Nylon-Head Mallets
These mallets are mainly used to avoid leaving marks from working the material.

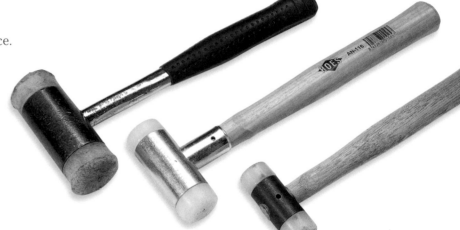

▲ Ball peen and forming hammers.

▼ Nylon-head mallets.

▶ Mallet (A), planishing hammers (B), raising hammers (C), forming hammer (D).

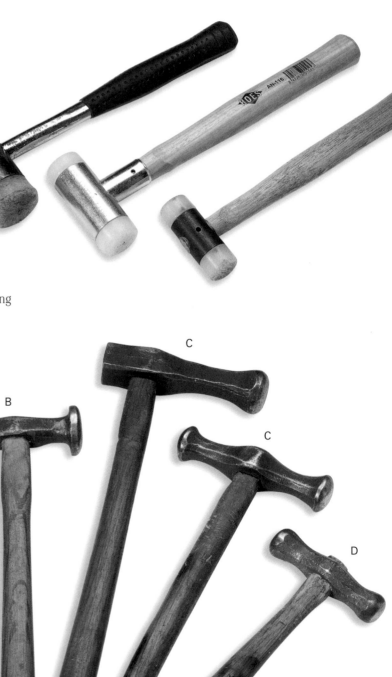

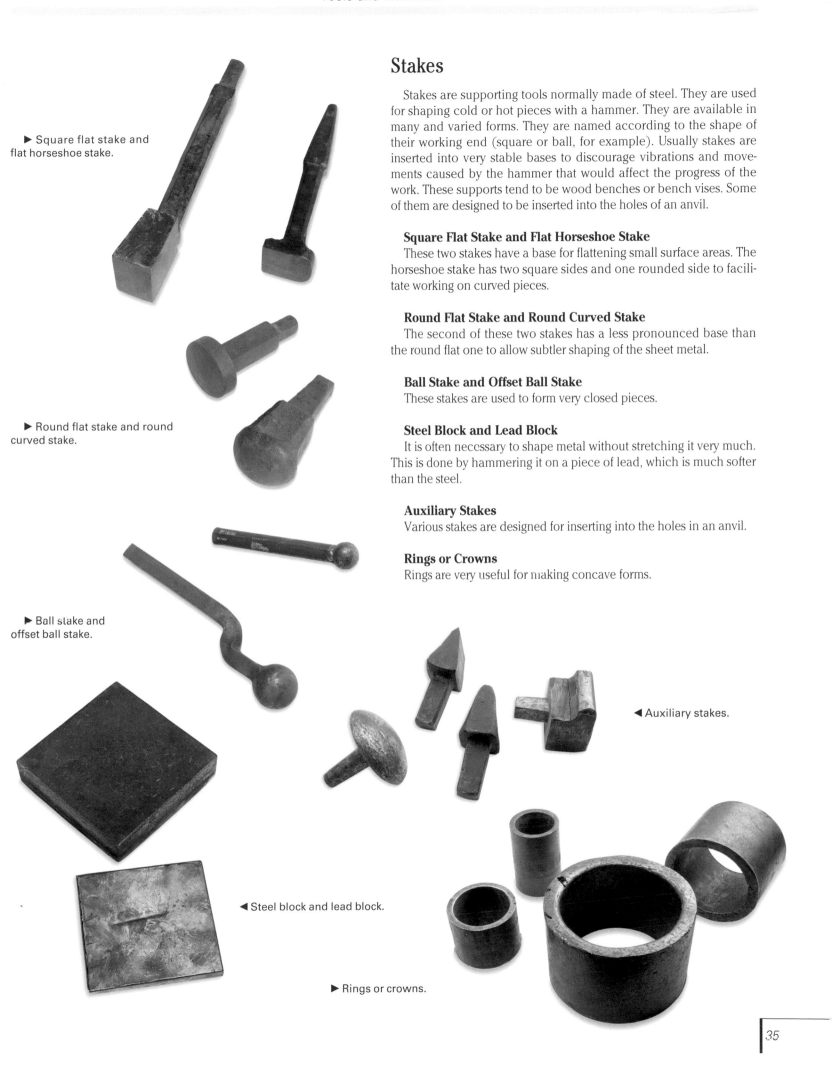

► Square flat stake and flat horseshoe stake.

► Round flat stake and round curved stake.

► Ball stake and offset ball stake.

◄ Steel block and lead block.

# Stakes

Stakes are supporting tools normally made of steel. They are used for shaping cold or hot pieces with a hammer. They are available in many and varied forms. They are named according to the shape of their working end (square or ball, for example). Usually stakes are inserted into very stable bases to discourage vibrations and movements caused by the hammer that would affect the progress of the work. These supports tend to be wood benches or bench vises. Some of them are designed to be inserted into the holes of an anvil.

### Square Flat Stake and Flat Horseshoe Stake

These two stakes have a base for flattening small surface areas. The horseshoe stake has two square sides and one rounded side to facilitate working on curved pieces.

### Round Flat Stake and Round Curved Stake

The second of these two stakes has a less pronounced base than the round flat one to allow subtler shaping of the sheet metal.

### Ball Stake and Offset Ball Stake

These stakes are used to form very closed pieces.

### Steel Block and Lead Block

It is often necessary to shape metal without stretching it very much. This is done by hammering it on a piece of lead, which is much softer than the steel.

### Auxiliary Stakes

Various stakes are designed for inserting into the holes in an anvil.

### Rings or Crowns

Rings are very useful for making concave forms.

◄ Auxiliary stakes.

► Rings or crowns.

# For Bending and Shaping

Manually controlled tools and machines are normally used for bending and shaping flat, round and square section material that is not heated. These apply a bending force on the material with pressure applied by hand or machine, with bending jigs or by percussion with hammers and stakes.

### Jigs

These are U-shaped tools made by a blacksmith with the radius that is to be applied to a piece, using material that is either hot or cold. They can be a round rod bent to form a "U", or simply two pieces of the rod welded to metal plates. Two pieces of thick-walled tube can be used, welded to a steel channel section as a base.

### Scroll Wrenches

These tools are similar to the jigs but they have handles. They are used to apply leverage to the hot or cold rods to bend, shape, and twist them. They are also made by blacksmiths, designed for use with the shapes of specific steel sections.

### Forming Table

This tool is designed for curving metal by striking it. The distance between the two steel angles determines the radius of the resulting curve. The rods are struck in the area between the two angles.

### Tube Roller

This manually operated hydraulic machine bends round tubing under pressure. It has jigs for making bends of different radii. They prevent the tubing from puckering on the inside of the curved area when pressure is applied.

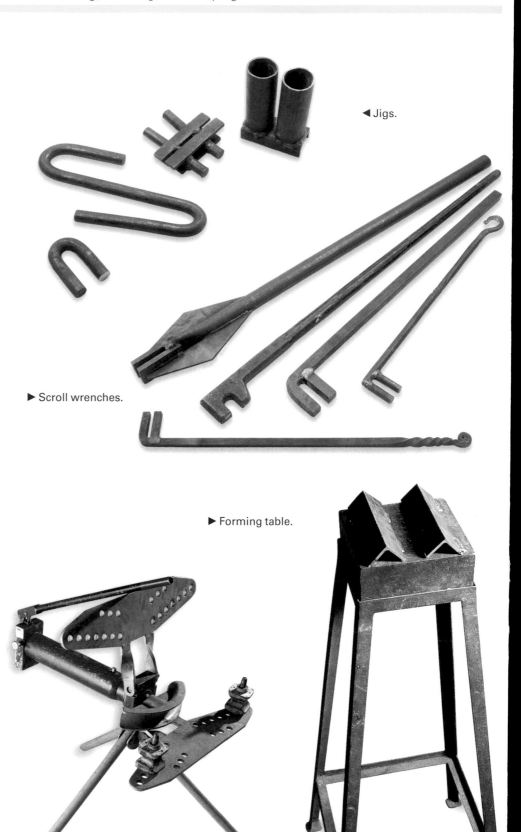

◀ Jigs.

► Scroll wrenches.

► Forming table.

► Tube roller.

### Rolling Mill

This machine consists of three hardened steel rollers that will curve metal pieces when the handle is turned to rotate the gears located at the ends of the rollers.

It can bend thin sheet metal, up to 0.060 inch (1.5 mm), and round rods up to 0.40 inch (10 mm) in the grooves located at one end of the rollers.

### Leaf Break

This is the name of the machine that is used for bending sheet metal no greater than 0.060 inch (1.5 mm) thick. It has two bars that act like jaws mounted to a base that holds the sheet metal with a lever, and a third moving bar that bends the sheet to the desired angle by pushing two handles with the help of a counterweight.

### Circular Bender

This machine is used for bending round and flat-section strip and tubing material. It consists of a heavy steel body where the section that is to be bent is placed, and a moving handle that makes the bend or curve by pivoting around an axle. It is controlled by a lever.

### Auxiliary Pieces

The circular bender has a series of complementary jigs that are interchangeable and that are used for making different curves and spirals.

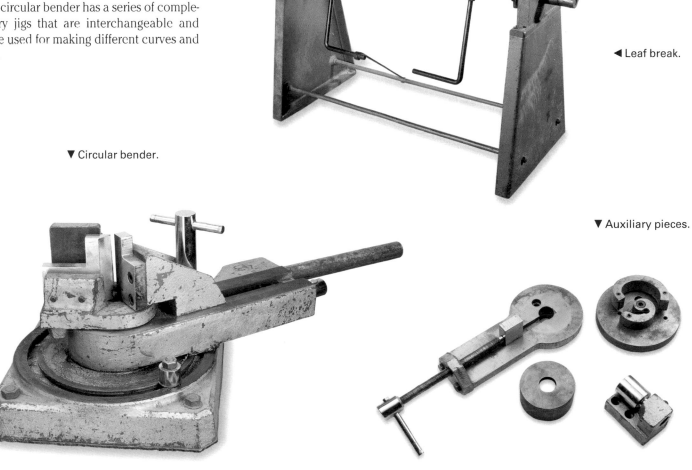

▶ Rolling mill.

◀ Leaf break.

▼ Circular bender.

▼ Auxiliary pieces.

# Drilling and Cutting

## Drilling

Drilling refers to the action of perforating or creating cylindrical holes. The bits create these holes, through the action of the drill that continuously turns them while imparting a forward motion.

Safety glasses must be worn while using this equipment.

### Drill Bits

Drill bits are made from cylindrical, tempered steel rods of different diameters. They have two spiraling grooves to help clear the chips created by cutting. One end of the bit has a cone-shaped point with two sharpened edges. These have a specific angle, normally 118°, which determines the cutting ability of the bit. Generally speaking, the harder and more durable the material being perforated, the greater the angle required on the cutting edges.

### Circle Cutters

These tempered steel accessories attach to the drill for making holes with large diameters, most commonly from ½ to 3¼ inches (14 to 83 mm). They have teeth like a saw that make the circular cut. A drill bit attached to the cutter functions as an axle that keeps the cutter centered.

### Portable Drills

Often simply referred to as drills, they are manual power tools consisting of an electric motor that transfers continuous rotational movement to the chuck. The chuck holds the bit or the cutter in place. It must keep them centered and firmly locked so they will not slip while drilling.

### Drill Press

This is a machine designed for making precision perforations. The advancing and rotational movements of the drill bit are mechanized. A lever is used to turn the mechanism that lowers the chuck with a straight and accurate motion. It has an adjustable table that is moved up and down on a column using a crank and toothed gears. The table also rotates around the column, and it can be locked in any position. Finally, a system of gears allows the revolutions per minute to be varied, changing the rotational speed of the drill bit.

### Revolutions Per Minute (rpm)

The rpm refers to the number of times the drill bit rotates in one minute. The rpms must be adjusted based on the diameter of the bit and the material that is being drilled. On the next page are listed some approximate speeds for drilling different metals.

▲ Drill bits.

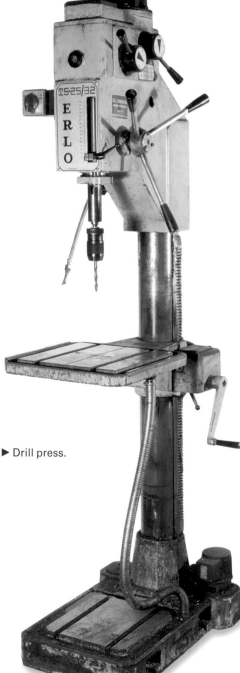

▶ Drill press.

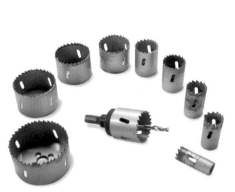

▲ Hole cutters.

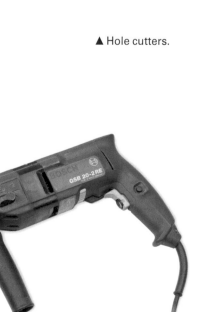

▶ Portable drill.

| TABLE OF APPROXIMATE RPM'S FOR DRILL BITS BASED ON THE METAL BEING PERFORATED | | |
|---|---|---|
| METALS | Dia. in mm | rpm |
| Soft steels, | 2 | 3,000 |
| aluminum, | 5 | 1,600 |
| lead, zinc | 10 | 650 |
| | 15 | 425 |
| | 20 | 300 |
| | 50 | 125 |
| Medium hard | 2 | 2,300 |
| steels, bronzes | 5 | 900 |
| | 10 | 450 |
| | 15 | 300 |
| | 20 | 225 |
| | 50 | 90 |
| Soft steel, | 2 | 1,600 |
| stainless steel, | 5 | 650 |
| cast iron, brass | 10 | 325 |
| | 15 | 200 |
| | 20 | 150 |
| | 50 | 65 |

# Cutting Without Making Chips

This refers to clean cuts made using well-sharpened tools that cut through the metal's fibers. Tools that make this sort of cut are chisels of different types that make the cut by striking, and hand shears or snips that cut with two sharpened edges. It is important to wear leather gloves when handling metal to avoid cutting your hands on burrs and rough metal edges.

## Chisels and Burins

Chisels, also known as cold chisels, are tools made from hard steel with tempered edges. They are wedge-shaped and are available in different sizes. The burins have a special shape, with cutting edges along the sides of the piece. This edge, so different from that of the chisel, is mainly used for making channels and grooves.

## Tin Snips

Snips are used for cutting sheet metal no thicker than 0.060 (1.5 mm). Some of them have straight blades that can be used for cutting very wide curves in addition to straight cuts. Snips with curved blades are used for cutting tighter curves.

## Power Shear

This is a very powerful tool, also called a table shear, that can cut heavy sheet and metal plate, and some will even cut section material like steel angle, round rod, and tee-sections. It has a lever and gears that increase the force applied to it, which can be increased with a longer lever.

## Electric Shear

The electric shear is a portable machine with a motor that operates small tempered steel blades. It will make straight and curved cuts in sheet metal up to 0.10 inch (2.5 mm) thick.

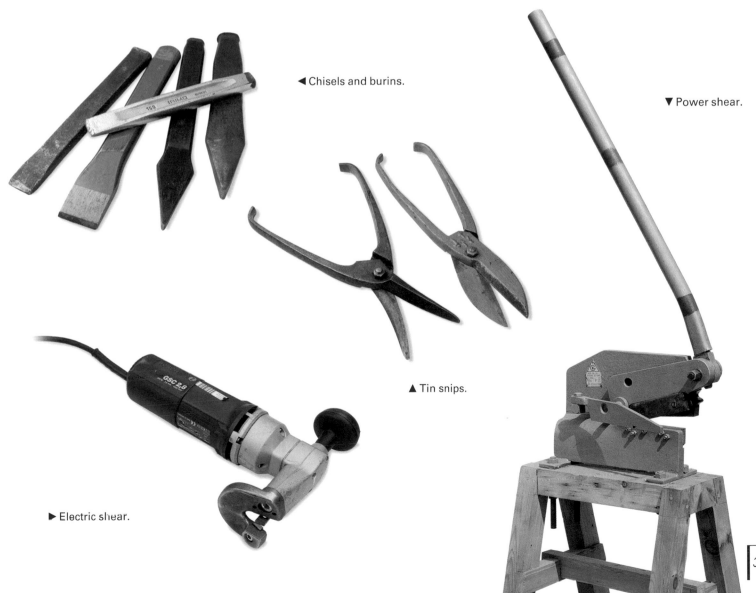

◄ Chisels and burins.

▲ Tin snips.

▼ Power shear.

► Electric shear.

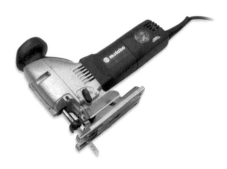

▲ Hand saws.

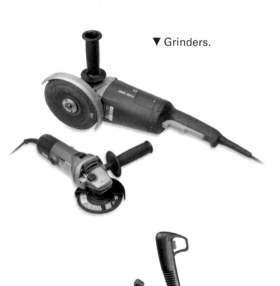

▲ Jig saw.

▼ Grinders.

# Cutting That Creates Chips

In this type of cutting the tools and machines throw off small pieces of metal, or chips. They do not cause warping and the cuts are clean and perfect. Some of these cutting machines and tools are: hand saws, skill saws, band saws, cutoff saws, and grinders. Safety glasses or clear face shields should be worn to protect your eyes from the flying metal chips, as well as ear protectors for the intense noise made by the cutting process.

### Hand Saws

These, of course, are manually operated tools. The saw blade, a flexible steel band with teeth, is held in a steel frame that controls its tension.

Jigsaws and jeweler's saws are used for cutting holes. They have thinner, finer blades, some of which are nearly as thin as a strand of hair.

### Jig Saw

This is a hand-held power tool that can make straight and curved cuts. An electric motor causes the blade to move in an up and down elliptical motion. Its speed and direction are variable and can be accelerated for straight cuts and slowed down for curves. It is important to wear eye protection when using this tool.

### Band Saw

The band saw is a tabletop power tool that can make a continuous cut because of its endless blade. The electric motor turns one of the two wheels that are on each side of the cutting area, on which the blade is mounted. It has a speed control to accommodate different metals, and it can make 90° and 45° cuts.

### Cutoff Saw

A toothed disk blade attached to an electric motor does the cutting for this machine. The motor and blade are mounted on a base that also holds the pieces being cut. It has a pump that supplies a lubricating and cooling liquid to the disk to keep it from overheating and to improve the cutting quality. Cutoff saws make both straight and angled cuts.

### Grinders

These are hand-held power tools that work at high speed, from 6,000 to 10,000 revolutions per minute. They use abrasive disks that wear down as they do the cutting or grinding. The action of these tools on metal creates chips in the form of sparks. Therefore it is very important to protect your eyes with a transparent face shield.

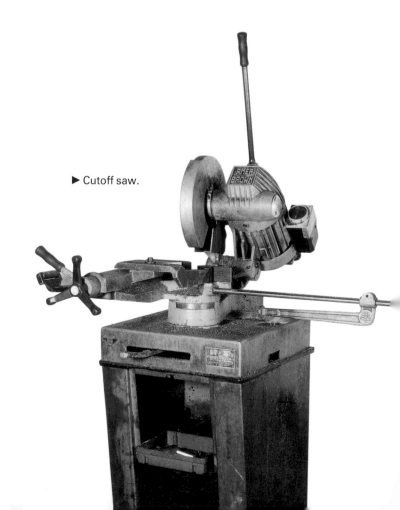

◀ Band saw.

▶ Cutoff saw.

# Special Cutting Methods

In this section we refer to special cutting machines because they use neither abrasion nor tearing of material to do their job. The metal is cut thermally, using steel combustion technology in one case, and the ionization of special gases in the other. These are known as **oxy-fuel cutting** and **plasma cutting**.

The equipment required for cutting steel with gas consists of two cylinders, one with acetylene or propane gas and the other with oxygen, and a cutting torch.

Plasma cutting requires a high frequency generator and a compressor for supplying air.

In both cases it is necessary to protect your eyes with special shields and use leather aprons and gloves for the incandescent sparks produced by the cutting process.

## Cylinders

The cylindrical steel containers are designed to hold gas at high pressure, approximately 125 to 150 atmospheres. There is a valve at the top with attached pressure gauges that regulate the pressure of the gas in the bottle to the ideal working pressure.

There is an accepted international code based on colors that indicate the kind of gas contained in the bottles. A cylinder containing oxygen is painted black with a white top. Acetylene has a red body with a brown top. All cylinders containing pressurized gas should be handled with utmost care and remain chained to the wall or portable cart.

## Cutting Torch

This brass tool consists of a handle with three valves at one end: two regulate the flow of oxygen and acetylene and the third regulates the additional pressurized air that is necessary for cutting steel. Between the hoses and the torch is a flashback valve that keeps the flame from moving back toward the hoses.

## Plasma Cutting Machine

The plasma cutter is a high frequency generator that creates an electric arc between the tip of the torch and the base metal.

On the front of the machine is a gauge that meters the amount of air required for forming the plasma. There is also a knob that controls the current, adjustable from 10 to 60 amperes.

## Compressor

This machine generates pressurized air, which supplies the plasma cutting equipment with the air needed to create the plasma flow.

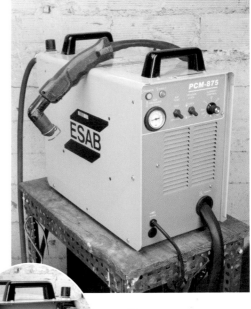

▲ Plasma-cutting machine.

◄ View of the rear of the plasma-cutting machine showing the power switch and the airflow intake opening.

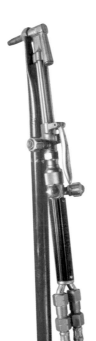

▶ The plasma-cutting torch and the base metal clamp.

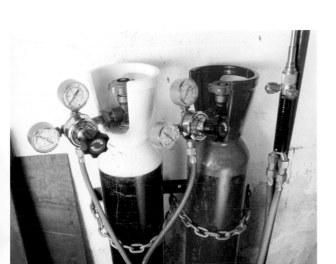

▲ Correctly restrained oxygen (left) and acetylene cylinders.

▶ Cutting torch in its holder.

▶ Portable air compressor with wheels.

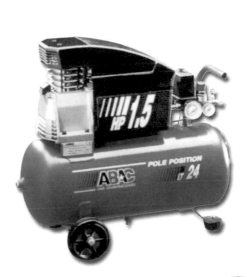

# Welding Equipment

## Equipment for Soldering

Soldering equipment is used for solders that melt at temperatures lower than 797°F (425°C). You must be careful when working with soft solder to avoid burns from contact with the soldered pieces or with any of the soldering equipment.

### Gas Torch and Electric Soldering Iron

These tools are used for heating the base metal to a temperature that will melt the solder and create a joint. The heat exchange is done with a flame in one case and electric resistance in the other.

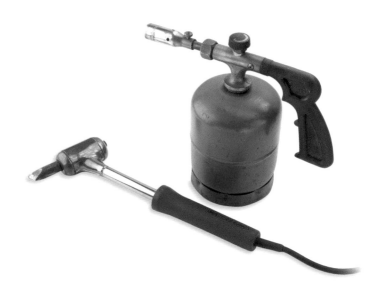

▲ Gas torch and soldering iron.

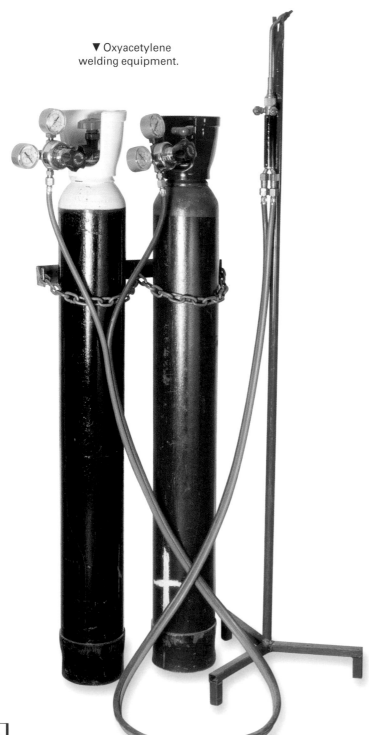

▼ Oxyacetylene welding equipment.

## Equipment for Oxyacetylene Welding

Oxyacetylene equipment is used for melting metals with a fusion temperature greater than 797°F (425°C). This procedure uses heat resulting from the combustion of a mixture of gases, usually acetylene and oxygen, but sometimes propane and oxygen.

The cylinders are chained to a wall or the mobile cart as a safety measure, to keep them from accidentally falling over. Eye protection, and a leather apron and gloves must be used to avoid injury.

### Oxyacetylene Equipment

The equipment consists of two cylinders that contain gases under pressure (acetylene and oxygen), two valves that indicate the gas pressure and regulate it for use, the hoses that carry the gas from the cylinders to the torch, and finally, the welding torch that mixes the gases and where the combustion takes place.

### On/Off Valves and Gauges

The gauges indicate the gas pressure, one is the tank pressure gauge, and the other measures the pressure in the line.

### Torch

The torch is designed to act as a handle and has two valves that regulate the flow of gases to the head tube, which is fitted with a welding tip at the end.

### Work Table

This table has a refractory brick surface that supports the metal pieces that are being welded.

### Goggles and Face Shields

These are safety equipment that protect against the intense light and the sparks thrown off when welding.

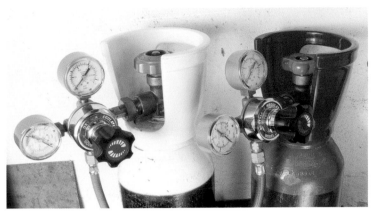

▲ Valves and pressure gauges.

▼ Work table.

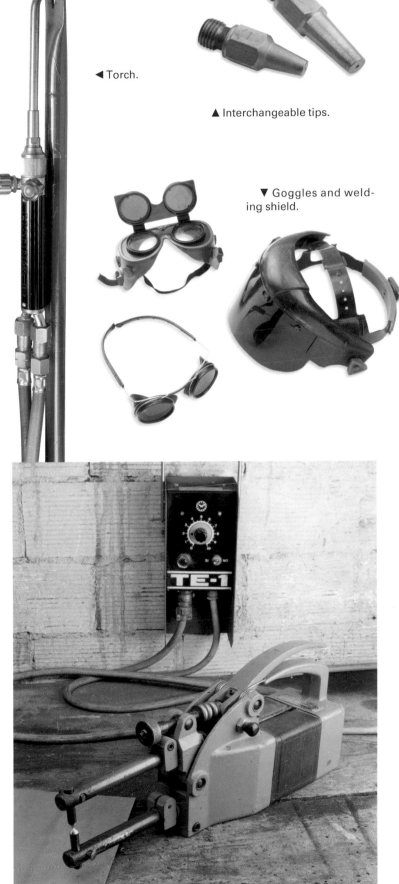

◄ Torch.

▲ Interchangeable tips.

▼ Goggles and welding shield.

## Resistance Welding Machine

The machine for resistance welding, also called spot welding, is used for welding overlapping pieces of metal held under pressure. The handles of some kitchen utensils like stainless steel pots and frying pans, for example, are welded using this process.

### Spot Welding

The spot welder consists of a transformer that reduces the voltage of the electricity and a timer that regulates the duration of the electrical discharge according to the thickness of the metal being welded. The transformer has two copper arms, each with an electrode, also copper, that hold the pieces being welded under pressure. The electrical discharge, controlled by a switch, passes through them.

► Spot welding machine.

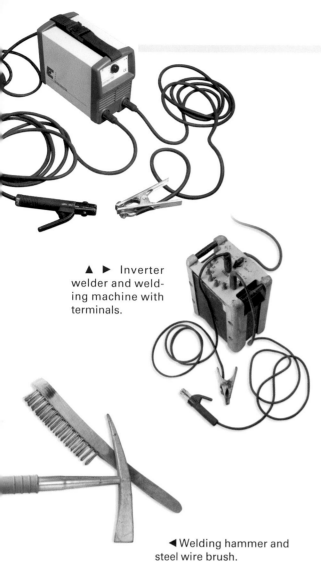

▲ ▶ Inverter welder and welding machine with terminals.

◀ Welding hammer and steel wire brush.

▼ Electrode holder and base metal clip.

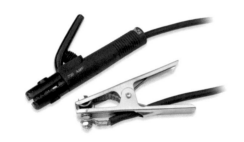

▼ Welding face shields.

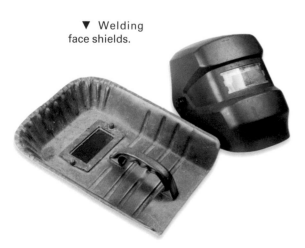

# Equipment for Welding with Coated Electrodes

Arc welding with coated electrodes is the most widely used process in metalworking. It is used for joining metals of the same or similar nature, using the heat generated by an electric arc generated between the electrode and the piece. During this process the electrode adds the extra material needed for the joint. This type of welding has some risks related to the use of electricity and burns. It is very important to protect your eyes and face from ultraviolet radiation and sparks with a special welding shield. Leather gloves, apron, and insulated safety boots must also be worn. Your whole body should be covered before beginning to weld.

### Welder with Terminals and Inverter Welder

Electric welding machines have transformers that modify the available power supply to direct or alternating current, stepping down the voltage according to the work. The welding machine with terminals is a transformer for alternating current that regulates the voltage with several terminals located on top. The inverter welding machine is a transformer that converts the current.

Both the aforementioned welding machines have the additional elements that create the circuit for welding: the electrode holder and the base metal clip.

### Electrode Holder and Base Metal Clip

The electrode holder has a hollow fiber handle and a trigger insulated with fiber that controls the copper jaws. It is used to connect the electrode to the cable that conducts the current for welding. The base metal clip attaches the base metal cable to the piece that is going to be welded ensuring good contact between them.

### Welding Hammer and Wire Brush

These are tools that are used to clean welded pieces. The welding hammer has hardened and filed points. It is used for breaking the slag produced by the coated electrode during welding. The steel wire brush is used to clean traces of slag from the weld bead. It is a good idea to wear safety glasses when using these tools.

### Face Shields

These are indispensable accessories for protecting your face while welding. They protect your eyes and face from injury and burns caused by the flashes of light, ultraviolet radiation, and spattering particles from the electric arc.

The main part of the face shield is a darkened glass that minimizes the flashes and filters the radiation from the electric arc. Some shields have glass that is electronically regulated, making the welding task easier.

# Semiautomatic MIG and MAG Welding Machines

Semiautomatic MIG and MAG welding are the most comfortable electric arc welding processes because they are easy to use. This is semiautomatic welding, characterized by the metal wire that acts as an electrode, wrapped in spools and automatically fed out by the machine itself during welding. Another characteristic is the use of a protective atmosphere, argon in the case of MIG, and carbonic anhydrate or a mixture of gases for MAG. Personal protective gear is required (special face shields, leather gloves and apron) and the whole body should be covered when welding.

### MIG/MAG Welding Machine

Generally speaking, this is a constant power rectifier, a generator that supplies the current necessary for melting the filler metal wire without producing great variations in the length of the electric arc. The protective gas is supplied from pressurized cylinders marked with a color code that indicates the gas they contain. A regulator controls the amount of gas supplied to the welding area. There are several dials that adjust the velocity of the wire feed, the current, and the kind of welding (normal, tack, interval, and point) on the front of the machine,

### Wire Spool and Feeding Mechanism

The wire spool is located inside or on the machine on a freely turning shaft. The wire passes between rollers that pull it and activate the pulsing of the welding gun.

### Welding Gun

This has an insulated and heat resistant body that holds the tubing (for the protective gas and the metal wire) and directs them to the tip. This tip directs the flow of the gas toward the welding area that must be protected. The wire also is directed to the same area by a tube that is made of copper, which transmits the electric current to the wire through contact with the base metal cable. To weld, the pistol has a trigger that controls the current, the wire, and the protective gas.

## TIG Welding Machine

The TIG welding system was originally used for joining pieces of stainless steel and other difficult to weld metals. Over the years it has been used more and more for welding any metal. It is characterized by the use of a tungsten electrode that is practically nonconsumable, which is not meant to be used as filler metal, but to create a very stable electric arc within the atmosphere of protective gas, usually pure argon. This process can be used to weld almost every metal used in industry. Furthermore, this welding process creates no spattering, fumes, or sparks.

It is very important to use personal protective gear to avoid eye and skin injuries.

### Inverter Welding Machine

The inverter welder is a frequency converter transformer. It converts the available current into an ideal welding current. It has a switch for regulating the intensity of the current (amperes) according to the metal being welded. A base metal cable and a torch cable are connected to the welder. This particular machine does not regulate the protective gas supply, which flows directly from the cylinder to the torch. However, the gas supply is regulated by the other TIG welding machines.

### Torch

This is the head where the tungsten electrode is located. One end has a refractory ceramic tip that acts as a diffuser for the protective gas. The torch regulates the flow of the protective gas to the welding area and also connects the electrode to the cable supplying the electric current.

### Gas Cylinder

The gas used to create the protective atmosphere for the electric arc in the TIG process is pure argon (99.9%). The cylinder of pure argon is painted yellow on the neck and has a black body, according to the accepted international guidelines for the classification and transport of gases. A pressure gauge controls the supply of gas to the weld.

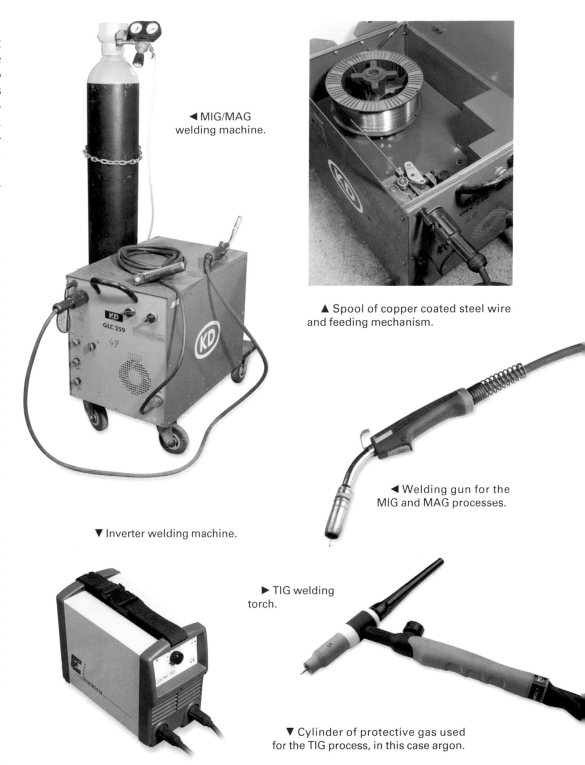

◀ MIG/MAG welding machine.

▲ Spool of copper coated steel wire and feeding mechanism.

◀ Welding gun for the MIG and MAG processes.

▼ Inverter welding machine.

▶ TIG welding torch.

▼ Cylinder of protective gas used for the TIG process, in this case argon.

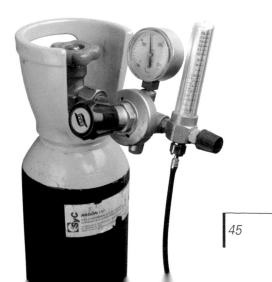

# Forging Tools and Equipment

Few tools are required for doing forge work: a forge for heating the metal before forming it, some tongs for holding the hot pieces, an anvil and a hammer to shape them when they have been heated, and a post vise for help in carrying out special operations that complement the forming of the piece.

## Fixed Installation

### Forge

The forge consists of a base raised off the floor, covered with refractory brick where the coal is burned and the metal pieces are heated. A fan, usually run by an electric motor and located beneath the fire, supplies a continuous supply of air to the bellows to intensify the fire. A ventilating hood connected to a chimney draws the smoke and gases produced by the combustion of the coal. The coal bin sits next to the forge; many shops put it outside so it will not take up workspace, but this is not always possible. Additional forge equipment are a poker for moving the coals and a container of water for sprinkling on the coal or cooling part of a hot piece of metal.

## Tools

### Anvil

The anvil is the most popular element in metalworking, and especially so in the blacksmith shop. This indispensable tool is a block of solid iron to which is welded a hardened steel face where the forming and shaping of metal is done with hammers. The face is the main part of the anvil, and it has two holes used for inserting forming accessories and for punching operations. It has two characteristic points called horns, one conical and the other square or pyramidal, on which raising, shaping, and bending operations are carried out.

Anvils are set on very sturdy bases, normally of oak, that absorb the blows and reduce bouncing.

### Ball Peen Hammers and Forming Hammers

These tools are very useful for cold or hot forming work. Both are commonly found in the blacksmith's shop. Ball peen hammers have a nearly spherical head on one end and forming hammers have a rounded wedge on one end. Their weight ranges from 1 to 4½ pounds (500 to 2,000 g) depending on the work that needs to be done.

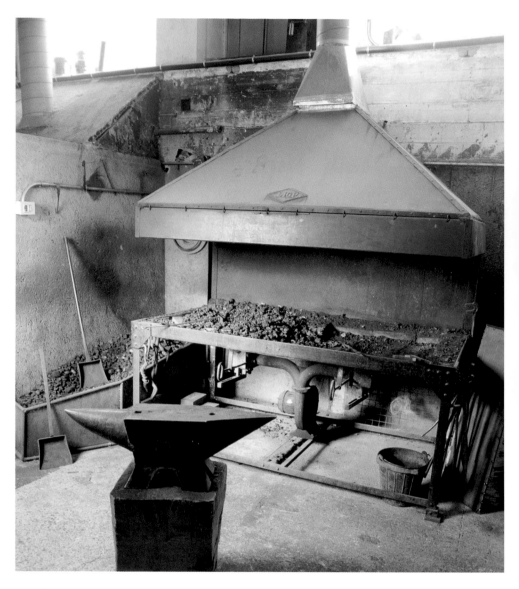

▲ Forging equipment.

### Post Vise

The post vise, also called a leg vise, the most widely used element in forging operations. It is a robust tool that stands up to very heavy use. It is made of forged and tempered steel to withstand great force.

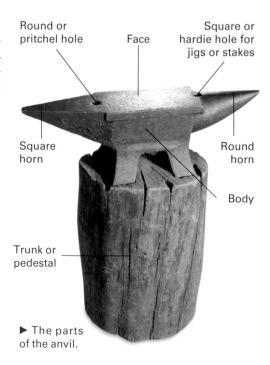

Round or pritchel hole    Face    Square or hardie hole for jigs or stakes

Square horn    Round horn

Body

Trunk or pedestal

▶ The parts of the anvil.

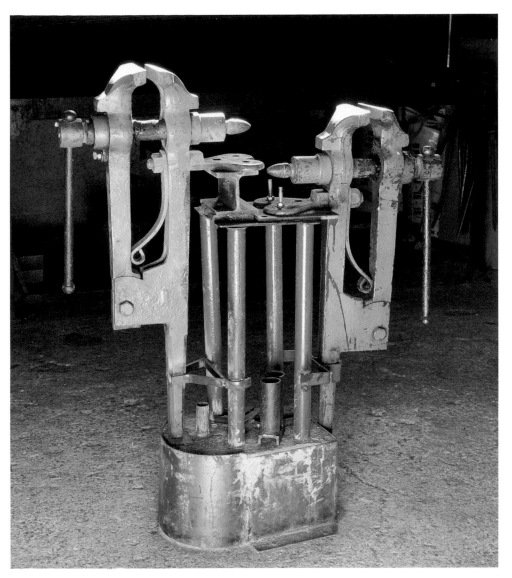

▲ Post vise.

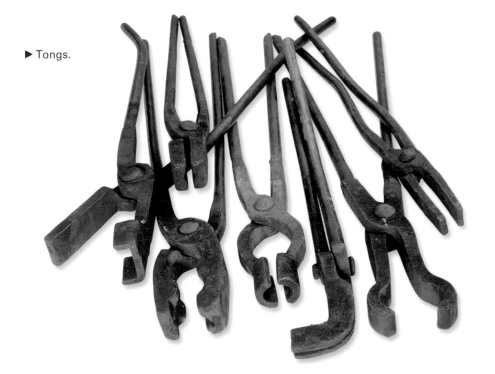

▶ Tongs.

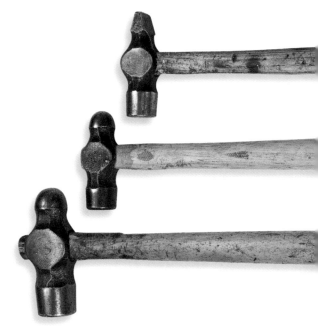

▲ Ball peen and forming hammers.

The post vise consists of a moving jaw that is connected to a fixed jaw with a laminated spring. The gripping surfaces of the jaws are not parallel to each other, since they would not hold pieces well when spread wide. Normally the post vise is attached to the leg of a work table with screws and braces. Sometimes special bases are created for them, so that there is free space around them, making it easier to work with large pieces.

## Tongs

Tongs are essential for forge work. They are required for handling the fire-heated pieces of metal, so they can be put into the coals, turned, or removed from the forge and manipulated on the anvil when this cannot be done by hand due to the size or temperature. They are especially necessary for working with small pieces. Tongs are made of two bars attached by a bolt that separates them into two parts: the handles and the jaws. They come in various shapes and sizes that are adapted to the different forms that they must hold firmly while they are being shaped. They can be flat, round, square, or curved.

# Finishing

## Files

Files are used to remove the burs caused by cutting, for creating pieces with the help of their diverse forms, and for smoothing surfaces. They are tempered steel bars with a wood handle and small teeth that cut the material. Files are distinguished by and named for their shape and length and their cut or relief. The filing operation is divided into three phases: the first is roughing, using coarse files that remove a lot of material and leave file marks on the surface. The second is refining with files that have a medium tooth to remove the previous file marks, and the third is polishing or finishing the surface, which is done lightly by filling the teeth with chalk and applying very little pressure to the file.

▲ A good selection of files is essential in a metal shop.

### CROSS SECTIONS OF FILES

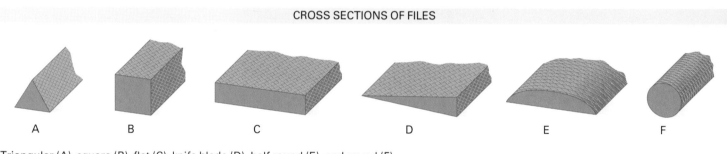

| A | B | C | D | E | F |

Triangular (A), square (B), flat (C), knife blade (D), half round (E), and round (F).

◄ Examples of rough-cut and smooth-cut flat files.

▼ Correct position for filing.

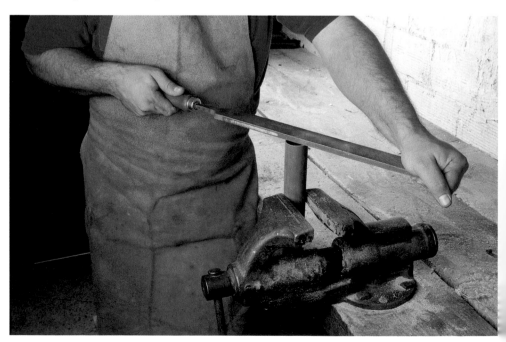

### Correct Position for Filing

The round part of the handle is rested against the palm of one hand while the other holds the metal end of the file. This way a uniform pressure is applied to the file. The cutting and removal of the material takes place with the forward motion. Very light pressure should be applied on the backward motion to minimize friction. Your body should move with the pushing movement to reduce premature tiring of the arms.

# Machines and Accessories for Finishing

The final sanding and polishing of metal surfaces can be done by hand or by machine. Machines speed up the process and lighten the workload, especially on large surfaces. Conversely, hand sanding and polishing will more easily reach corners where machines cannot. The accessories used in both cases are of similar nature, but their shapes are based on how they will be used, by hand or attached to machines.

Some of them are used for softening polished areas and others for sanding and polishing scratched surfaces. They all beautify the pieces, giving them excellent finishes of very different kinds.

### Orbital Sander

This is a handheld power tool that is used for sanding and finishing smooth surfaces. An electric motor rotates the plate, which can be round or rectangular and has a sanding disk attached to it with adhesive or clips. This tool is used for light sanding on metal.

### Belt Sander

Like the orbital sander, the belt sander is used for sanding flat surfaces. The electric motor turns a continuous sandpaper belt. This machine is more powerful than the orbital sander and can remove much more material.

▲ Steel wool and scrubbing pad.

◄ Emery paper sheets of different grades.

► Rectangular orbital sander.

▲ Circular orbital sander.

▲ This sander is a very practical combination of both rectangular and round orbital sanders.

▲ Belt sander.

◄ Rubber disk, polishing disks, and multiple-flap disks of different grits for use with a grinder.

► Belts and disks for belt and orbital sanders.

▲ Multiple-flap disks of different grits and steel and brass wire brushes for use with a power drill.

# The Workshop: Safety Recommendations

In the metal shop, the materials, tools, and machines that are employed can expose their users to risky situations. Knowledge of the dangers inherent in their use can help to avoid accidents. An informed person is less likely to be injured since he or she will pay closer attention and make use of safety precautions.

## Cleanliness and Order

Cleanliness and order are two essential aspects of a shop that is an efficient, creative space where one can work comfortably and risk free.

Commonly used hand tools like hammers, pliers, screwdrivers, squares, tin snips, and so on, should be arranged on boards so they will be easy to find. After they have been used they should be put back in their places.

Containers for temporarily holding metal scraps should be kept organized and clean to make reuse and recycling easier for future work.

There should also be an area for storing sheet metal and any metal sections that could be used at any time for a project. It is good to avoid compulsive collecting that fills up these areas and to store only material for short-term projects.

▲ Metal drums are very useful for storing long metal sections and scraps to be reused.

▶ Often-used tools should be arranged near the work area on easy-to-use hangers.

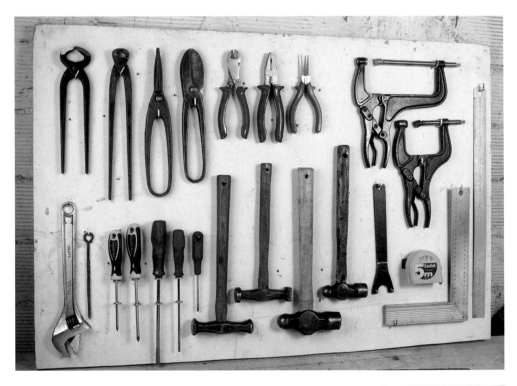

▶ It is important to assign an area of the workshop for storing sheet metal and scraps.

# Using the Tools

Handheld power tools like grinders, drills, sanders and power saws are indispensable in the metal shop. However, they are frequently the cause of bad accidents when used without taking the proper precautions.

Some precautions should always be observed when working with power tools no matter how obvious. For example, a machine with a defective electrical cable should never be used. Nor should power tools ever be unplugged by pulling the cord, only by pulling directly on the plug, to avoid internal damage or the plug flying back into the face of the user.

Electrical machines that have accidentally gotten wet should never be used, nor should you work outside in the rain with them or when some part of the user's body is in contact with water. Your body should be insulated from the ground.

▶ Besides immobilizing pieces, it is important that the machines have correctly mounted safety shields for incandescent sparks.

◀ It is very important to firmly hold the pieces when cutting or grinding them, using a clamp or bench vise to avoid uncontrolled movement that could cause an accident.

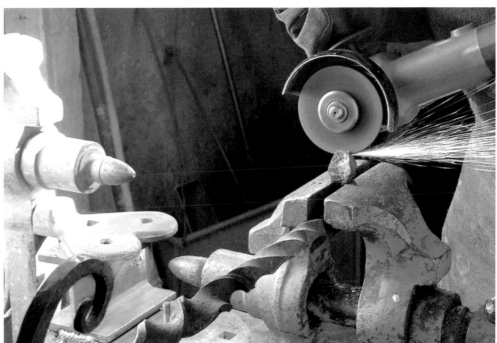

# Holding the Pieces

When cutting, grinding, sanding, or drilling pieces, they should be held firmly and immobilized. This will avoid accidents caused by sudden movements or falls caused by the power and rotational speed of some power tools.

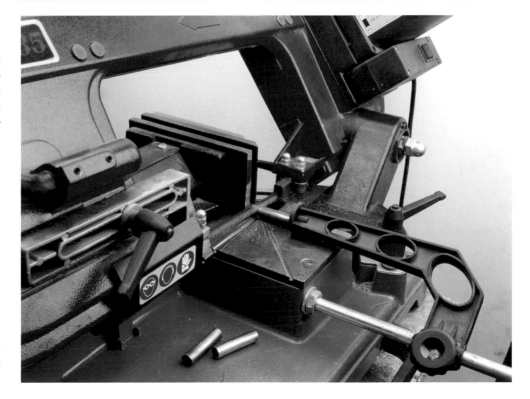

▶ Fixed machinery like cutters and band saws incorporate a clamp to immobilize the pieces being cut.

# Personal Protection

Personal protection is the most important aspect of workshop safety. Machines that incorporate elements that rotate or move at great speed can cause pieces of metal to break off. They can be projected in all directions with a velocity that will cause accidents of different kinds.

As a safety measure, it is a good idea to protect yourself from any projectile from machinery that is cutting metal or welding it.

Generally, it is a good idea to use a leather apron to protect your body from possible projectiles, whether chips from cutting or polishing, or incandescent particles caused by welding or grinding.

It is also necessary to always wear leather gloves when welding, grinding, or cutting with saws or oxy-fuel to avoid burns from contact with the projectiles or recently worked pieces.

In addition, you must protect your face and eyes with transparent shields and safety glasses.

Another essential protective element is safety footwear, which protects your feet with steel toes.

Finally, helmets and foam earplugs are recommended for the noise caused by the machines and tools and the metal pieces.

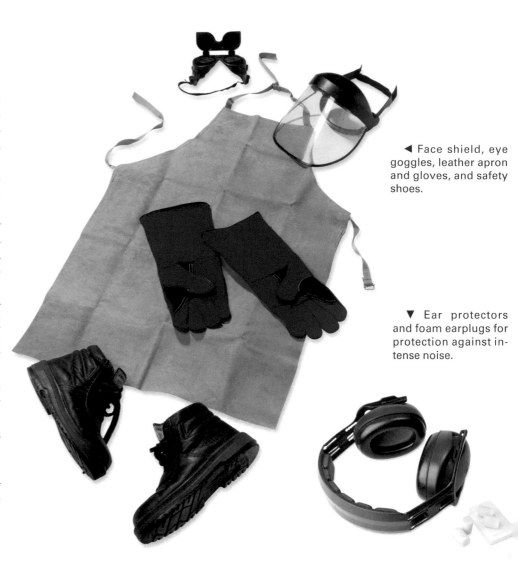

◄ Face shield, eye goggles, leather apron and gloves, and safety shoes.

▼ Ear protectors and foam earplugs for protection against intense noise.

► It is important to be protected against noise and projectiles caused by power tools.

▼ Shield for protecting the face and eyes, and safety glasses.

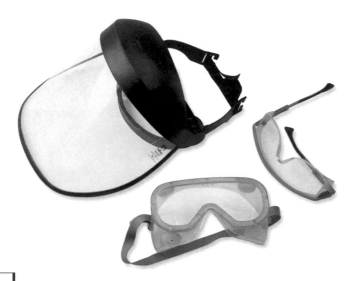

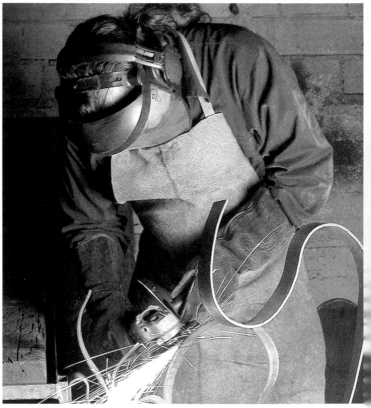

# Protection for Welding Operations

Working with welding machines carries the risk of accidents caused by electric currents, burns, fire, and explosions. There are also health risks like exposure to ultraviolet radiation and toxic fumes and gases.

These risks must be prevented by using equipment in good repair, with electrode holders that firmly grasp the electrode and cables that are in good condition and that maintain good contact.

Welding cables must be protected from spattering metal caused by the welding process.

It is also recommended to not weld metals that have contained flammable products to avoid the risk of a fire.

Ultraviolet rays are produced by an electric arc, and prolonged exposure can cause eye injuries. It is necessary to use a face shield with a darkened glass filter whose characteristics vary according to the intensity of the current used.

Welding operations should be carried out with optimal ventilation to avoid inhaling gases emanating from the electric arc.

Removing slag from welds made with coated electrodes should be done while wearing safety glasses to avoid contact with it.

Electrodes should never be changed by hand without a glove, since there is a risk of electrical contact.

▲ Protective face and eye shields with glass filters that protect the eyes and skin from possible burns caused by light and ultraviolet radiation produced by the electric arc.

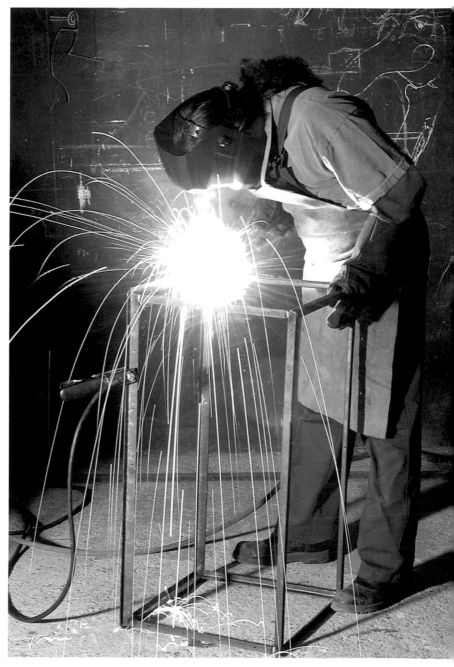

▲ It is a good idea to completely protect yourself against incandescent projectiles during electric arc welding operations, as well as against light and ultraviolet radiation.

▲ Protective goggles and shield for oxygen cutting and oxy-fuel welding operations.

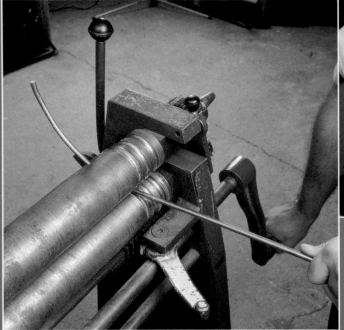

*I*n the following pages, we show some of the basic techniques used for working with metals and alloys. We felt that it was relevant to include those techniques that do not require excessive technological involvement, other than what it is strictly necessary, like some cutting and welding procedures.

The idea is to show and to teach techniques that allow the creation of objects by using the tools presented earlier.

Finally, it is important to remember to always use the precautionary safety measures required by the use of electrical machines and compressed air equipment, as well as the personal protection needed in each case.

# *Basic* Techniques

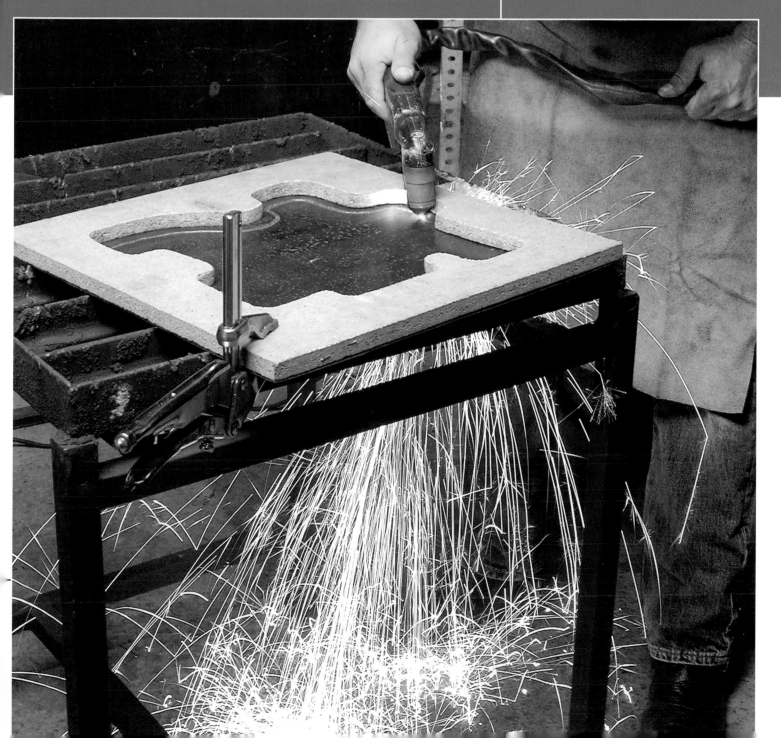

# Cutting

## Cutting with a Chisel

One of the properties of metals is that they can be chiseled, that is, they can be divided into parts using cutting tools and without producing metal chips. Chiseling, or cutting with a chisel, is used to produce thin pieces or strips. A chisel acts like a blade in a pair of clippers, applying pressure on the metal like a clamp's jaw. A hammer is used to cut with a chisel.

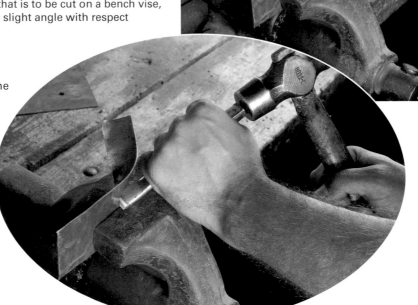

**Cutting Sheet Metal with a Chisel**

▶ **1.** After firmly securing the metal that is to be cut on a bench vise, the blade of the chisel is positioned at a slight angle with respect to the piece.

▶ **2.** Next, the cut is performed as the chisel moves forward with the tapping of the hammer. It is important to carry out the entire cutting procedure against the surface of the vise to ensure a straight edge. For long pieces, the metal can be moved as the cut reaches the end of the vise, or two long pieces can be placed against each other in the vise to act as a clamp for holding the piece, allowing the cut to be made along its entire length (as explained in the section devoted to folding on a vise).

**Pierced Work**

▲ **1.** To create pierced work with a chisel, first, a few holes are made on the piece of metal with a drill, so as not to damage the chisel's blade. One hole indicates the beginning of the cut and the other one the end; therefore, two are the minimum number of holes needed to produce an opening.

▲ **2.** Cutting is done from one of the holes up to the next, turning the piece as the cuts are made. Once the cut is completed, the piece is placed flush on the vise or on a flat stake, and the edges are smoothed out with a file to remove the marks left by the chisel.

# Shearing

The act and effect of cutting a piece of metal into sections using two blades with sharp edges that rub against each other is called **shearing**. The blades apply pressure on the metal compressing it and breaking the fibers with the force of the traction. The fibers harden, lose elasticity, and break.

The tools that are used for shearing metals are: tin snips and metal shears, either table top, manual, or industrial. Their use depends on the metal and its thickness. For example, to cut a 0.060 inch (1.5 mm) piece of very hard metal, we use the shear, so that we multiply the effect of the effort that must be exerted. However, a piece of zinc of the same thickness can be easily cut with tin snips.

Both tin snips and metal shears are commonly found in metalworking shops. Basically, the technique used is the same for both tools. The shear will cut metal pieces and shapes comfortably and without producing any shavings.

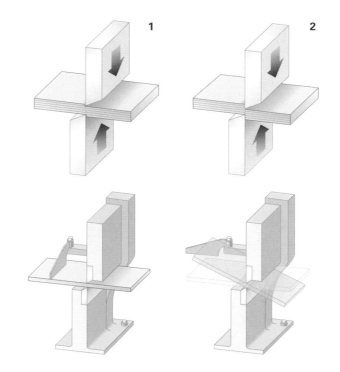

◀ **1.** The force exerted by the blades on the metal compress the fibers and partially cuts them.

◀ **2.** The fibers are subjected to a traction force; they harden as a result of the sharp impact and end up breaking.

◀ ▼ Cuts on the shear must be carried out with the stopper in place to prevent the metal piece from sliding as a result of the moving blade. If this is not possible because the stopper is in the way of the cutting line, the sheet metal should be held firmly with a gloved hand.

If we perform the cut without the stopper or without holding it with the hand, the metal sheet will become a wedge between the blades and deform the frame of the shear.

As a result of this deformation, the blades separate and the gap makes cutting impossible.

◀ To make circular pieces of sheet metal with the power shear, the cuts must be performed on a tangent to the curve. In long metal pieces, the cuts should be short and not extend beyond the length of the blades, because if we made the cut with the entire length of the blade, it would leave deep marks on the metal. All power shears have a special hole for cutting round rods and some can cut T-shaped and L-shaped sections.

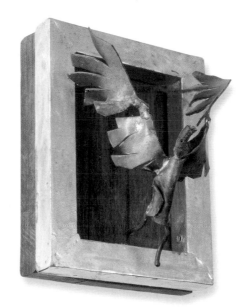

◀ Ares, *Un petit pas*, 1999 4½ × 3⅝ × 3⅝ inches (11.5 × 9 × 9 cm). In this brass piece, the cuts on the wings were made with metal sheers.

# Cutting with Saws

Saws make cuts that produce chips. Saw blades should be mounted in their frames with their teeth facing forward. Each saw has a specific pitch or cutting grade, which is the same as the number of teeth per linear centimeter. It is important to choose the saw based on the metal. For example, for hard metals, like stainless steel, a saw with a small pitch is used, but for cutting aluminum, a material that is slightly softer than steel, a saw with a larger pitch is used. It is important to protect your eyes during this process from the danger of flying chips and your ears from the intense noise of the cutting.

► To begin cutting manually, the saw must form a small angle to the surface of the piece. If at the beginning of the cutting process the entire surface of the saw blade is pressed against the piece, it will slide off and will cause many marks as well. Saws only cut on the forward motion; therefore, no pressure should be applied on the pulling motion, as this could cause the teeth to wear off or to break. It is important to work with the biggest saw allowed and to use the entire length of the blade, if possible, to avoid wearing out only in the middle section.

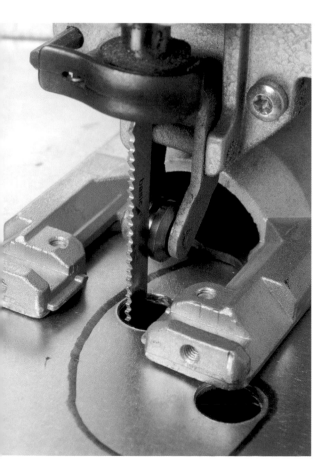

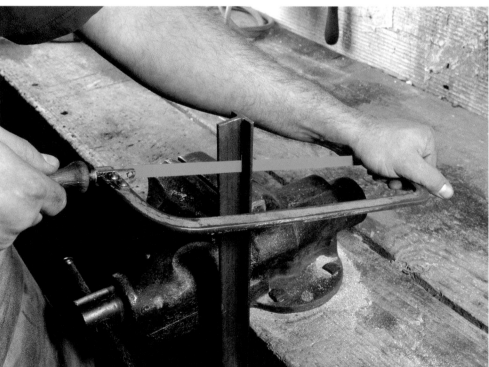

▲ During the sawing process you must maintain the same direction at all times and not twist the saw sideways, because this could break the blade.

Hacksaws have two working positions: the most common one is with the teeth parallel to the arch of the frame; the other is less common but very practical. The teeth of the saw blade are placed perpendicular to the arch, in such a way that the latter does not get in the way of deep cuts. In both cases the hacksaw is held with both hands. One hand is placed on the handle and the other at the other end as if it were a file, to maintain the direction and to prevent the blade from twisting and breaking.

◄ To begin cutting with an electric jig saw, it is very important to move the teeth of the blade away from the edge of the piece. Otherwise, there could be jerking movements from the swinging motion of the blade upon starting the machine, since the saw blade would be in contact with the piece at the moment the power is turned on. Once the machine is on, the cutting is done slowly and gently, holding the power tool firmly with both hands.

◄ When turning or making round cuts, it is important not to move hastily and to free the piece with straight cuts that would leave smaller and easier pieces to remove with the power saw. As a safety measure, it is important to wear goggles for the eyes and ear pieces as protection against the loud noise that is made when cutting.

▼ A sculpture of pierced steel, Ares, *Des de l'interior*, 2000, 10 × 10 × 10 inches (25 × 25 × 25 cm).

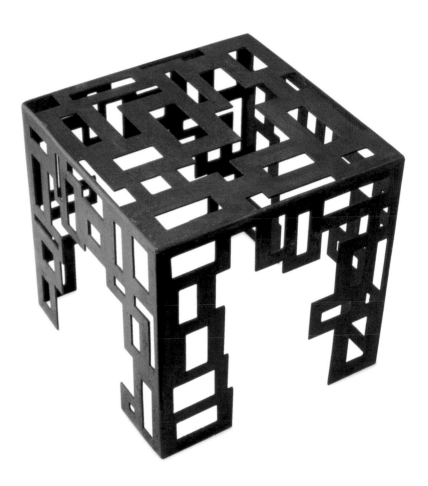

## Cutting with a Horizontal Bandsaw and a Cutoff Saw

It is important to pay attention to the position of the sections when cutting with mechanical saws, like the bandsaw, or with disks with steel teeth, like the circular saw. Incorrect placement could speed up the deterioration of the machine and cause breakage of teeth and blades.

It is very important to have an entry angle between the disk or the saw and the edge of the rolled form. It is also important to apply the appropriate cutting speed for each material, as recommended by the manufacturer of the machine. This way, the proper functioning of the machine is ensured and there is a good chance that the bandsaw and the circular saw will have a longer life.

### Correct Position for Cutting Rolled Sections

▼ In this diagram we show, only as a reference, the different positions of the sections in relation to the forward motion of the saws and disks.

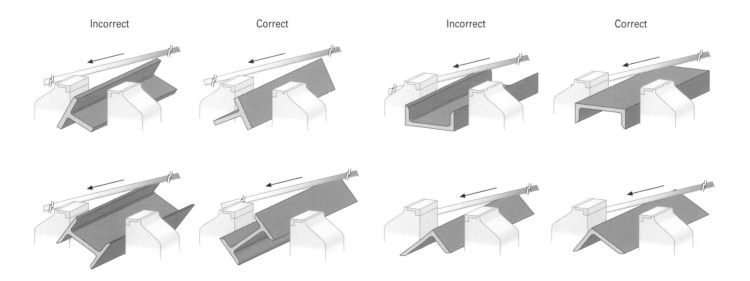

| Incorrect | Correct | Incorrect | Correct |

# Oxy-fuel Cutting

The oxy-fuel cutting process is based on the combustion of certain metals in the presence of oxygen. It is a procedure reserved for cutting ferrous metals, since not all metals share the necessary conditions to allow oxy-fuel cutting. Steel at room temperature is not combustible, but if its temperature is raised to the point of ignition, above 1,652°F (900°C), and a stream of pure oxygen is applied, a reaction is produced, which is the combustion of steel.

Aluminum, on the other hand, cannot be cut with oxy-fuel. When the preheating flame is applied, it immediately forms a layer of oxide whose fusion temperature is superior to the aluminum itself. This quality causes the metal to fuse, not to cut. The same is true of stainless steels.

### Oxy-fuel Cutting Process

To begin the oxy-fuel cutting process, a preheating flame and a stream of pure oxygen are needed. Heating is produced by the combustion of a mixture of combustible gas and oxygen. Combustible gases can be natural gas, hydrogen, propane, and acetylene. The latter is the most commonly used for the oxy-fuel process.

The function of the **preheating flame** is to raise the piece of steel to the temperature of ignition and to clean the surface of slag, oxides, and paint residue. It must be sufficiently powerful to heat up the piece to a radius scale between ⅛ and 9⁄32 inches (3 and 7 mm) and in a time of 5 to 10 seconds to the temperature of ignition.

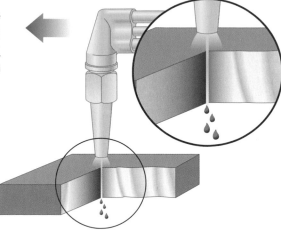

► The oxy-fuel cutting procedure begins by heating up the metal with the preheating flame until the metal turns a light red, at which time the oxygen release valve should be opened and moved in the direction of the cut.

◄ Lines characteristic of the kerf produced by the oxy-fuel cutting.

◄ In this piece the curved lines on the lower part indicate excessive cutting speed and the slag adhered to the grooves tell us that the mouth of the torch is getting dirty and cutting unevenly.

In addition, it must possess a very high heating power to maintain the temperature during the entire process of the oxy-fuel cutting. This characteristic creates warping that can alter the shape of the oxy-fuel cut metal sheet.

The **stream of oxygen** burns the metal upon reaching the temperature of ignition and removes the slag that has formed, producing a narrow groove called the kerf.

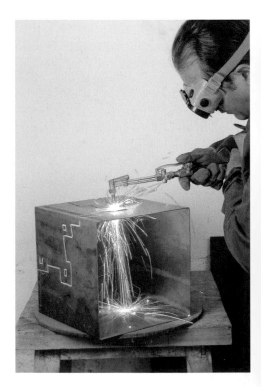

◄ Ares, *Potser algún dia esquerdarem el nostre gruixut mur d'estupidesa*, 1999, 10 × 5 × 8 inches (26 × 12 × 20 cm).

▲ During the oxy-fuel cutting process you must protect yourself appropriately with gloves, a leather apron, and safety goggles against spattering and to neutralize the intense light from the incandescent metal.

# Plasma Cutting

Cutting with plasma is based on the idea of thermal cutting, which separates the metal through fusion and subsequent removal of the molten material. The cut is made with a stream of plasma, resulting from the combination of a continuous throttled electric arc and a gas or mixture of gases. The gas is ionized when energy is added through an electric arc and throttled when forced to pass through a narrow nozzle, forming the stream of plasma. In addition to the thermal action, which registers temperatures of 36,032°F (20,000°C), the cut depends on a mechanical stream of plasma that moves at high speed, in the order of 3,300 feet (1000 m) per second, removing the molten material continuously.

The gases, called plasmagenous, used to generate the plasma are argon, hydrogen, and air (a mixture of hydrogen and oxygen). The latter is the most commonly used for these operations.

The necessary equipment for cutting with plasma consists of a direct current generator, a distributor of plasmagenous gas, and an electrode holder or torch to produce plasma continuously and to eject it in the direction of the piece that is to be cut.

Unlike the oxy-fuel cutting process, cutting with plasma may be used to cut any metal that conducts electricity.

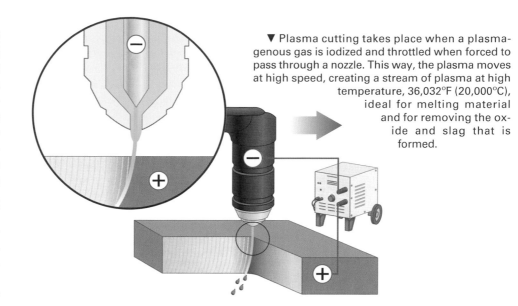

▼ Plasma cutting takes place when a plasmagenous gas is iodized and throttled when forced to pass through a nozzle. This way, the plasma moves at high speed, creating a stream of plasma at high temperature, 36,032°F (20,000°C), ideal for melting material and for removing the oxide and slag that is formed.

▲ In this cutting surface, we observe the characteristic skin that results from the high cutting speed and intensity used.

◄ To achieve a quality cut, the torch must be maintained perpendicular to the surface of the piece, and the distance between it and the nozzle must be constant and adequate.

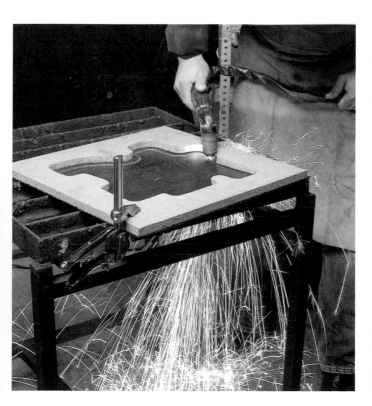

◄ The work table for cutting with plasma must allow for the molten material to escape. One can be improvised by using a metal grid as a tabletop.

► Lacquered aluminum piece cut with the plasma process. Work by Nerea Aixàs Olea, 2000, 10 × 10 × 20 inches (25 × 25 × 50 cm).

## Riveting

Riveting is a simple procedure by which two pieces of thin sheet metal can be joined together. It also allows thin metal to be attached to hollow pieces with narrow walls. It consists of a fastener that holds the pieces together through pressure.

The rivet is made of an aluminum body, the rivet itself, and a rod or mandril placed inside to create pressure on the aluminum body. To carry out the riveting procedure it is necessary to drill holes of the same diameter as the rivet in the pieces that are to be joined together. Once the rivet is placed inside the holes with the riveting tool, the mandril is pulled, generally in several steps, until the closing force breaks it, projecting outward and joining the pieces. The advantage of this system is that the rivet is inserted through the same side that it closes, making the assembly easier.

### Pop Riveting Tool

This is the tool used to activate the rivet. It is formed by two jaws controlled by their corresponding handles, whose function is to pull from the rivet, forcing the pieces to stay together.

### Pop Rivets

They come in different sizes, which depend on the thickness of the material that is to be joined together.

▲ Pop rivets.

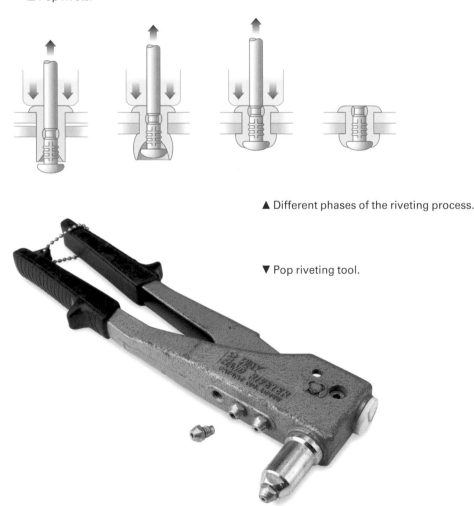

▲ Different phases of the riveting process.

▼ Pop riveting tool.

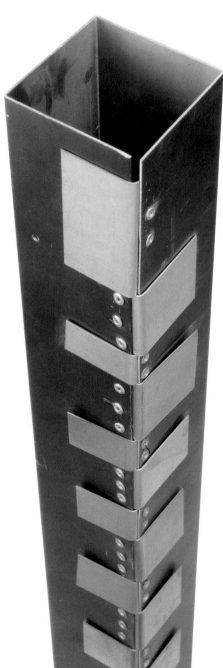

▶ In this work the rivets play an important aesthetic role, in addition to acting as fasteners. Work by Nerea Aixàs Olea, 2000, 4 × 4 × 26 inches (10 × 10 × 65 cm).

# Fastening with Bolts and Screws

Bolts are used for making strong assemblies held together by the pressure of the two pieces that can be removed if desired. We use **bolts with nuts** or **self-tapping screws** or **sheet-metal screws** as fasteners for the assemblies. In all cases, holes must be drilled in the pieces that are to be joined together to insert them.

Bolts and screws create pressure on the pieces, tightening them against each other with the pressure of the nut. In these cases, the hole where the screw or bolt is to be inserted and the screw itself should have the same diameter. Sometimes washers are used to spread the force of the pressure and to protect the metal from the turning nut.

However, sheet-metal screws need a slightly smaller diameter hole than the screw itself, because the threads of these screws must make their way into the metal of the piece that is to be joined together to form their own threads. For this reason, they are also known as self-tapping screws.

Threaded rod is also available by the foot. This allows the user to customize the length of the bolt, expanding the creative possibilities.

▲ Bolts and some screws consist of several parts, including a threaded shank with the head at one end and a nut that can be attached or removed from the other end. The illustration shows different bolts.

▲ These sheet metal screws are made of durable steel and have a short shank.

▼ Different kinds of sheet metal screws.

▼ Sheet metal screws inserrted into screw channels in extruded aluminum sections.

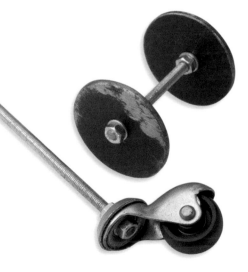

▲ There are many creative possibilities and uses for threaded elements, either as screws or as threaded rods.

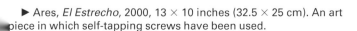

► Ares, *El Estrecho*, 2000, 13 × 10 inches (32.5 × 25 cm). An art piece in which self-tapping screws have been used.

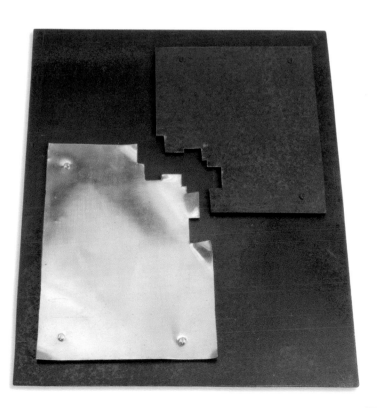

# Manual Threading

A good solution for joining several metal pieces together is to make threads manually in the pieces themselves, to create either nuts or bolts. Joining pieces together in this way eliminates the need for welding.

The tools required for manual threading are called screw taps and screw dies.

**Screw taps** are used to create the threads inside the hole, which becomes the nut. They have the shape of a screw and are made of tempered steel. To create the threading inside a piece, a series of three screw taps are used, inserted into a tap wrench.

Each tap has a slightly smaller outer thread cutter and core diameter than the next one. This way, the work that they must perform is spread evenly. The first tap produces the outline of the thread, the second cuts it, and the third one finishes it.

On the other hand, the **screw dies** are the tools used to create bolts. The shape of a screw die resembles that of a bolt, and it is also made of tempered steel. To produce the threading on a piece, only one of the settings of the die is used, and it is operated with a handle.

It is important to know that the threads have a designation according to their type and a standard related to their shape and application. The **metric** thread is the most common. It is characterized by the fact that the measurement of the thread's outer diameter is given in millimeters.

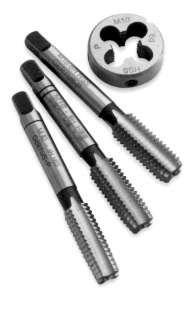

▲ A set of three screw taps and a screw die of the same size.

◄ Set of screw taps, dies, hand die, and tap wrench to produce threads of various sizes.

### Process for Making a Screw out of a Metal Piece

▲ **1.** The piece that is to be threaded is securely attached to the bench vise. It is a good idea to bevel the edges of the tip where the threads will be cut to facilitate the insertion of the screw die before the process begins. It is also important to apply a few drops of lubricating oil over the threading area, which will reduce the friction of the screw tap against the piece.

◄ **2.** The screw die with the handle is placed on the piece. It must be centered on the end of the future screw. While applying a little bit of pressure, the die is turned a few times until it is observed that its tooth has bitten into the rod. It is important to make sure that the thread is being cut straight by placing the die perpendicular to the screw. This will prevent the threads of the die from breaking, and it will maintain the tool in proper working condition.

◄ **3.** When the thread is being cut, a few more drops of lubricating oil are applied to the area and the threading procedure continues by turning the hand die, alternating one full turn and backing off one-half turn until the desired threads have been completed.

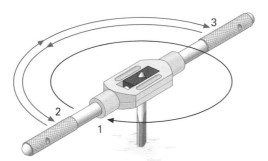

◀ Diagram of the alternating turn at half-turn intervals. The goal of this procedure is to thread the metal at one end, forcing the shavings to come out of the other. It is necessary to execute the alternating turn in both thread-creating procedures, whether it is to make nuts or bolts.

**Process for Tapping a Metal Piece**

▲ **1.** To begin the tapping of this piece, a hole must be drilled through it. The diameter of this hole should be slightly smaller than the size of the thread of the screw that will go in it. It is a good idea to do a test on a piece of scrap metal of the same kind to confirm the diameter of the hole. In this case, the metric size of the hole required is 6 mm and the diameter of the bit to drill the hole is 5 mm.

▲ **2.** With the piece properly secured in the bench vise, the threading procedure begins. After lubricating the threading area with oil, the screw tap is inserted into the hole with the tap wrench, making sure it goes in perfectly perpendicular. After that, it is turned on its axis until you notice that the first thread has been cut; then, the tap is turned alternately, to one side first and then the other, the same way it was done when creating the screw. This process is repeated with the second and third taps of the assembly.

◀ **3.** View of the completed nut and bolt. Now the iron piece and the bronze piece can be assembled by screwing them together.

▶ **4.** Ares, *Haikú planta III*, 2003, 7 × 6 × 4 inches (18 × 15 × 10 cm). Forged iron and bronze.

# Forming

## Bending on a Bench Vise

**M**any procedures can be carried out using the bench vise. One of them is bending small sheet metal pieces, of a thickness no greater than 0.10 inch (2.5 mm), by hammering. Bending produces a curve with a very small radius; therefore the resulting fold has a rounded edge. To create a sharp edge, first two pieces of metal are welded together at an angle, and then the weld bead is reduced with the grinder until the desired edge is achieved.

When bending a piece of metal on a bench vise, as a precaution, it is a good idea to begin hammering in a staggered fashion so the area is bent simultaneously over the entire surface. This way the expansion of the metal in the area of the force, which would cause it to warp, will be prevented.

To bend long pieces, two angle sections are placed facing each other, firmly held with a handscrew or a clamp that applies pressure at the other end of the sections, allowing the piece to be firmly held in place.

▲ **1.** To begin bending, the entire length of the sheet metal is hammered in steps.

▲ **2.** Without changing the rhythm, the metal continues to be hammered in steps until the desired angle is achieved.

▲ **3.** When one end of the metal is struck brusquely, a line is created between the area that has been hammered and the one that has not, causing the metal to lose its shape.

▲ **4.** To bend long pieces that do not fit in the vise, two steel angle sections and a clamp are used to increase the gripping pattern of the vise. This method is also applicable for cutting sheet metal that is longer than the vise with a chisel.

# Bending with Machines

Some bending machines have mechanisms that make bending sheet metal and flat bars of small and medium thickness easier. Generally, they are divided into two parts: one immobilizes the sheet metal or bar that is to be bent, and the other applies pressure in one area of the metal, causing it to fold and then bend.

Common bending machines have a counterweight that helps the bending motion, adding its weight to the force exerted by the person who is operating the movable part.

However, machines that bend sections lack a counterweight, so they must be mounted onto tables or strong stands that counteract the force produced when bending thick bars.

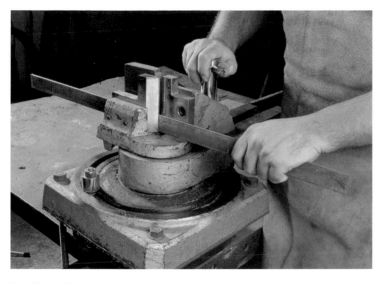

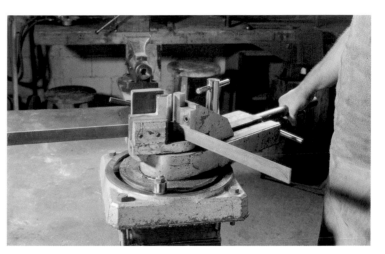

**Bending a Bar**

▲ **1.** The flat bar is placed in the stationary part of the bending machine's vise. The piece should remain properly secured in the clamp so it does not move while pressure is applied to it.

▲ **2.** Before bending, the elements of the machine's movable parts are adjusted and immobilized to allow the application of adequate and even pressure on as much of the surface of the section as possible. Then, the lever is turned until the desired angle is achieved. This tool has an adjustable stopper in the trajectory of the turn, which is set to a specific position to repeat the same type of angle. It is very useful for making several similar pieces.

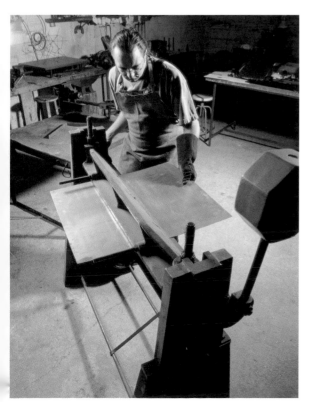

**Bending Sheet Metal**

◄ **1.** The sheet metal is placed between the bars that act as a vise, and the lever is thrown to immobilize it. It is important for the top bar to line up with the marks made on the sheet metal that indicate where to bend.

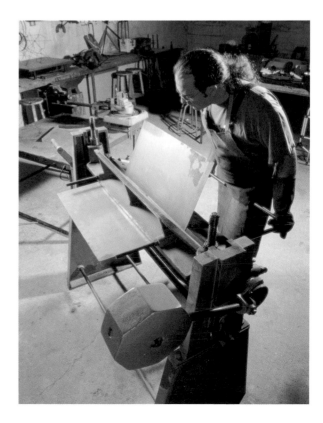

► **2.** Once the sheet metal has been lined up with the bars, bending begins. To do this, the movable bar is activated with the two levers located at each side of it, applying pressure to the area of the sheet metal that is to be bent. A counterweight will help create the force.

# Twisting Cold Steel

Twisting is a procedure that consists of making spiral bends on a rod or a small bar. Flexibility, one of the properties of metal, is exploited to create decorative forms without the need for heating the piece. Generally, flat pieces, like small plates, are used. It is necessary for the pieces to have a medium thickness to stand up to the twisting.

A bench vise is used to hold the piece firmly in place, and a scroll wrench helps twist the metal bar.

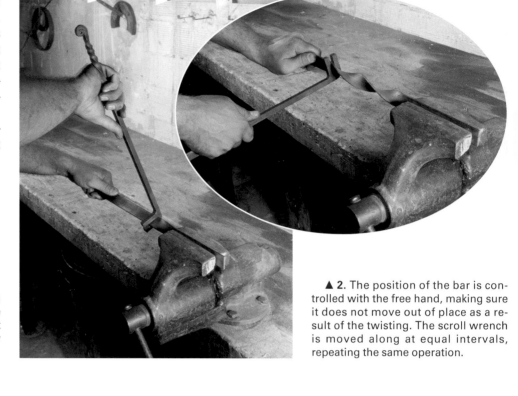

▶ **1.** The steel bar is placed in the bench vise. Then, the teeth of a scroll wrench are placed on the bar, at the place where the first twist is to be made, and the metal is slowly rotated.

▲ **2.** The position of the bar is controlled with the free hand, making sure it does not move out of place as a result of the twisting. The scroll wrench is moved along at equal intervals, repeating the same operation.

# Bending with a Jig

Bending consists of forming metal rods into circles by exploiting their flexibility. As with twisting, to bend cold metal wires the pieces must have a specific thickness and the curvature radius cannot be too small.

▶ **1.** With the fork secured in the vise, the metal wire is placed between the bars, and the force of the entire body is pressed against it as the piece is moved along to form the circle. Moderate pressure should be applied against the fork to prevent marks from appearing on the curved bar.

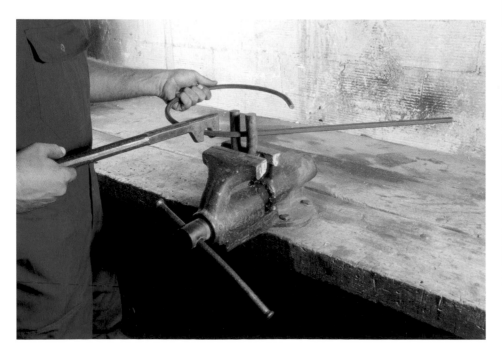

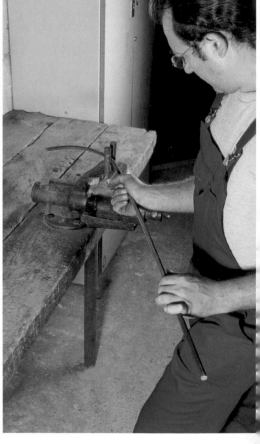

◀ **2.** In some cases, a bending tool can be used to adjust the curvature of the circle.

## Curving on a Form

Curving on a form consists of hammering metal strips or bars into circles. The hammer strike is applied over the hollow area located between two steel angles, welded together to form a block, or with a concave or U-shaped piece, for example. The process begins by striking on the metal gently but firmly until the piece begins to fit within the hollow part. It is surprising to see how the circle begins to form as the precise hammering operation progresses, without the need of sophisticated technology.

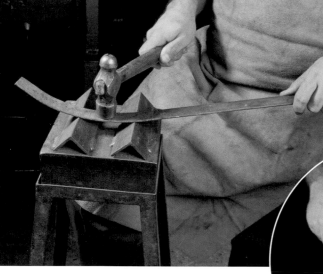

▲ **1.** A band of sheet metal is placed over a forming jig, which can be two pieces of angle welded together on a steel block. The hammering is done in the hollow area located between the two angular pieces. This way the metal reacts to the hammer strikes and the shaping process takes place.

◀ **2.** After several rounds of hammering over the entire piece, and when the metal is visibly taking shape, more precise and calculated hammering blows are applied. In other words, the metal is hammered only where needed and on the areas where the radius of the circle does not conform to the shape. It is very helpful to have a full-size drawing of the required circle handy to check the curvature by placing the piece over it as the hammering progresses.

## Rolling with a Rolling Mill

Rolling mills can produce uniform circles in sheet metal and rods. This is achieved by passing the metal through two rollers that project the sheet metal or rod forward with the help of gears and a handle. A third roller, which is the curving piece, imparts a series of continuous flexing motions to the metal, generating a uniform curvature.

▶ Rolling a piece of sheet metal in a rolling mill. The forward movement of the piece is activated by a handle. The rollers apply uninterrupted flexing motions to the piece.

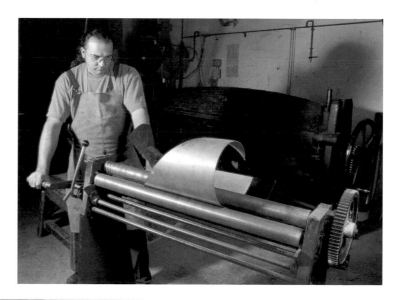

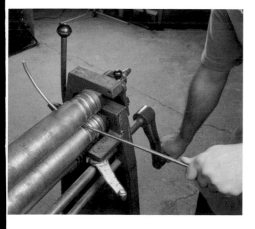

**Rolling Rod**

◀ **1.** Rolling mills have a rolling area of various widths at one end for curving round stock, bars, and certain small-diameter pipes.

◀ **2.** The top roller has a system that allows it to be removed from the machine, enabling you to take the rolled piece out, which in this case is a round copper rod.

▲ If the hammer strikes on the sheet metal with a circular motion, the crystalline structure expands following the radius of the circle, which produces a similar expansion in all directions.

However, if the contact surface of the hammer is long and narrow, the structure moves perpendicularly. This produces a big expansion transversally and a small one lengthwise.

▲ Hammering on a support compresses the metal between the support and the hammer, causing thinning first, followed by expansion.

However, when hammering over hollow, the metal flexes, causing expansion first, followed by thinning.

# Forming by Hand

Forming by hand includes all the techniques that are used to shape metal pieces through hammering. The process consists of causing a displacement of metal mass to create volumes, making it expand or contract as needed by hammering.

Metals are formed by a myriad of polyhedron crystals, that is, multifaceted crystals that create sliding planes. This characteristic makes it possible to create a series of displacements that change the shape of the structure of these crystals, thus creating the metal's form.

Hammering the piece into **shape through stretching** produces an enlargement of the material's surface. This procedure is the most common one for creating volumes by hand.

Forming pieces through stretching depends on:

- the shape of the hammer used;
- the way hammering is done, striking on solid or in hollow;
- and the position of the hammer, vertical or at an angle, at the time of the strike.

In a previous chapter we showed how hammers have different shapes, depending on their intended function. These shapes form the metal differently according to the blow. For example, a hammer with a round head, like the one used for forming, makes the metal expand in a radial form, the same way in all directions. And a hammer with a flat end does so transversally.

The way the hammer strikes is also important. For example, the same forming hammer when worked on a support produces greater work hardening of the metal than when it is worked over a hollow area.

### Work Hardening

Metal is subject to forces of compression during the drawing process, and to flexion during forming in hollow. The crystalline structure expands under these forces, creating a thinning of the metal.

Hammering also alters its mechanical characteristics as a result of accretion. The metal increases its hardness, resistance, and elastic limit, at the same time reducing its malleability, ductility, and its plasticity. Also, it reduces its resiliency, returning to its fragile state. These effects can be eliminated by annealing the hammered piece, which consists of bringing it up to a certain temperature, depending on the metal, and then letting it cool down slowly.

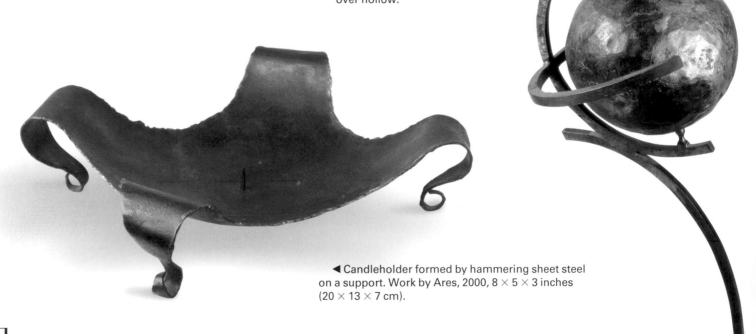

▶ Ares, *Bola*, 1998. 6-inch (16-cm) diameter. Piece created by forming two steel halves over hollow.

◀ Candleholder formed by hammering sheet steel on a support. Work by Ares, 2000, 8 × 5 × 3 inches (20 × 13 × 7 cm).

# Forming a Dish

This exercise will demonstrate how to create a dish by combining two manual forming techniques, forming over hollow and planishing, using a thin sheet of tin.

▶ **1.** The forming process begins with the technique of forming over hollow. To do this, the sheet of tin is placed over a steel mold or tube, whose interior diameter is the same as the desired size of the dish. Then, we begin to hammer the metal with a forming hammer, which will establish the dish's edge.

▼ **2.** It is important to strike with the rounded part of the hammer and to hold it at a slight angle, to push the metal toward the areas of the dish that will suffer the greatest change in shape.

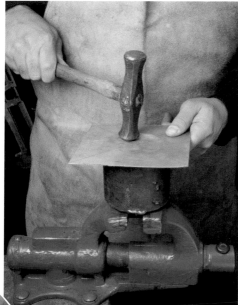

▶ **3.** To finish the process of forming over hollow, the entire concave surface should be hammered with blows directed to specific areas until the desired spherical form is achieved.

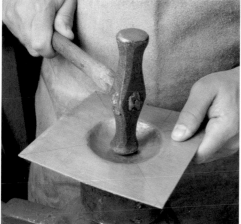

▶ **4.** After cutting off the formed section with tin snips, the dish is planished by placing it on a ball-shaped stake and hammering with the flat side of the forming hammer. This will even out the thickness of the piece while giving it some texture.

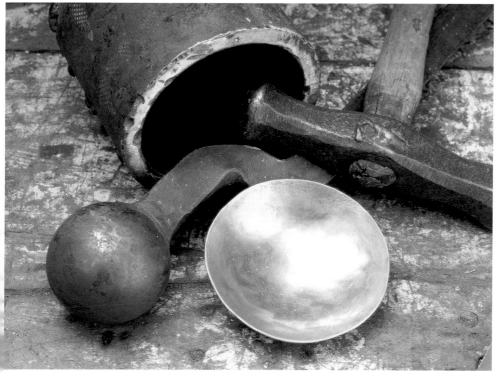

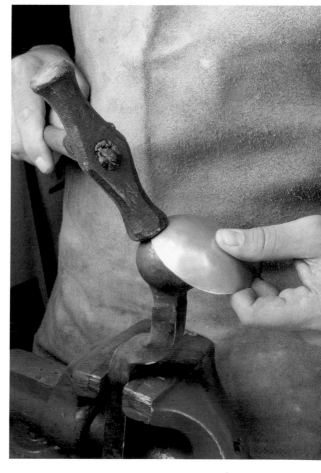

◀ **5.** The spherical tin dish and the tools needed for making it.

# Forging: Basic Concepts

Experience with forging is achieved by practicing bending and hammering heated iron over an anvil. This way, one can learn and begin to understand how iron reacts when it is exposed to heat. To become proficient in the art of blacksmithing, it is necessary to observe four basic rules. The following sections will explain how to ignite the forge, how to recognize the temperature of the metal by simply observing the color of the metal, the thermal treatments that are produced, and some of the basic forging processes that are required to learn blacksmithing.

## Igniting the Forge

There is no single way of igniting the forge; each blacksmith has his or her own system. Here we explain one of them.

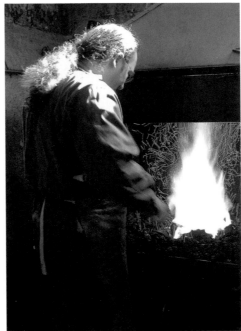

◄ The different shades of color produced by the heating process can be seen better in the dark.

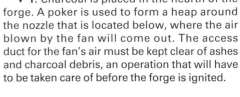

▼ **1.** Charcoal is placed in the hearth of the forge. A poker is used to form a heap around the nozzle that is located below, where the air blown by the fan will come out. The access duct for the fan's air must be kept clear of ashes and charcoal debris, an operation that will have to be taken care of before the forge is ignited.

▲ **2.** A few pieces of paper mixed with some wood chips are placed in the center of the mound, and they will be used to start the fire.

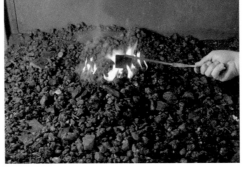

▲ **3.** Then, the charcoal is spread over the fire and a vent is cleared to provide air to the fire from the nozzle located below.

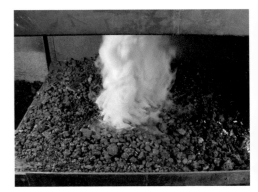

▲ **4.** A plume of thick smoke indicates that the charcoal has caught on fire. To expose the iron to the coals, we must wait until this smoke rich in sulfuric components burns up, otherwise the metal could be damaged.

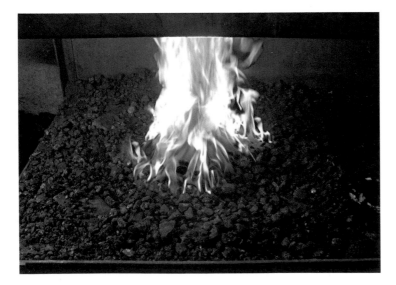

▲ **5.** Once the thick smoke has vanished, the iron pieces are heated up for forging. The pieces should not be placed directly over the fan's air vent to prevent oxidation from forming on the surface of the metal, which would weaken it.

## Temperature and Color

### General Factors

Heating the metal is necessary for forming and for preventing the cracks and fissures that would make the metal fragile. Heat should be applied based on the nature of the metal and its mass. Improper heating weakens and suppresses the characteristics of the metal and especially some of its essential properties, such as its ability to resist corrosion. For example, in the case of steel, temperatures below 1,292°F (700°C) increase its fragility and decrease its tensile strength.

In any case, the speed at which metal heats up depends on:
- the physical and chemical nature of the metal; a metal that is a better conductor than another will absorb the heat needed for forging;
- its mass and the relationship between its dimensions; between two pieces of the same composition and the same weight, the one with the largest surface will absorb more calories and will heat up faster;
- the temperature of the coals in the hearth.

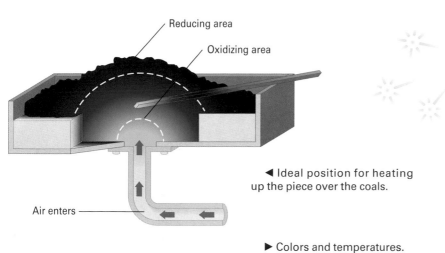

Reducing area

Oxidizing area

◄ Ideal position for heating up the piece over the coals.

Air enters

► Colors and temperatures.

| | |
|---|---|
| 1,400°C | Light white Maximum limit for forged iron |
| 1,300°C | White yellow |
| 1,200°C | Light yellow |
| 1,100°C | Yellow |
| 1,000°C | Orange |
| 950° | Yellow red |
| 900°C | Light red |
| 850° | Red |
| 810° | Light cherry red |
| 800°C | |
| 760° | Cherry red |
| 740° | Dark cherry red |
| 700°C | Minimum forging temperature |
| 680° | Dark red |
| 620° | Brown red |
| 600°C | |
| 550° | Dark brown |
| 500°C | |
| 400°C | |
| 360° | Gray |
| 340° | Blue gray |
| 320° | Light blue |
| 300°C | Blue |
| 290° | Dark blue |
| 280° | Violet |
| 270° | Purple red |
| 260° | Tan |
| 250° | Coffee |
| 240° | Dark straw |
| 230° | Light yellow |
| 220° | Straw |
| 200°C | Light yellow |

The conclusion is that the process of heating the pieces should be carried out carefully. It is necessary to create a free dilation of the entire piece to avoid interior tension that could weaken the metal and produce cracking inside it.

### The Piece and the Coals

Heating up the piece should be carried out with care, turning it at regular intervals over the coals to heat up all the surfaces of the piece equally and to reach the center, especially in very thick pieces. The piece should be exposed to the coals between the oxidizing area and the reducing area, that is, away from the direct exit of the air vent to prevent the surface of the piece from accumulating oxide (oxidizing area), but inserted well enough to avoid the upper part of the coals where the piece would heat up too much (reducing area).

### Coloration and Temperature

Heating produces changes in color in the metal, and the color varies depending on the temperature. Soft steel, which has a carbon content of between 0.1 and 0.3%, is by far the best metal for working on the forge.

The different shades produced during the heating process help us recognize the temperature. For example, we know that a dark cherry red color indicates that the temperature has reached approximately 1,364°F (740°C) and that orange indicates about 1,832°F (1,000°C)

The temperature observations vary according to the composition of the steel and the light under which it is viewed. To see the colors clearly, it is a good idea to observe them in the dark.

When working with aluminum and its alloys, it is important to keep in mind that their forging temperatures range between 572° and 932°F (300° and 500°C) and the color shades are not distinguishable. In these cases, it is necessary to use pyrometers that indicate the temperature. A practical way, although not exact, is to touch the heated surface with a piece of wood; the shade of brown imprint left by it will indicate its approximate temperature.

Copper and its alloy brass change colors when heated, but their shades are practically unnoticeable. When heating copper or brass pieces, it is important to pay close attention to prevent pieces from vanishing in the flames. Often, the oxyacetylene torch is used to more effectively control the heat applied to these pieces. Alloys with a copper content greater than 60% are good for forging.

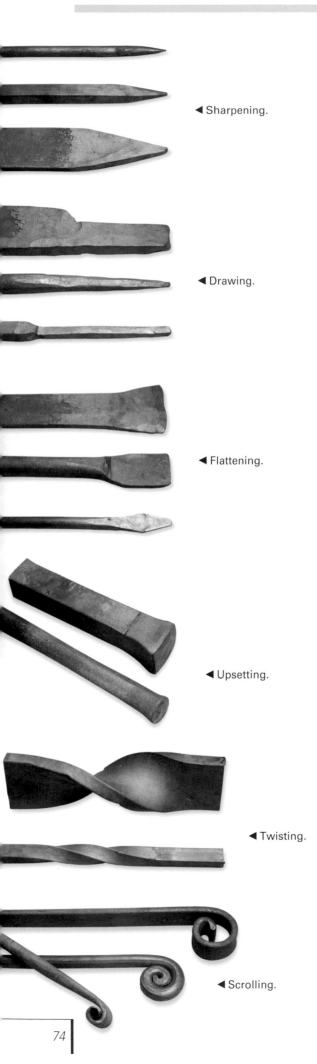

◀ Sharpening.

◀ Drawing.

◀ Flattening.

◀ Upsetting.

◀ Twisting.

◀ Scrolling.

## Some Basic Forging Processes

It is important to know some of the basic forging processes. Many of the forged objects that we normally see are the result of the combination of simple blacksmithing operations. It is a matter of practicing with easy projects on the anvil and the bench vise, working the metal when red hot.

• **Sharpening.** In this procedure the size of the metal is altered by flattening it into a point.
• **Drawing.** This consists of modifying the original profile of the piece by making it longer and reducing its thickness.
• **Drawing out.** In drawing out, the cross section is changed by reducing it and increasing its width.
• **Flattening.** With this procedure the initial thickness of the piece is decreased and the width is increased.
• **Twisting.** This consists of creating spiral shapes in the metal by twisting.
• **Scrolling.** This consists of rolling the piece around itself.

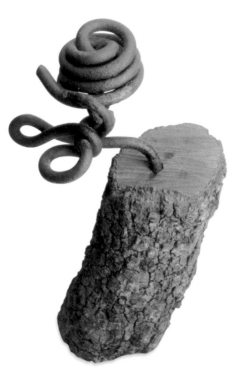

▲ Ares, *Rosa rosae,* 1997, 11 × 4 × 7 inches (27 × 10 × 18 cm). This rose made of metal is an example of the plastic possibilities that can be achieved with the various blacksmithing techniques.

▲ Process of scrolling, or making a spiral, by forging.

## Thermal Treatments

The object of a thermal treatment is to change the mechanical properties of metals. It is the process through which a metal is heated until a certain temperature is reached, which is maintained for some time and then cooled off at a specific speed. This way, heating and cooling changes the structure of the metal. The results obtained with these variations depend on the temperature reached and the speed at which the metal is subjected to them.

Thermal treatments are divided into two groups:
- treatments without a change in the composition, that is, with no change in the components;
- treatments with change in the composition, meaning that more components are added or that the proportion of those existing is modified. They are also known by the name of thermochemical treatments.

Here, we are going to talk about thermal treatments without changes in the composition of its components. They are: tempering, heat treating, and annealing.

### Tempering

This is a thermal treatment through which a metal increases its resistance and hardness, but in contrast, it also makes it more brittle. Tempering consists of heating the metal piece uniformly to a specific temperature, and then cooling it suddenly in a bath or water, normally at room temperature. How the piece is inserted into the water for cooling is an important procedure. The container of liquid should be sufficiently large to easily put the entire piece in and take it out. It is important to do this following its vertical axis. Its shape will determine how to shake it in

the liquid, either in one direction or in the other. This treatment is widely used for making steel tools whose carbon content is less than 0.9%.

### Heat Treating

This is a procedure that eliminates the tensions produced by sudden dilations and contractions that occur when the metal piece is heated. It consists of annealing the tempered piece at a fairly low temperature, between 212° and 608°F (100° and 320°C), and cooling it off afterward. With heat treating the piece loses hardness but gains tensile strength.

### Annealing

Annealing is a treatment used to restore the qualities that the metal has lost as a result of the mechanical operations such as hammering cold, or flattening, or simply when a tempered piece has to be modified.

It consists of heating the metal piece up to a certain temperature, between 392 and 1,292°F (200° and 700°C), keeping it there for some time and then cooling it off slowly at room temperature. This way, we restore properties such as ductility. Annealing is also used for softening and to achieve lower levels of hardness that make the metal easier to work.

### Tempering a Cutting Blade

The tempering of tools is a procedure that requires great observation and practice. Knowledge of the technique is based on continuous experimentation. Presented here are the steps for tempering a cutting tool, and we encourage the reader to learn this process and to continue gaining experience.

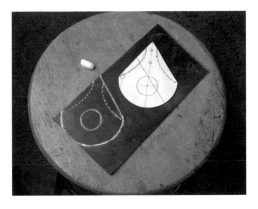

▲ **1.** The design of the shape is transferred to a 0.80-inch (2-mm) thick metal piece using a paper drawing and white chalk. It is a good idea to make the straight sides of the drawing coincide with those of the metal piece to minimize the work and to make better use of the material.

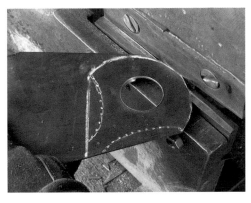

▲ **2.** The piece is cut with a power shear. The circle inside has been cut on a drill press. To make the concave sides, a grinder is used fitted with a grinding disk.

Next, two holes are made in the narrow area of the piece with a power drill, to attach a wood handle later.

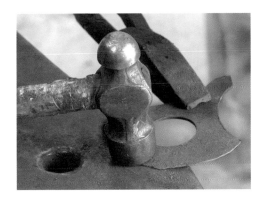

▲ **3.** After the piece has been heated in the forge, it is sharpened by striking the edges of the piece, which will later be tempered, with the hammer.

▲ **4.** After the sharpening is finished, the piece is secured in the bench vise and the outside is filed. The parts of the piece that are going to be tempered are heated. It is important to let the metal heat up slowly and uniformly by constantly turning the piece in the forge.

▶ **5.** When the piece acquires a cherry red color, it will indicate that the tempering level has been reached, between 1,310° and 1,562°F (710° and 850°C). The moment when the piece should be cooled down suddenly in the bath is when the color changes from bright cherry red to dark cherry red.

It is inserted in the water following a movement in the direction of the blade's curve, and one can see how the colors of the tempering change through the iron piece.

▶ **6.** Final view of the cutting blade tempered and sharpened.

# Waxes, Varnishes, and Paints

To preserve metals from their natural oxidation process, it is necessary to soak them with adhesive substances that protect their surfaces from exposure to air and humidity.

These substances are applied by hand with rags and brushes.

**Varnishes** are transparent substances that dry very fast, forming a thin and strong film over the metal objects. They provide a polished and shiny finish that blends the colors of the surface.

**Waxes** can be of plant origin, like carnuba; of animal origin, like beeswax; or mineral origin, such as paraffin.

Waxes polish the surfaces of objects and make them even the same way varnishes do, with the advantage that unlike the latter, one has control over the degree of shininess the surface should have. In fact, when the wax is applied with a brush it creates a matte layer on the surface. Once the layer is dry, it can be made shinier by rubbing with a cotton rag.

**Paints** are pigments and coloring agents mixed together with synthetic binders. They are opaque and fast drying. They can be shiny or matte and very binding.

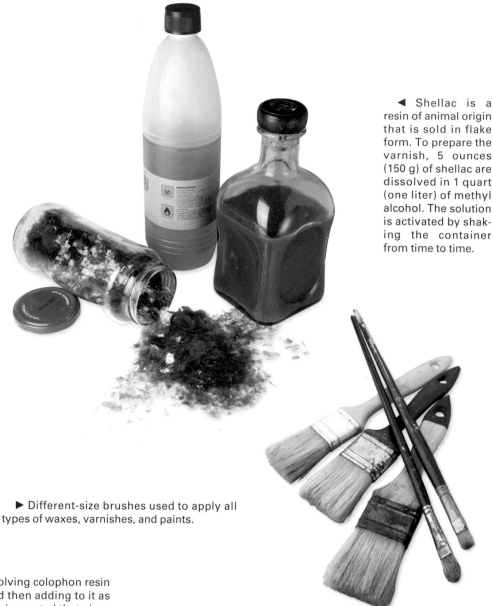

◄ Shellac is a resin of animal origin that is sold in flake form. To prepare the varnish, 5 ounces (150 g) of shellac are dissolved in 1 quart (one liter) of methyl alcohol. The solution is activated by shaking the container from time to time.

► Different-size brushes used to apply all types of waxes, varnishes, and paints.

▼ Another natural varnish is produced by dissolving colophon resin in methyl alcohol until it becomes saturated and then adding to it as much black pigment as desired. A strong varnish is created that gives metal objects a dark tone, which reveals the texture of the pieces, depending on the amount of pigment that has been added.

▼ Wax and varnish preparations for metals as sold in stores.

## Preparation of a Varnish-Type Mixture to Preserve Metals in General

Next, a mixture is created to apply to any metal to protect it from oxidation. It consists of a cream made of wax and resin that is applied with a brush. It takes a few hours to dry and it is very effective for preserving metals. Also, it blends the colors and gives the metal a very pleasant satin glow.

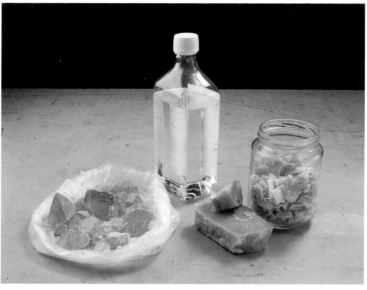

◄ **1.** Three ingredients are needed to make the mixture: mineral spirits, beeswax, and colophon resin.

▼ **2.** Beeswax is normally sold in bars. To make it melt faster it is shredded into small pieces.

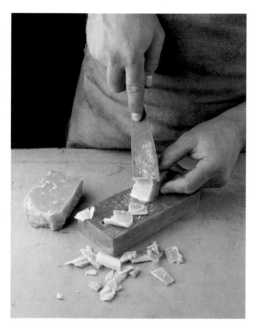

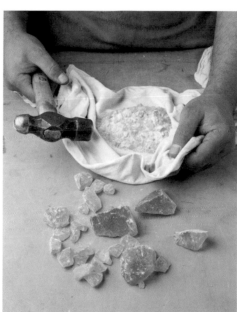

◄ **3.** The colophon resin is the residue left over from converting natural resins into essence of turpentine; it is sold in the form of crystal pieces. To make it dissolve faster, it is wrapped in a rag and turned into powder by pounding it with a hammer.

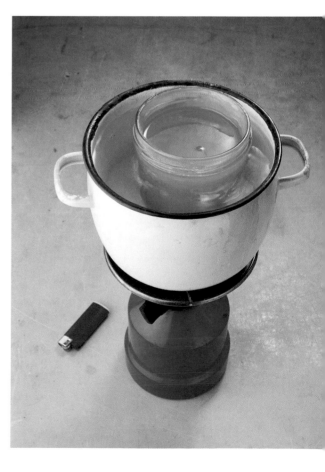

► **4.** Next, one part beeswax and one part colophon resin are mixed in a glass jar. Immediately after, three parts of mineral spirits are added. The mixture is dissolved in a double boiler, that is, placing the glass container that holds the mixture inside another container with water, which is heated on a burner in a moderate setting.

◄ **5.** The mixture becomes smooth when the wax and the colophon dissolve in the mineral spirits, turning into a liquid. This solution acquires consistency as it cools off, resulting in a semi-liquid mixture at the end of the process.

# Patinas

A patina is an oxide film formed on the surfaces of metal objects. This film usually has colors that make the objects lustrous and beautiful, giving them an antique finish.

To apply the patina, the surface of the object must be free of oils and traces of rust that could cause its decay, making the patina wear off with the passage of time.

One of the easiest types of patinas to achieve is to speed up the formation of a protective layer of oxide on iron objects (carbon steel). To do this, the piece is covered with a solution of distilled water and common salt, using a brush. With time, a fine layer of iron oxide of very characteristic orange and reddish tones will form. When the color combination reaches a stage that satisfies our purpose, the oxide layer is fixed and protected with two coats of transparent varnish for metals. The varnish will highlight the color tones and will create a subtle difference between the dark tones and the lighter ones.

### Blackening Solution for Forged Pieces

This blackening patina is used for pieces that are made by forging. This type of patina preserves the texture that is created when the pieces are made on the anvil. It can also be used on pieces that have not been forged.

Linseed oil is applied with a brush over the forged piece and then it is heated with the flame from a gas torch to carburize the oil, until the blacking appears on the piece. The operation is repeated as many times as needed until the desired patina is achieved.

To finish, the piece is buffed cold with a cotton rag and waxed to seal the surface pores and to make it shiny.

▲ Ares, *Resonancia*, 1999. Iron piece (carbon steel) with a natural oxide patina, which was accelerated through applications of a mixture of distilled water and common salt and later varnished.

### Gray Patina

This gray color is ideal for heavily textured pieces, since it preserves all the character of the object.

In a small amount of raw linseed oil we dilute about 3½ ounces (100 g) of graphite powder until the mixture turns into a smooth paste. More linseed oil is added until we have one-half quart (half a liter), and we continue stirring the mixture until all the graphite powder has dissolved. One-half quart (half a liter) of all-purpose solvent is added to complete one quart (one liter) of the solution.

At this point we have made a gray sealing patina. To make a darker tone, about 0.35 ounces (10 g) of black pigment are added. Other colors can also be added, like oxide red, siennas, and some type of green to obtain warmer colors.

### A Bath for Brass and Copper Pieces

These are chemical solutions that cause different colored oxidation from reactions on brass and copper pieces.

The blue product illustrated on the following page is a solution of selenium nitrate, copper sulfate, and water, which is applied by submerging the brass pieces in it for 30 seconds. Then they are rinsed in running water and are left to dry. A brownish tone is obtained in brass pieces.

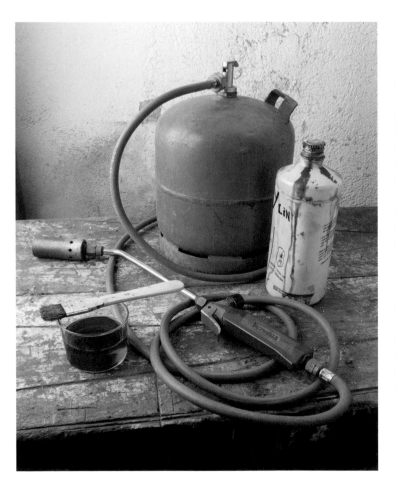

◄ Tools and products for creating a black patina for forged pieces.

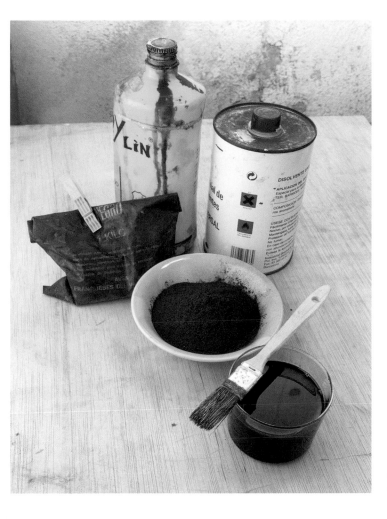

◄ Products required for applying a gray patina.

▲ Ares, *Cargol i cargols*, 1998. Steel and copper screws. In this case, only the copper piece has been submerged in the green solution to create a greenish oxidation on it.

The greenish product is also a chemical solution whose formula is guarded under great secrecy by each manufacturer. Copper pieces and its alloys react when they are submerged in it creating a very characteristic green color patina.

In both cases these products are highly poisonous, and protective goggles and gloves specified for chemicals should be worn. It is also necessary to use a special mask as protection from the vapors that they give off.

► Ares, *Enigma*, 1999. Hammered brass. This piece has been treated with the browning bath mentioned before. It has been highlighted by gently rubbing with a brass-wire brush.

◄ Chemical solutions for brass and copper objects.

# Welding
# Processes

K nowledge of the welding processes for joining any metal piece or object is essential, and the subject deserves an entire chapter in this book.

Here we demonstrate the most commonly used welding processes, leaving out some others that are more complicated. We want to demonstrate the most practical welding techniques that can be utilized in any workshop, and teach the guidelines that one must be aware of for different cases and for different materials. Welding experience can only be gained with intense practice, and many mistakes will be made while learning the necessary skills. At the same time, it is important to follow the safety measures laid down by the manufacturers of the supplies and the welding equipment.

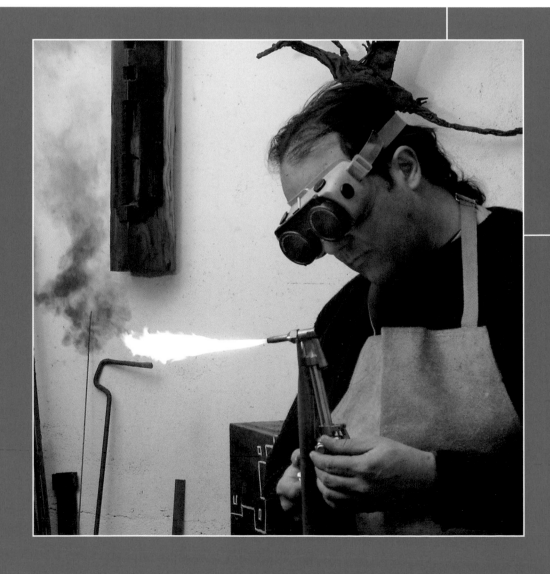

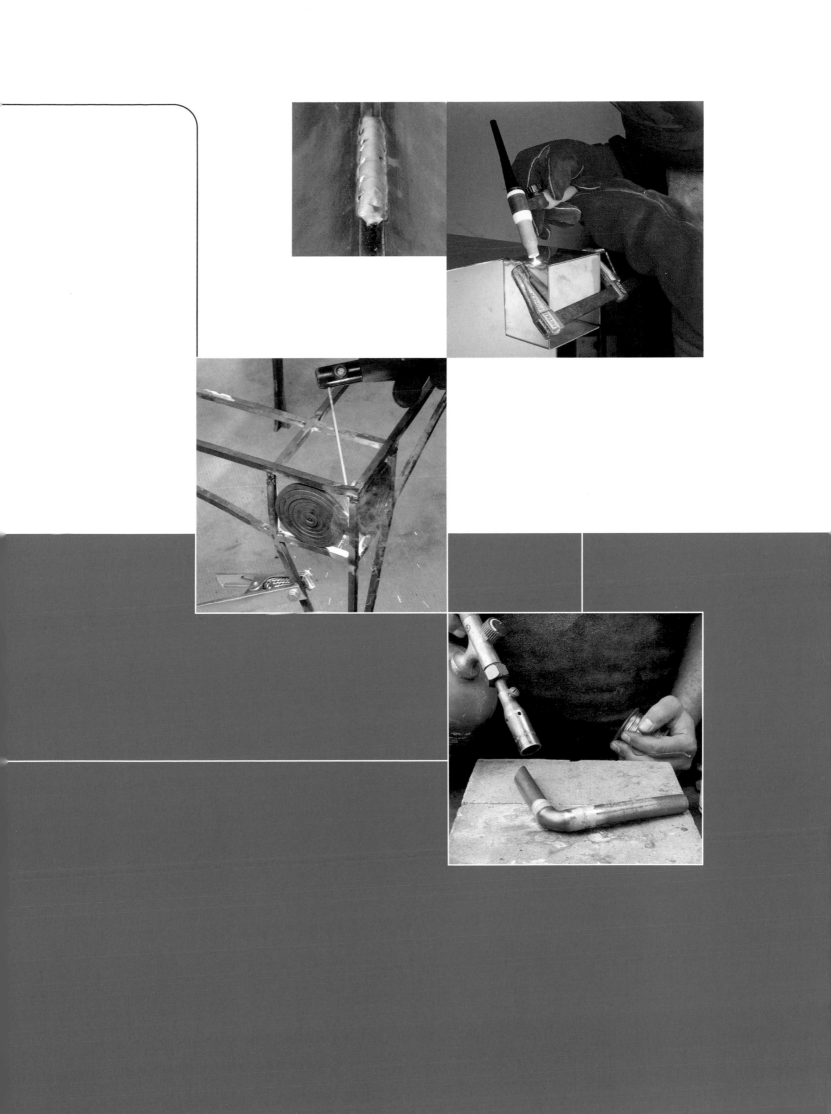

# General Considerations

To be able to speak correctly about the joining processes in welding, it is necessary to know the meanings of the most commonly used terms. For example, **welding** means solidly joining two pieces with another material that is the same or of a similar nature. Therefore, the joint created by the welding action is known as the **weld**.

When talking about the metals, we must distinguish between the **base metal** and the **welding rod** or **filler rod**. The first refers to the two or more parts that are being welded, while the other two are used to join the base metal.

Another welding technique is fusion, which consists of joining two edges by melting them without the use of welding rods, where the base metal supplies the material for producing the weld.

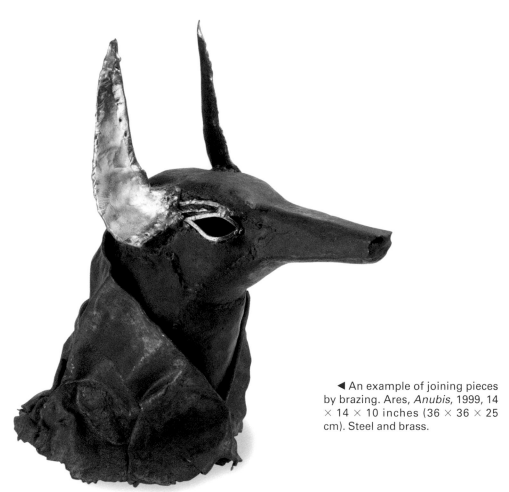

◄ An example of joining pieces by brazing. Ares, *Anubis*, 1999, 14 × 14 × 10 inches (36 × 36 × 25 cm). Steel and brass.

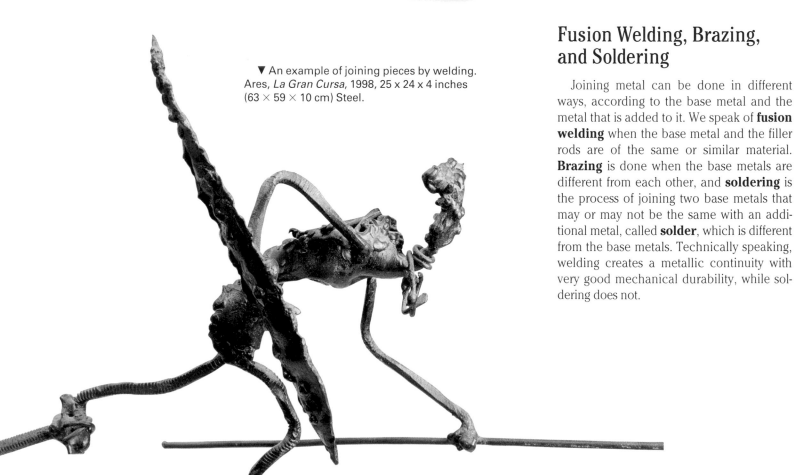

▼ An example of joining pieces by welding. Ares, *La Gran Cursa*, 1998, 25 x 24 x 4 inches (63 × 59 × 10 cm) Steel.

## Fusion Welding, Brazing, and Soldering

Joining metal can be done in different ways, according to the base metal and the metal that is added to it. We speak of **fusion welding** when the base metal and the filler rods are of the same or similar material. **Brazing** is done when the base metals are different from each other, and **soldering** is the process of joining two base metals that may or may not be the same with an additional metal, called **solder**, which is different from the base metals. Technically speaking, welding creates a metallic continuity with very good mechanical durability, while soldering does not.

Within these categories are the additional processes that are seen in the chart on this page, with their individual characteristics.

| CHART OF METAL JOINING PROCESSES | | | | | |
|---|---|---|---|---|---|
| Heterogeneous | | Homogeneous | | | |
| Brazing | Soldering | Fusion Welding | | Pressure Welding | |
| Brass, bronze | Pewter, lead, and low temperature metals | Arc welding | Torch welding de | Resistance welding | Forge welding |
|  |  | Electrode, MIG, MAG, and TIG | Oxy-fuel |  |  |

▼ In brazing a clear separation can be seen between the surfaces, while in welding there is a continuity of metal.

# Weldable Metals

Weldable metals are those metals that have the ability to be permanently joined by fusion. This characteristic lets us construct objects using the different welding techniques; however, not all metals have the same propensity to be welded. This depends on factors like the coefficient of expansion, fluidity when melted, thermal conductivity, grade of purity, and melting point, for both the base metal and the filler rods or solder. Such factors determine the most appropriate process for joining metals of different kinds. For example, when brazing copper, which has a thermal conductivity ten times greater than carbon steel, very powerful heat sources must be used and the pieces should often be preheated. The high thermal conductivity of copper makes it difficult to localize the heat required for melting the edges and making a joint.

The melting point is also related to the ease with which they can be welded. Pure metals melt at a specific temperature, while alloys do not have a fixed temperature, since they are composed of various metals and are said to have a **melting range**. This means that an alloy that has a range between 1,562°

and 1,742°F (850° and 950°C) will begin to melt at 1,562°F (850°C) but is not totally melted until reaching 1,742° (950°). The clearest case is that of brass, an alloy of copper and zinc. Zinc melts at 788°F (420°C) and begins to boil at 1,652°F (900°C). Brass melts at a range of 1,562°F to 1,832°F (850° to 1,000°C), according to its composition, and at these high temperatures part of the zinc will begin to boil and burn off. Because of this, a brass weld line will have less zinc and its original properties will be modified.

Another factor affecting the ability of metals to be welded is the level of oxidation. The contact between metals and the oxygen in the air creates a layer of oxide that makes metal joining processes difficult. An example of this can be seen when aluminum and its alloys are welded. In contact with the air, aluminum generates a fine layer of oxide called alumina. This oxide melts between 2,192° and 3,632°F (1,200° and 2,000°C), much higher than the metal itself which melts at 1,220°F (660°C), and this impedes the union between the base metal and the welding rod.

To avoid problems joining metals due to oxidation, chemical solutions called pickles

or mechanical surface grinders are used to clean the areas that are to be joined.

It is also a good idea to use fluxes like borax. This product acts as a de-oxidizer and keeps oxides from forming during welding or soldering, while controlling the melted material by reducing its fluidity.

▲ Fluxes and pickles help avoid and eliminate the formation of oxides during welding, brazing, and soldering operations.

# Notes on Electricity

Electricity is one of the most widely used sources of energy in the welding process. In fusion welding it produces the electric arc, and in resistance welding it creates the heat using the Joule effect. It is also used in soft soldering with the electric soldering irons. It is therefore important to know some terms from the field of electricity that are often used in welding technology.

An electric current, simply put, is the movement of electrons between the poles of a circuit. When it always circulates in the same direction, from the negative pole to the positive, we call it **direct current (DC)**. The welding equipment that uses it has a positive terminal and a negative one, and the current originates in a rectifier that changes the supply. In the other kind, **alternating current (AC)**, the electrons circulate from the negative pole to the positive and vice versa, changing direction 50 or 60 times a second, depending on the country. This is the form the electric companies supply. The welding equipment that uses it has transformers, and there is no talk of polarity since it continually changes.

The single-phase alternating current has the shape of a sine wave, both in tension and in intensity, and varies with time. Each complete wave is called a cycle, and the number of cycles per second is called the frequency, which is measured in hertz (Hz). **Triple-phase** industrial alternating current is normally used in workshops. This consists of three single-phase alternating currents.

The **intensity (I)** of an electric current is the quantity of electrons that pass through a section of conductor per unit of time. The unit of current in the International System of Units is the **ampere (A)**.

Another essential concept is the tension or difference of potential between the poles, which is measured in **Volts (V)**. The electric companies supply 125, 220, and 380 V, the first two in single-phase alternating current and the last in triple-phase, at 50 or 60 Hz. But for other uses they can supply up to 25,000 V, and transport it with voltages that reach 400,000 V at great distances.

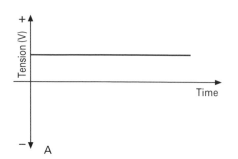

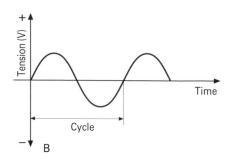

▲ A) In direct current the direction and the level of intensity of the current remain constant in time. B) In alternating current the direction of the intensity varies periodically.

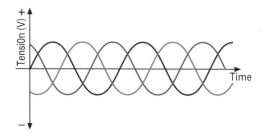

◄ The triple-phase alternating current consists of three single-phase alternating currents.

# Electric Arc

In these welding processes, the source of heat that melts the filler metal and the base metal is the electric arc. It is created by running electricity through a gas between two slightly separated conductors. One of them is the **electrode**, which is usually the introduced metal in various kinds of arc welding (except the TIG process), and the other is the **mass**, which is the base metal of the pieces that are to be joined. The gaseous zone crossed by the current, called the **plasma column**, can be the air that is ionized when the spark jumps and that surrounds the area that is to be welded, the vapors given off by the coating on the electrodes, or a protective gas used in some welding processes. A very high temperature is generated in this area that melts the metal at that point. The electric arc is the result of the transformation of the electric energy into heat and light, and reaches temperatures of about 10,800°F (6,000°C).

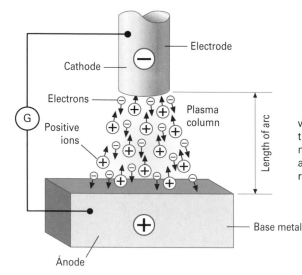

◄ The electrons move toward the positive terminal and the positive ions toward the negative terminal, generating a plasma column that can reach about 10,800°F (6,000°C).

## Energy Sources for Arc Welding

Electric companies supply alternating current of high intensity and low voltage. However, for welding we need electricity with low intensity and high voltage, between 50 and 1,500 amps and from 20 to 80 volts, enough to form a stable electric arc. The supplied current must be modified to be alternating or direct and have the required characteristics. This is commonly done with transformers, rectifiers, and inverters. Transformers modify the amount of voltage and the intensity of the alternating current. The rectifiers convert alternating current to direct current, while inverters convert direct current to alternating current.

Generally, the use of one or another energy source influences the sophistication of the welding process. The power source for MIG and MAG welding supplies direct current using a rectifier; but when welding with covered electrodes rectifiers, transformers or inverters can be used, based on the electrode being used or the vacuum tension that is required.

## The Weld Bead

The weld bead is the result of the metal introduced during the welding process. Two parts of it can be distinguished: the **face** and the **root**. Simple observation can distinguish between a good weld and a bad one. The presence of the root of the bead is proof that the weld sufficiently penetrated between the pieces, forming a good joint. On the other hand, a bead with excessive buildup on the surface in comparison with the thickness of the joined pieces usually indicates lack of penetration, and therefore a weak joint.

◄ Designs made with stainless steel weld beads on carbon steel sheet. The weld bead can be used as an independent graphic and aesthetic element, in addition to its use for joining pieces.

Furthermore, in the different welding processes the movement of the electrode, welding rod, and the torch also influences the structure of the bead. Because of this the bead can be straight or wavy. In the first case we are talking about a bead made with no oscillations. It is appropriate for thin pieces and it makes the weld quickly, reducing the amount of heat applied and the resulting deformations. In the second case, a side-to-side movement is used to ensure penetration in medium and thick edges. There are four distinct side-to-side movements: circular, for beads that do not require a great amount of added metal nor deep penetration; semicir-

cular, describing an arc or crescent that ensures very good fusion at the edges; zigzag, for wide beads and quickly filling joints; and weave beads, for a good-looking finish that covers fill beads.

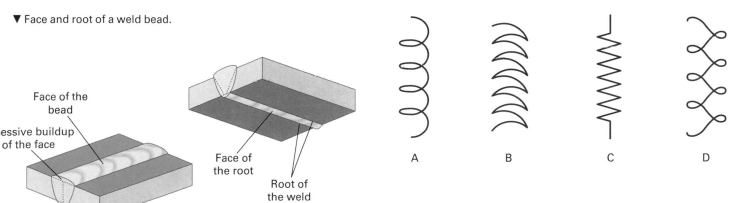

▼ Face and root of a weld bead.

Face of the bead

essive buildup of the face

Face of the root

Root of the weld

cessive buildup of the root

A    B    C    D

▲ Diagram of the side-to-side motions when making a weld bead: circular (A), semicircular (B), zigzag (C), weave (D).

## Types of Welded Joints

There are several ways of joining pieces with a weld bead. The one used depends on the welding process, the base metal that must be joined, and the welding equipment that is available. The shapes and sizes of the pieces that are to be welded also make a difference. For example, the recommended joint for soft soldering requires the greatest possible amount of contact between the pieces to encourage capillary action so the solder will flow into the joint and acquire the most strength. However, to make a weld bead without added material, the edges that are to be joined must be in close contact so that each piece will contribute some of the metal that will make the joint possible.

The different joints are known as the butt joint, corner joint, T-joint, and lap joint. These names describe the positions of the pieces that are welded to each other. The butt joint and corner joint are the most common in cases where extra metal is not needed, like in oxyacetylene welding or TIG welding. The lap joint is often used when using soft solder, hard solder, and resistance welding.

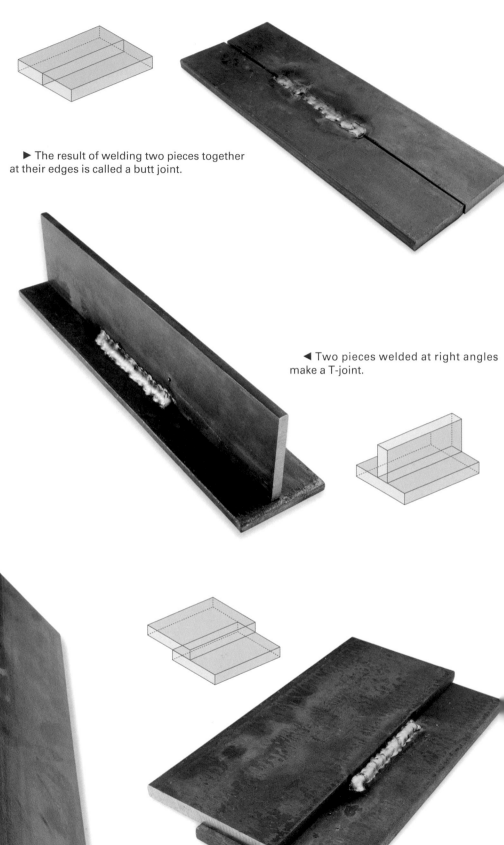

► The result of welding two pieces together at their edges is called a butt joint.

◄ Two pieces welded at right angles make a T-joint.

► Two versions of the corner joint.

▲ Two pieces welded with a lap joint.

# Preparing the Edges

The edges and surfaces of pieces to be joined must be correctly prepared to ensure that the weld will be strong. This also facilitates the welding process. There are three distinct ways to do this according to the edges or surfaces that will be welded: straight edges, beveled edges, and raised edges.

When using a butt joint, the edges should be square to the surface of the piece. Generally, a separation is left between the pieces to allow the metal to flow in, at a distance that is approximately one-half the thickness of the metal edges, except when filler rods are not being used, in which case they should be in contact. This technique is used for pieces whose edges are no more than 0.20 inch (3 mm) thick; those with a greater thickness must have their edges beveled. The beveled edges should form an angle that varies according to the metal thickness, which will allow the weld to penetrate well and make a stronger joint. A V-shaped bevel is made on

metals that are 0.20 to 0.40 inch (5 to 10 mm) thick, each part shaped to a 45° angle with a mechanical disk grinder. The two ground edges together will form a 90° V-shape. A flat area is usually left on the edges to keep them from burning during the welding process. This is called the **face**.

When working with edges thicker than 0.40 inches (10 mm), a double bevel is used. This is just a V-shaped bevel made on both sides of the edge while maintaining the corresponding face.

Another possible preparation is that of raised edges. This consists of slightly bending the edges of the pieces to be welded so they will supply the metal required for welding, without the addition of any extra material. This is used for 0.040 inch (1 mm) thick edges and works very well for welding copper and brass. As we have said, this is for oxyacetylene welding without welding rod and for TIG.

# Welding Positions

Weld beads can be created in different positions: flat, angled, vertical ascending or descending, horizontal, and overhead. Whenever possible, it is best to place the pieces being welded in a flat position, since it is best for creating a good weld bead. As a rule, when welding overhead it is necessary to reduce the intensity of the flame by 10%, compared to flat welding, to counter the effect of gravity on the welding rod when it melts. When welding in **vertical**, the **descending** technique is applied with thin pieces, since the reduced ability of the weld to penetrate in this position keeps the pieces from becoming perforated. However, the **ascending** vertical weld is appropriate for a thickness greater than 0.25 inch (6 mm) because of its penetrating power.

► The different angles on the prepared edges for holding the weld bead: straight (A), beveled (B), double bevel (C), and raised (D).

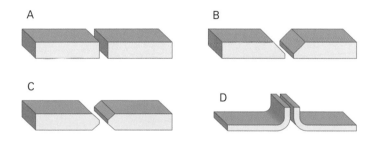

► It is necessary to make bevels on edges greater than 0.20 inch (3 mm) to ensure a strong joint.

▼ Different positions in the welding process: flat (A), angled (B), vertical ascending (C), vertical descending (D), horizontal (E), and overhead (F).

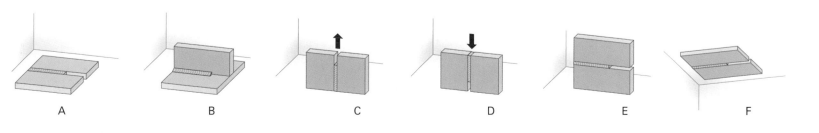

# Deformation of the Pieces

Heat causes the metal to expand in all welding processes. The volume of the pieces increases and then they return to their original state when they cool. This always happens when the heating and cooling take place uniformly in all the pieces; when it does not, part or all of the piece can become warped.

Usually, heat is applied locally in the areas where the weld bead is deposited. These heated areas are surrounded by cold areas that impede free expansion, which causes warpage and internal stresses in the pieces.

# Preventing Warping

There are several ways to counteract the deformations caused by welding. In the first place, it can be kept to a minimum by not depositing more metal in the joint than is necessary, since this will avoid excessive heating of the pieces. Next, the design of the edges should be symmetrical and have the minimum amount of bevel that is possible. The way the pieces are assembled, for example, holding the pieces with clamps or heavy objects will discourage the movement that causes internal stresses and the resulting warping; and deforming the pieces beforehand in the opposite direction can also work. The

welding procedure should also be done carefully, like making the welds quickly to reduce the amount of heat, or preheating the pieces before welding so they will not cool too quickly, allowing them to adapt to the changes in volume, especially when working with very thick pieces. Other techniques are making symmetrical weld beads, so that each bead will counteract the deformation caused by the previous one, and finally, the order of the welds, that is, the sequence that is used when applying the welds. On long welded joints you can use the technique called back welding, which consists of compensating for the deformations by making small beads in the opposite direction as the welding advances.

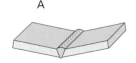

◀ Different kinds of deformation: angular, in a butt joint (A); longitudinal contraction (B); angular in a T-joint (C).

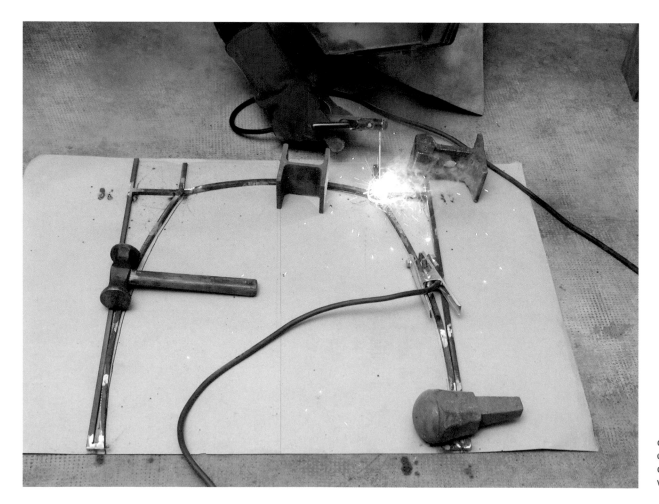

◀ Placing heavy objects on the pieces can keep them from deforming during welding.

You can also help reduce deformations by alternating evenly spaced beads, welding them in the opposite direction ahead of the advancing welding.

Even after taking all these precautions, you cannot always avoid stressing and warping the metal. Other ways of dealing with these deformations are based on heat treatments applied after the welding. It is a matter of uniformly or locally heating the pieces and making them cool slowly.

▲ A weld bead made in an open beveled angle creates a more pronounced deformation than one made in a smaller beveled angle.

▼ The welding sequences for back welding (A), and alternating weld beads (B).

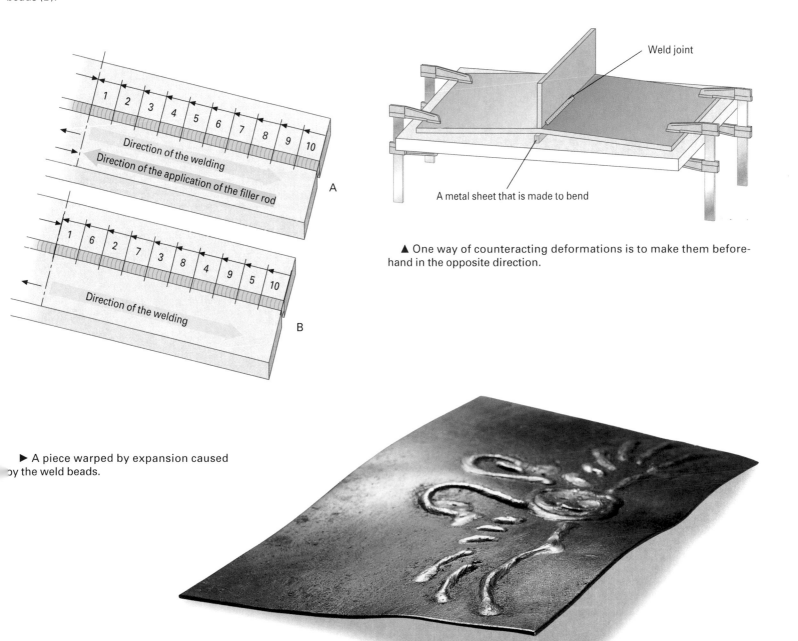

Direction of the welding

Direction of the application of the filler rod

A

Direction of the welding

B

Weld joint

A metal sheet that is made to bend

▲ One way of counteracting deformations is to make them beforehand in the opposite direction.

▶ A piece warped by expansion caused by the weld beads.

# Welding with Coated Electrodes

In welding with coated electrodes, the fusion of the metal, including both the welding rods and the base metal, is produced by the heat that is generated by an electric arc that is established between the end of the coated electrode and the base metal of the pieces being welded.

Welding with coated electrodes requires much practice, because it is necessary to control several parameters of welding at the same time. On the other hand, the required equipment is quite easy and inexpensive to acquire, and it is portable. It can be used to weld a great variety of metals thicker than 0.060 (1.5 mm) thick. Metals with a low melting point like lead, pewter, and zinc and their alloys cannot be welded using this method because of the high temperature involved. But it can be used for ferrous metals (carbon steel, alloys, stainless steel, and cast iron) and some nonferrous (aluminum, copper, nickel, and their alloys).

## The Coated Electrode

This is the part that establishes the electric arc, protects the molten bead, and becomes the added material. It consists of a metal wire called the **core**, covered with a compound of different chemical substances. The metal of the rod is made of various ferrous and nonferrous materials, depending on the base metal that is to be welded. The **coating** has the function of creating the arc and forming the gases that protect the bead so that the oxygen and nitrogen in the air do not reach it. It also forms a coating that covers the weld bead to impede the harsh cooling that could cause cracks, and continues to keep the bead from oxidizing and developing pores in its interior that would weaken it.

There are five basic types of carbon steel electrodes, depending on the coating: titanium dioxide, basic, cellulose, acidic, and oxidizing. The most common is the titanium dioxide electrode, which can be used with alternating or direct current, in the latter case attaching it to the negative pole. Also, the titanium dioxide rod will weld in all positions (flat, vertical, horizontal, and overhead) and produces a stable and soft arc that is easy to control. It also creates a dense slag that is uniformly distributed along the weld bead.

The other kinds of electrodes possess special characteristics that are complicated to use and they are recommended for special welding work done by professionals.

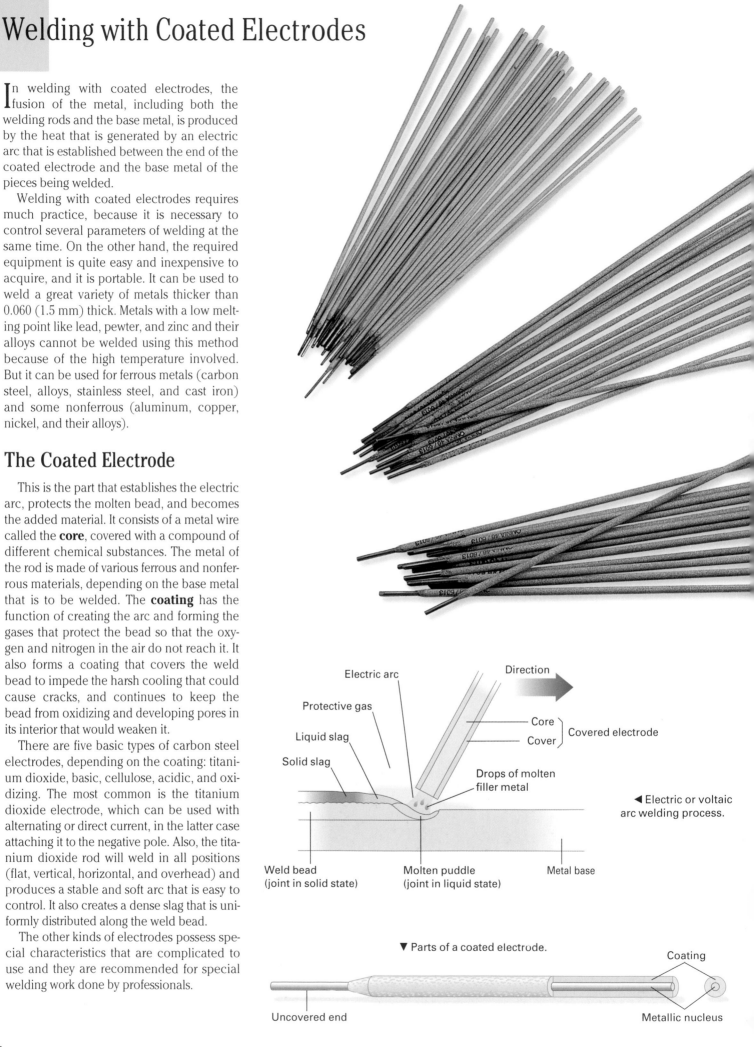

Electric arc

Direction

Protective gas

Liquid slag

Solid slag

Core ⎱ Covered electrode
Cover ⎰

Drops of molten filler metal

◄ Electric or voltaic arc welding process.

Weld bead (joint in solid state)

Molten puddle (joint in liquid state)

Metal base

▼ Parts of a coated electrode.

Coating

Uncovered end

Metallic nucleus

◄ Electrodes of different lengths and widths.

## Characteristics of the Electrode

Electrodes are normally 6, 8, 10, 12, 14, and 18 inches (150, 200, 250, 300, 350, and 450 mm) in length, according to the diameter of the core. This diameter is also standardized, the most common being 0.06, 0.08, 0.10, 0.14, and 0.16 inches (1.6, 2, 2.5, 3.25, and 4 mm).

The diameter of the electrode is selected according to the thickness of the pieces being joined. One that is too large would create too much heat and burn through the material at the area of the weld; on the other hand, a very small size would mean using more electrodes and adding more heat over more time, which would cause warping.

## Electrode Codes

To ensure the uniformity of electrodes made by different manufacturers, the AWS (American Welding Society) and the ASTM (American Society for Testing of Materials) established a series of norms and require-ments for their classification, and designated a code of letters and numbers to indicate their welding characteristics. This code indicates the current (alternating or direct) that can be used, the welding positions it will allow, the type of metal, and the amount of its tensile strength. It consists of a letter, called a prefix, followed by four numbers. For example, the prefix E indicates that it is an electrode for electric voltaic arc welding. The first two numbers indicate the tensile strength in thousands of pounds per square inch (psi). So the number 60 indicates that the deposited material will resist a pressure of at least 60,000 psi, and 100,000 psi is equivalent to 70 kg/cm$^2$. The third number indicates the welding positions that the electrode will allow. The number 1 indicates that it will weld in all positions, a 2 that it should only be used for flat and horizontal welding, and a 3 that it should only be used flat. Finally, the fourth number determines the specific characteristics of the electrode, like the coating, the electric requirements, and the penetrating strength; these values range from 0 to 8.

▼ The part of the electrode that is not covered by the protective cover should be held between the jaws of the stinger, or electrode holder.

OMNIA 46 / 6013

▲ In practice, some electrodes have only the four numbers that indicate their characteristics. In this case, the code follows the brand and the forward slash. It shows that the tensile strength of the material is 60,000 psi (or 43 kg/cm$^2$), that it can be used for welding in all positions, and finally, the 3 indicates that the coating is a titanium dioxide base with potassium salts that can be used with direct current at either polarity or with alternating current, and that it will deposit a bead of medium quality with little penetrating strength.

# Guidelines for Welding

When making a weld with coated electrodes, we must observe several important guidelines that influence its quality.

The **diameter** of the electrode should be selected based on the thickness of the material, the joint, and the position of the weld. Thus, in the overhead, horizontal, and vertical positions thick electrodes should be avoided so the added metal will not drip because of gravity. In general, electrodes of small diameter should be used for thin pieces, and whenever we wish to avoid overheating the pieces.

The **intensity** of the welding current is related to the depth of the weld in the base metal and depends on the diameter of the electrode and the position. The more intensity, the greater the penetration, but in excess it will produce ragged edges and increase the spattering of incandescent particles. The position of the welding also influences the intensity and the quality of the weld; so, in the flat and horizontal positions it should be more intense than in the overhead position to counteract the effect of gravity on the molten puddle. However, in the angled welding position the intensity should be much greater that that of the other positions to ensure that the molten metal enters sufficiently into the angle.

The **length of the arc** also influences the quality of the weld and is related to the intensity, the diameter, and type of electrode, and the welding position. In general, the length of the arc should equal the diameter of the electrode, and it is essential to maintain a constant distance during the entire process to avoid uneven penetration.

The **speed of advance** should cause the arc to progress a little ahead of the bead. Speed will keep the base metal from overheating and will produce fine weld beads that cool quickly. However, if it is excessive it will make it more difficult to remove the slag and cause pores to appear in the bead.

The **inclination** of the electrode in relation to the pieces influences the form and quality of the weld bead. An inadequate angle can favor the inclusion of slag inside the bead. The inclination is defined by two angles: one longitudinal, between the electrode and the weld bead, and the other lateral, between the electrode and the pieces being welded. These angles vary according to the welding position.

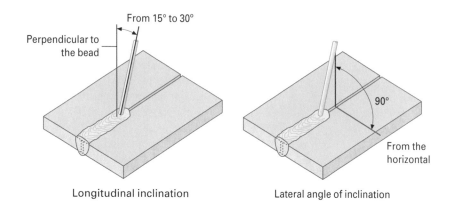

Longitudinal inclination

Lateral angle of inclination

▲ ▼ Approximate angles of the electrode in relation to the piece and the weld bead for different welding positions.

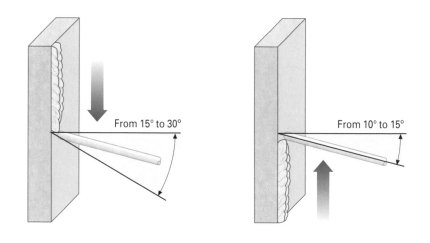

▲ To find out if the welding intensity is correct, look for a hole in the shape of a keyhole at the end of the weld bead. This should not be very large, which would indicate excessive intensity. In this picture we can see the size of a hole at the end of the weld bead that indicates the correct intensity.

# Striking the Arc

Striking the arc is lighting the electrode by causing a short circuit between it and the piece that is connected to the mass, to establish the electric arc to begin soldering.

Striking consists of lightly tapping the point of the electrode on the piece where the weld is to start and immediately pulling it back to a distance equal to the diameter of the electrode, starting the electric arc. Another way to fire the arc consists of making a movement with the end of the electrode on the piece as if you were striking a match.

Besides the technique used to fire the arc, it is important to immediately raise the electrode to the correct height to establish the arc; if you do not, it will adhere to the piece and quickly turn red hot because of the current flowing through it. In this case, quickly remove it by pulling the electrode holder, or if this does not work, releasing the electrode from the holder. Both operations are done without removing the welding helmet so that the intense light will not damage the eyes.

After the electric arc has been established, begin welding using the correct speed, intensity, electrode inclination, and length of arc. When all this is correct, a noise is created that is characteristic of the welding process, similar to the sizzling of hot oil in a frying pan.

▼ Two ways of striking an arc: lightly touching the end of an electrode against the piece (A), and scraping the end as if you were striking a match (B).

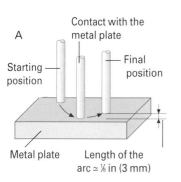

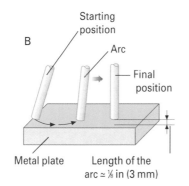

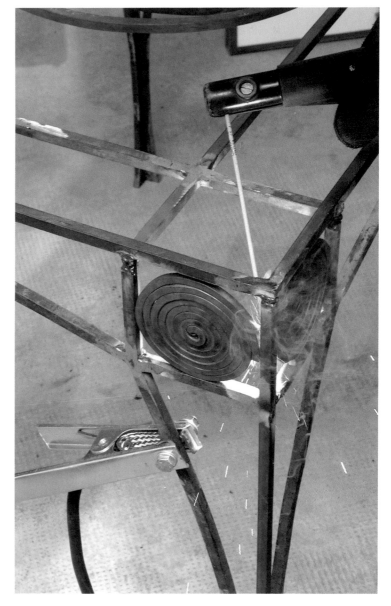

▲ The ground clamp is attached to the piece that is being welded, so that the circuit is closed when the electrode is in contact with the piece.

◄ Slag after the welding process and after it has solidified. When the slag is not controlled well in the molten puddle, it creates an inclusion in the weld bead. To avoid this you must try to keep the slag from moving into the molten puddle.

# Resistance Welding

Resistance welding makes use of the **Joule effect**, which is based on the fact that all conductors become hot when an electric current runs through them. The heat increases when the resistance of the conductor, the intensity, or the amount of time is increased.

In resistance welding, the heat required for melting the metal is produced by a high-intensity electric current that is made to travel through the joint in a short time, using two copper electrodes. In addition to the heat generated by the intensity, pressure must be applied to the area of the joint while the current is passing through it.

Generally, resistance welding equipment works with alternating single-phase and triple-phase current generated by a transformer and applied with two copper rods called **contact electrodes**. An external timer controls the amount of time the current is on, and a mechanical lever applies pressure with the electrodes at the point of the weld. The most common resistance welding process is **spot welding**, which is used to join pieces of carbon steel, stainless steel, aluminum, and copper.

## The Welding Process

When doing spot welding, it is important to use lap joints. The overlapping pieces are placed between two copper electrodes that apply pressure as the current passes through them. A dimple typical of this process is created at this moment. This is the point where the two metal pieces are melted and joined through the action of the pressure and the heat of the electricity. The spot weld appears only between the electrodes, and it is here where the resistance to the flow of the current is the greatest, and therefore where the most heat is produced.

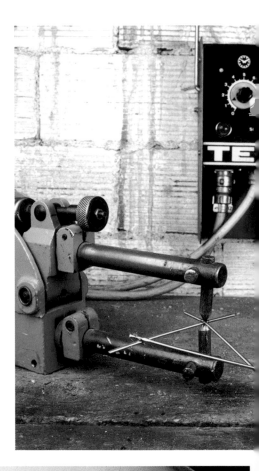

▶ This welding process creates the joint between two overlapping pieces.

▼ The characteristic marks made by spot welding.

▼ The sequence of steps in making a resistance spot weld. When the electrodes first come into contact with the pieces, and before any pressure applied to them, only between 10 and 30% of the section is in contact (A). When all the pressure is applied, the contact is greater (B). When the electric current begins to flow, the heat is centered in the area of contact (C). At this moment a dimple is formed and the heat increases (D). When the flow of electricity ends, the electrodes are left in contact to dissipate the heat (E). When the electrodes are raised, the mark is left on the surfaces of the pieces (F).

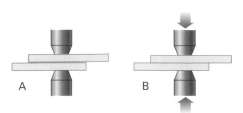

A          B

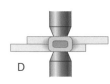

C

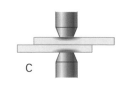

D

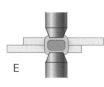

E

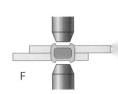

F

# Electric Arc Welding with Gas Shield

In some arc welding processes the molten puddle is protected by surrounding it with a gas while the welding takes place. The main function of this gas is to keep the puddle and the electrode from becoming contaminated or oxidizing. Air is mainly composed of nitrogen and oxygen, as well as water vapor. When the oxygen comes in contact with the molten puddle, it reacts with it to form oxides. At the same time, nitrogen, as well as the water, causes pores or small bubbles in the bead, which can cause internal cracks. All this produces weak and unreliable welds.

In addition to the protective function, the gas also helps stabilize the arc and makes the welding easier.

The gases used in these processes are classified in two groups: active and inert. **Active gases** are considered to be those that react chemically to the temperature of the arc. **Inert gases** are those that are always unaltered. Oxygen, carbon dioxide, nitrogen, and hydrogen belong to the first group, argon and helium to the second. They are also used in mixtures. In this case the mixture is inert when the gases in it are inert, and active when one of the gases in the mixture is active, regardless of the amount of active gas. An example of an active mixture of gases is that of argon and carbon dioxide, and one of inert gases is the mixture of argon and helium.

The three arc-welding processes with gas are called MIG, MAG, and TIG. MIG and MAG refer to the same welding process, which uses a consumable electrode, a solid metal wire without a coating used as a filler rod that is automatically supplied by the welding equipment. The difference between the two processes lies in the gas used. The letters MIG stand for **M**etal **I**nert **G**as, and the process uses inert gases, while MAG stands for **M**etal **A**ctive **G**as, a process that uses active gases. The letters TIG stand for **T**ungsten **I**nert **G**as because it uses a non-consumable tungsten electrode and generates an arc inside an inert gas shield, usually pure argon.

## The MIG and MAG Welding Processes

The welding processes generically referred to as MIG and MAG establish an electric arc between the electrode and the base metal surrounded by a protective gas shield, one inert and the other active. Furthermore, both processes use a small diameter continuous wire as an electrode, supplied in rolls weighing several pounds that are automatically fed through the welding machine. The continuous wire has no coating to protect it from melting and therefore does not create slag.

The protection is supplied by blowing a gas through the same tip as the wire electrode. The gas is released at a slightly higher pressure than that of the atmosphere, so it will displace the air surrounding the area where the arc is produced. This creates an environment where the arc is established, the filler metal is transferred, and where the edges of the metal are melted. In both cases, the person doing the welding holds and guides by hand the wand or torch that the electric current, the filler rod, and the gas travel through.

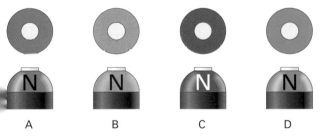

A  B  C  D

▲ In many countries metal cylinders for storing industrial gases are marked with colors for quick identification, in addition to the corresponding labels that list their characteristics. Here we only show the cylinders used for voltaic arc welding. According to the new European guidelines (EN 1089-3), the argon cylinder is painted black or dark gray and the top part is dark green (A), the carbon dioxide cylinder is black or dark gray with a gray top (B), and the helium cylinder is black or dark gray with a brown top (C). The cylinders that contain mixed gases are painted with a color that indicates the properties of the mixture. In the case of inert gases, like argon or helium with carbon dioxide, which are used as protectors, the color of the top is a luminous green (D). During the transition period for applying these guidelines, the new cylinders must be marked with an uppercase N. In the United States and Canada, this color coding system does not apply (CGA Publication PS-2).

▶ Diagram of the MIG and MAG processes.

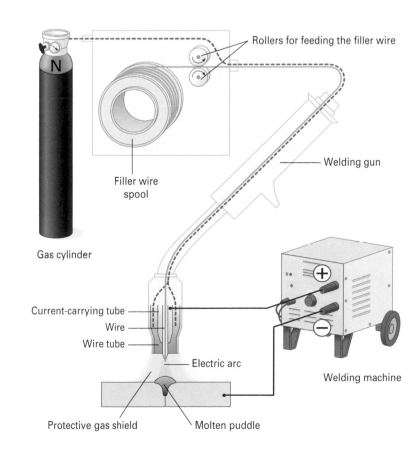

Rollers for feeding the filler wire

Filler wire spool

Welding gun

Gas cylinder

Current-carrying tube

Wire

Wire tube

Electric arc

Welding machine

Protective gas shield

Molten puddle

## Characteristics of the Weld

In continuous wire welding there are no interruptions since the electrode does not have to constantly be changed. This reduces the chances of defects where weld beads would overlap. Slag is not created either, making it easier to see and control the molten puddle and to eliminate defects caused by scale inclusions in the weld.

In addition, it reduces the heat in the pieces, reducing the area affected by the heat and creating less stress and warping due to expansion of the pieces. On the other hand, the protective gas limits the places where it can be used to those where there are no strong air currents that would displace the protective gas, letting the molten puddle come into contact with the air and cause flaws.

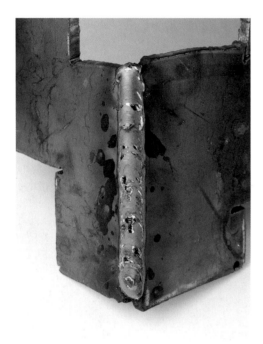

▲ A weld bead with no slag, typical of semi-automatic welding.

## Self-Regulation

The filler metal is automatically supplied at the correct speed in these welding processes. The wire must melt as soon as it appears so that the electric arc will stay constant. For this to take place, the wire feed and the intensity of the current must be adjusted before welding. In MIG and MAG welding machines the intensity automatically varies until it reaches a welding speed that matches the wire feed while not causing variations in the length of the arc. Increasing or decreasing the voltage changes the arc length.

The operator selects the speed of the wire feed and holds the torch a specific distance from the piece during the welding process. The machine supplies the correct current for melting the wire, while a greater or lesser length of electrode wire is fed out, based on whether the person doing the welding moves the torch closer or farther away from the piece.

## Transferring the Filler Metal

The electric arc heats the end of the filler wire until it melts. At this point the drop of metal moves to the molten puddle. The manner in which it separates from the wire, its size, and the way it is transferred to the molten puddle influence the development and the results of the welding operation. There are several ways of transporting the molten metal to the puddle: **short-circuit transport**, **globular transfer**, and **spray transfer**.

In the first case, the drop on the end of the wire is not incorporated into the molten puddle until coming into contact with it, at which moment a short circuit is created between the wire and the puddle. The end of a wire fed at a constant speed arrives at the puddle and the electric arc short circuits and then stops when the drop comes into contact with the puddle. When the drop is no longer part of the wire, the arc is reestablished.

The electric arc continually stops and starts, thus reducing the amount of heat transferred to the piece. This is enough heat for thin metal and difficult welding positions.

Globular transfer requires a greater amount of energy in the electric arc so the molten metal drops off before coming into contact with the puddle. Large drops are formed that do not always move toward the arc, which makes them difficult to control.

In spray transfer, innumerable miniscule drops of molten metal are formed, which cross through the arc and are deposited in the puddle. The arc is very stable, but the molten puddle is very hot, making it difficult to use this process in the overhead and horizontal positions. It is more appropriate for flat welding and thick pieces.

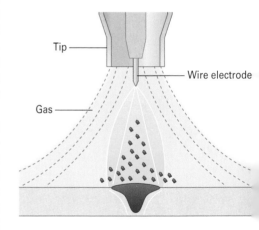

Tip

Wire electrode

Gas

▲ Spray transfer of the molten filler metal to the puddle.

▼ Transferring molten filler metal to the puddle by: short circuit (A), globular (B).

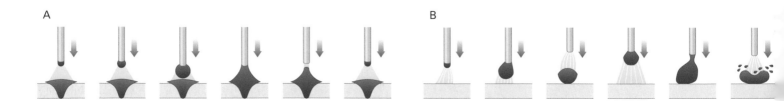

A

B

# Welding Parameters

There are four variables affecting welding that must be kept in mind with the semiautomatic welding processes. They are: the tension of the arc, the intensity of the current, the length of the end of the wire, and the speed of advance.

The **tension of the arc** influences its length; the greater the tension, the longer the arc. It also influences the penetration and the form of the weld bead. A small arc length produces narrow beads and good weld penetration. It also allows short-circuit transference combined with carbon dioxide as a protective gas.

The **intensity of the current** increases or decreases at the same time as the feed rate of the filler wire. The welding machine automatically supplies the intensity required for melting the wire. If the feed rate is increased, the welder will apply more heat, and therefore cause warping.

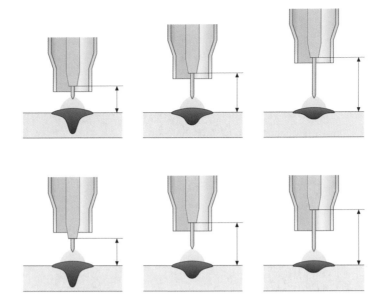

◄ This shows the effect of the length of the end of the wire on the weld, when the tension and the feed rate of the wire are constant.

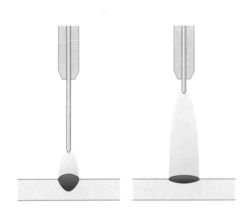

▲ The influence of the length of the arc in relation to tension on the form and penetration of the weld bead.

The **length of the end of the wire** refers to the part of the wire that is between the contact tube and the piece. When this distance is excessive, the number of projections increases and the penetration of the weld decreases. In addition, the protective gas will be insufficient. On the other hand, if it is too short, you run the risk of some projection adhering to the contact tube and restricting the advance of the wire.

The **speed of advance** of the weld along the joint affects the shape and size of the weld bead, the size of the puddle, and the amount of heat transferred to the pieces being welded. The slower the speed of advance, the greater the penetration of the weld.

# TIG Welding Process

The welding process generically called TIG (Tungsten Inert Gas) is based on an electric arc that supplies heat to the base metal and a non-melting electrode that generates a protective atmosphere of inert gas.

In this welding process the filler metal is added manually using metal rods. Sometimes, if the edges of the pieces are in contact, they can be welded without any filler metal, since the sides of the pieces being welded will melt and supply this.

The TIG welding process is appropriate for a large variety of metals. It produces uniform weld beads without slag and does not spatter incandescent metal. It can be used to solder thin material and is not recommended for joining pieces thicker than ¼ inch (6 mm), since this would not be efficient.

Generally, this process makes high-quality welds, as long as they are not made in places where there are strong air currents that could blow the protective gas shield away from the area of the weld bead.

◄ Here is a description of the TIG welding process. The electrode is not consumed, that is to say, it does not add its metal to the molten puddle. The metal is added with a hand-held filler rod. The job of the electrode is to establish and maintain the arc.

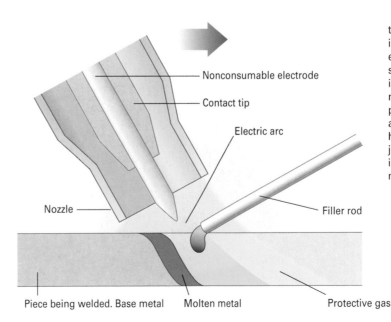

Nonconsumable electrode

Contact tip

Electric arc

Nozzle

Filler rod

Piece being welded. Base metal    Molten metal    Protective gas

97

# Current

Both direct and alternating currents are used in TIG welding. When using direct current, it is best to use direct polarity, that is, the electrode connected to the negative pole and the mass to the positive pole. This will keep the electrode from overheating. Welding machines incorporate a high frequency generator for welding with alternating current that helps establish and stabilize the arc. The high frequency source adds the tension required at the moment that the arc "goes out," twice per cycle, when there is no voltage.

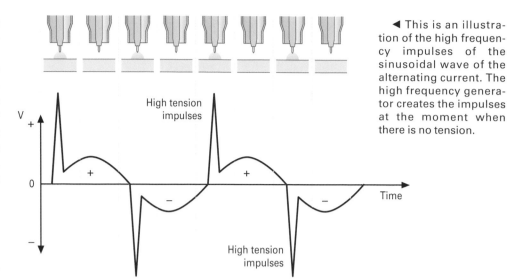

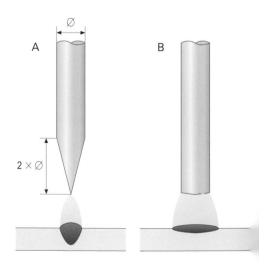

◄ This is an illustration of the high frequency impulses of the sinusoidal wave of the alternating current. The high frequency generator creates the impulses at the moment when there is no tension.

▼ Filler rods for welding carbon steel. They are applied manually by placing the end of the rod near the molten puddle inside the protective shield of the inert gas.

# Non-melting Electrodes

Non-melting electrodes for TIG welding are made from a metal with a very high melting point to keep the rod from being used up. **Tungsten** or **wolfram**, whose chemical symbol in the periodic table of elements is **W**, is the material used to make these electrodes.

Thorium or zirconium oxides are added to the tungsten to encourage the sparking and stability of the arc, in addition to making the electrode more resistant to the intensity of the current. For example, tungsten electrodes alloyed with thorium oxide have a melting point of approximately 7,232°F (4,000°C). It is often used for joining carbon steels, stainless steels, and copper.

Thorium is radioactive, but there are tungsten alloys with cerium and lanthanum that are not radioactive that encourage sparking and stability of the arc in the same way as thorium.

# Shaping the Point

Electrodes used for the TIG process must have a specially shaped point for each current to discourage an unstable arc. Generally, thin electrodes in relation to the thickness of the material being welded should be used whenever possible. The object is to center the arc to limit the molten puddle so that there will be good penetration and limited warping. For example, a correctly shaped electrode, whose point is twice as long as its diameter, produces a very stable arc concentrating the heat at one point and creating a good weld bead. However, a poorly shaped point will create an erratic, difficult to control arc with a wide molten puddle and little penetration. When grinding the point it is important to follow the direction of the fibers to encourage the creation of a stable arc and the concentration of the heat at one point.

▶ This shows the influence of the point on a tungsten electrode: the correct length forms a stable electric arc that localizes the heat and produces a good penetration of the weld bead (A); a poorly shaped point creates an erratic electric arc that makes a wide bead with little penetration.

▲ This is how the electrode should be held in relation to the rotation of the wheel when grinding the point.

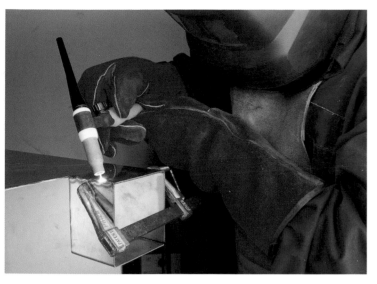

◀ Proper protective leather gloves and welding helmet should always be worn when welding.

▶ A nonconsumable electrode for TIG welding.

## Operating Technique

The joints must be correctly prepared to achieve good weld beads with the TIG process. For example, if the welding is done without filler rods (only in metal less than 0.125 inch (3 mm) thick), it is a good idea to use raised edges. In any case, both the base metal and the filler should be free of traces of paint, grease, or any residue to avoid contamination that will result in a faulty weld bead or that would cause the welding process to be uncomfortable.

▶ Diagram of striking an arc by scraping the electrode.

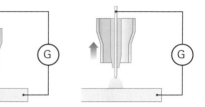

▶ Diagram of striking an arc using high frequency impulses.

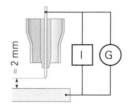

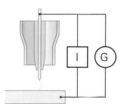

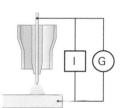

## Striking the Arc

There are two ways of striking an arc in the TIG welding process: one is simply lightly scraping the electrode across the base metal to which the ground clamp is attached. The disadvantage of this method is that it tends to damage the end of the electrode, making it difficult to control the electric arc. The electrode must be immediately pulled back to ⅛ inch (3 mm) above the base metal after striking.

The other method consists of using the high frequency current to generate the arc. In this case, it is not necessary to make contact between the electrode and the base metal, since the high frequency current will overcome the electrical resistance of the air at about ⅛ inch (3 mm) and generate an arc. A weld bead is established by simply maintaining the ⅛-inch distance from the base metal while advancing along the joints to be welded.

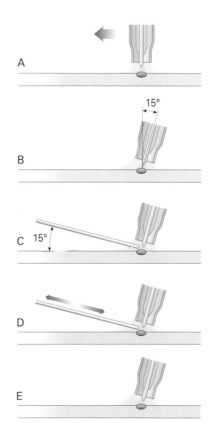

◀ The phases in the formation of a weld bead with filler rod. After striking the arc a molten puddle is created by making a slight circular motion with the electrode above the base metal (A). The electrode point is immediately moved along the side of the molten puddle at an angle of approximately 15° to the vertical (B). Then the filler rod is introduced inside the protective atmosphere near the puddle, at about a 15° angle to the horizontal and in front of the advance of the weld bead (C). The rod is moved back and forth, without leaving the protective gas atmosphere, to deposit molten material in the puddle and create the weld bead (D). When the bead is completed, it is a good idea to continue protecting it with the gas until it has completely solidified.

# Oxy-Fuel Welding

This process uses a flame resulting from the combustion of a gas with oxygen as an energy source for fusing metal. Technically a **carburizing gas** (the oxygen) is required to facilitate the burning of a **combustible gas** (the acetylene or propane). When the combustible gas is acetylene, the process is called **oxyacetylene welding**, and when propane is used, it is called **oxy-propane welding**. Welding heats the pieces that are to be joined until the areas in contact melt and produce a weld bead.

This can be done with or without added metal. When added metal is required, filler rods, usually of the same metal as the base, are used.

A disadvantage of oxy-fuel welding is that it creates a lot of heat in the pieces, causing warping and internal stresses. Furthermore, using oxygen causes the metal to oxidize, necessitating the use of deoxidizers when welding some metals like aluminum and alloys like brass. Gas welding is appropriate for thin metals and for heavy welding techniques with copper and brass.

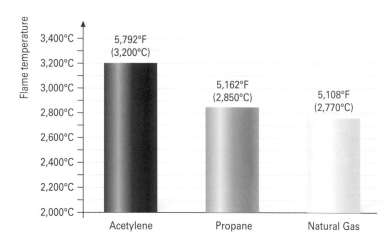

▲ Table comparing the temperatures obtained from the mixtures of oxygen with different combustible gases.

## Gases

Oxygen and acetylene are the most widely used gases. Combinations generally reach temperatures up to 5,792°F (3,200°C), while oxygen with propane produces lower temperatures, about 5,162°F (2,850°C). Natural gas can sometimes be used with oxygen, but it is less efficient.

## Safety Aspects

The cylinders containing the gases should always be kept upright and attached to the wall, or in a cart if necessary. Oil or grease should never be applied to the parts of the equipment. The welder's hands should also be kept free from grease when using them. The cylinders should never be bumped or exposed to high temperature. If they have any defect or damage, do not handle them and contact the supplier immediately.

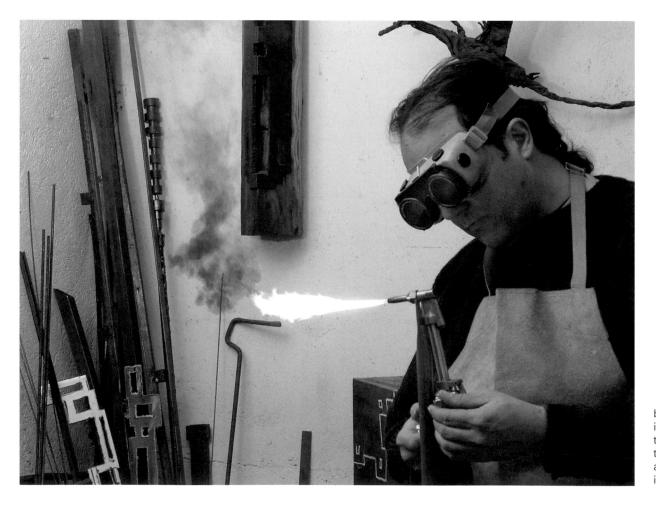

◀ When acetylene burns, it produces an intense and characteristic black smoke that leaves innumerable particles of soot in the air.

# The Flame

Two very different parts can be distinguished in a gas flame. One is the **inner cone**, with a blinding intense white color where the combustion of the acetylene and oxygen takes place; the other is the **envelope** that surrounds the cone and protects the molten puddle. There is a third part that is not easy to see, called the **working area**, located immediately after the inner cone, which has the highest temperature. A separation of ³⁄₃₂ to ³⁄₁₆ inches (2 to 5 mm) should be left between the cone and the molten puddle, according to the size of the flame.

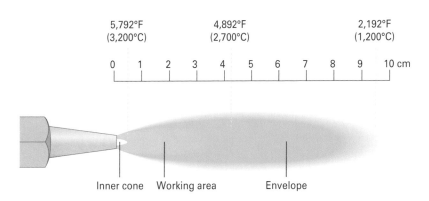

▲ The parts of the oxyacetylene flame and the relation between the temperature and the distance from the inner cone.

# Kinds of Flames

Three distinct oxyacetylene flames can be distinguished. A **neutral flame**, about 5,792°F (3,200°C), is made with equal amounts of oxygen and acetylene. It is the most commonly used for welding almost all metals because it will not alter their properties. A greater proportion of oxygen to acetylene will produce an **oxidizing flame**, used a lot for welding brass to avoid burning up the zinc in the alloy. And a **reduction flame** is produced when there is a greater proportion of acetylene than oxygen. It is used for welding aluminum since it creates less heat than the other flames.

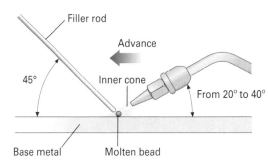

# Setting Up the Equipment

Before connecting the regulator to the gas cylinders it is a good idea to open the valves slightly. This will purge the bottle of any possible impurities. Regulators should not be exchanged with cylinders of different kinds of gas.

The regulator should be adjusted according to the diameter of the nozzle. The oxygen should usually be at a working pressure of between 28 and 43 psi (2 and 3 kg/cm²), while that of the acetylene should fall between 0.7 and 1.4 psi (50 and 100g/cm²). At no time should the acetylene have a pressure greater than 14 psi (1 kg/cm²).

◀ The relation of the angle between the base metal and the inner cone in the gas welding process: without filler rod (A), with filler rod (B).

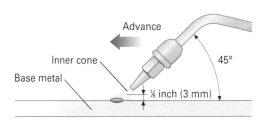

# Lighting the Torch

After opening the valves allowing the gas to pass from the cylinders, to the torch, the acetylene valve is opened first to light it. This is done with a striker or a match. The oxygen valve is then opened slowly, until the flame is neutral. A welding mask should be worn while doing this as protection against the intense light. To turn the torch off, the acetylene valve is closed first and then the oxygen.

▼ Characteristic look of a weld bead created by gas welding.

# Operating Technique

The inner cone of the flame should be held about ⅛ inch (3 mm) from the base metal to cause the edges that are to be joined to melt. The moment that the edges are fluid, a slight twisting motion is made with the torch to fuse them.

To make a weld without added metal, the molten bead is pushed using the pressure of the inner cone at a 45° angle to the seam.

When using a filler rod, the previously described procedure should be followed, varying the angle. In this case, the inner cone should be between 20° and 40°, and the welding rod at 45° to the bead.

# Soldering and Brazing

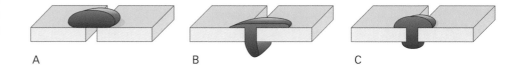

▲ Steel wool, solder, and flux used for the soldering technique.

◀ Alloys of copper-phosphorous (above) and copper-silver with flux coating and without (below) used for brazing copper. The coating on some products is a deoxidizer.

The soldering and brazing techniques are processes in which the base metal and the solder have different melting temperatures. Generally, in the soft soldering technique, the solder has a melting point lower than 797°F (425°C). In the brazing technique, the filler metal melts at more than 797°F (425°C).

These joints are made by melting only the added metal, which is spread through capillary action along the surfaces of the edges being joined. The edges being joined must be very close together for the capillary effect to work.

## Solder and Filler Metal

Both the brazing metal and the solder must have lower melting temperatures than the base metal and must be very fluid when in the liquid state to flow into the joint through capillary action.

The most widely used solders are alloys with a great amount of tin, whose melting point is 448°F (231°C). The most common is a 50% tin and 50% lead alloy, but tin-silver and tin-zinc alloys are also used.

Brass is the most commonly used material for brazing, although copper-phosphorous and copper-silver alloys are used. All of them are appropriate for joining ferrous and non-ferrous metals and alloys, except for aluminum, which must be brazed using aluminum-silicon alloys.

▼ This shows how solder will flow based on the temperature of the base metal: Base metal is too cold, the drop of solder does not flow well, causing a faulty joint (A). Base metal is too hot, the solder flows too much and creates a faulty joint (B). Correct temperature of the base metal, the solder flows well and a good joint is created between the pieces (C).

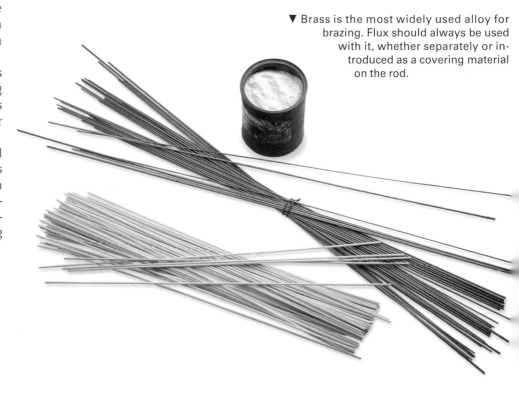

A         B         C

▼ Brass is the most widely used alloy for brazing. Flux should always be used with it, whether separately or introduced as a covering material on the rod.

# Fluxes

It is very important to use flux or deoxidizer for both brazing and soldering. Their main function is to prevent the metal from oxidizing at the moment it is being soldered. It also improves the flow of the solder across the surface of the base metal and helps control the working temperature. As it melts, it signals the moment for applying the solder.

Borax is the most important of the deoxidizers, being used in all soldering and brazing processes except when aluminum and its alloys are involved. It is a compound called sodium tetraborate hydrate and it melts at 1,400°F (760°C).

# Soldering and Brazing Procedures

The flame of a torch is used to heat the pieces that are to be joined by brazing or soldering. A neutral oxyacetylene flame is used for brazing. Conventional welding techniques or capillary action can be used; in the latter, the edges being joined must be overlapped.

When using either approach, the metal pieces should be heated using the working area of the flame, without holding the cone too close. When the flux melts, it is an indication that the solder or filler metal can be applied, but if you notice that it forms drops that roll across the surface, it means that the base metal is not hot enough. After the solder or filler has been applied correctly, the cone of the flame should be pointed at the solder or filler metal and not the edges.

The most common method used for soldering is capillary action. An overlapping joint should be used to ensure a strong joint. The pieces, which should be clean and have the correct flux, are heated with the flame of a gas torch until the flux indicates the correct temperature and the solder can be applied. It will immediately melt along the edges that are touching and fill them to create the joint. An electric soldering iron can also be used, although this is not advised for large pieces and for metals that conduct heat very well.

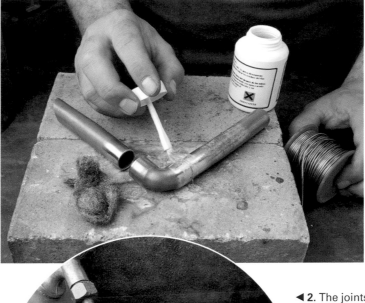

◀ **1.** The surfaces that are to be joined must be cleaned with steel wool before applying the flux.

◀ **2.** The joints are immediately heated with a gas torch flame. The flux indicates the correct temperature for applying the solder by a change in color.

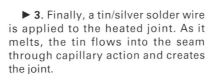

▶ **3.** Finally, a tin/silver solder wire is applied to the heated joint. As it melts, the tin flows into the seam through capillary action and creates the joint.

▶ A work made by brazing copper to steel using brass as the filler metal. Ares, *Cargol i famella*, 1997.

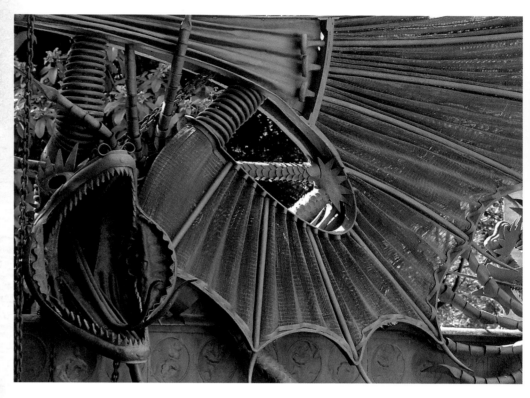

*Gallery*

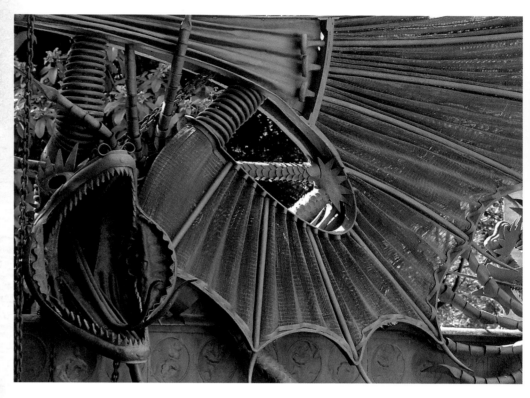

▲ Antoni Gaudí, *Winged Dragon*, 1885. Detail of a 197 × 138 × 12-inch (500 × 350 × 30-cm) forged iron door constructed by the Vallet i Piquer workshop, designed by the ingenious architect for the stables of the Güell farm in the Pedralbes neighborhood of Barcelona.

◀ Pablo Gargallo, *Weathervane*, 1930. Hammered copper sheet, 27½ × 16½ inches (70 × 42 cm). Museu Cau Ferrat (Sitges, Spain). Photo Rocco Ricci.

▶ Julio González, *Madame Cactus (Homme Cactus II)*, 1929. Forged and soldered iron, 26 × 11 × 6.10 inches (65.5 × 27.5 × 15.5 cm).

▼ Ares, *Trenca el Silenci la Claror Inesperada d'un Raig de Lluna*, 2003. Laser-cut iron sheet, 86 × 10 × 10 inches (220 × 25 × 25 cm).

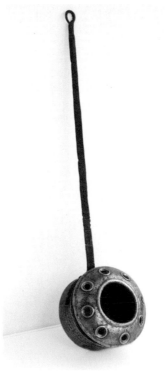

◀ Popular crafts, *Bed Warmer*, 1890. Forged iron and hammered copper, 43 × 12 × 8 inches (110 × 30 × 20 cm).

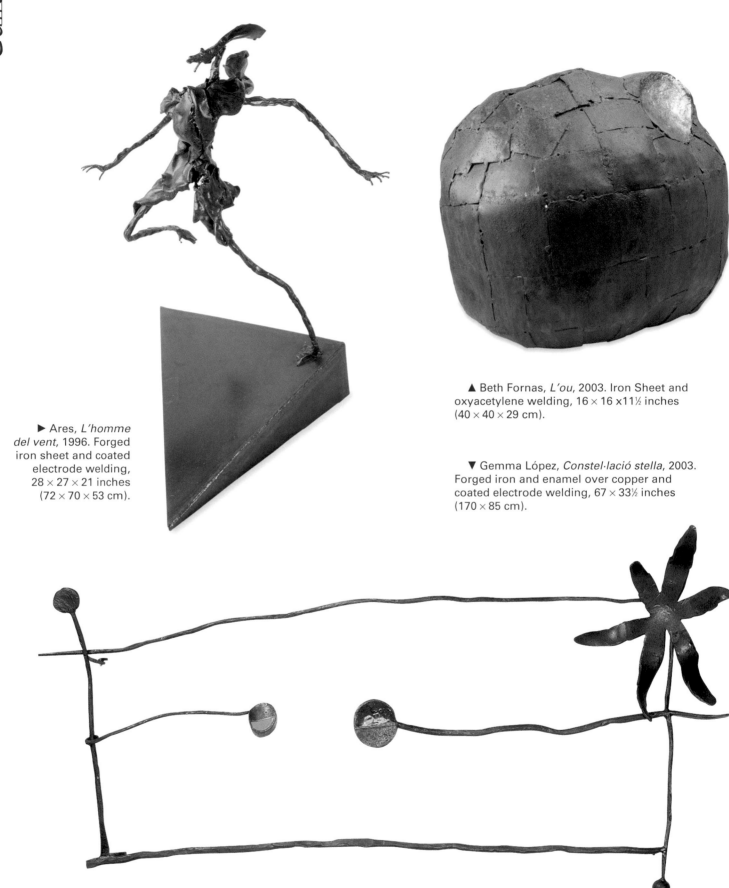

▶ Ares, *L'homme del vent*, 1996. Forged iron sheet and coated electrode welding, 28 × 27 × 21 inches (72 × 70 × 53 cm).

▲ Beth Fornas, *L'ou*, 2003. Iron Sheet and oxyacetylene welding, 16 × 16 x11½ inches (40 × 40 × 29 cm).

▼ Gemma López, *Constel·lació stella*, 2003. Forged iron and enamel over copper and coated electrode welding, 67 × 33½ inches (170 × 85 cm).

► Ares, *El Salt de l'angel*, 1997. Iron sheet and oxyacetylene welding, 138 × 43 × 59 inches (350 × 110 × 150 cm).

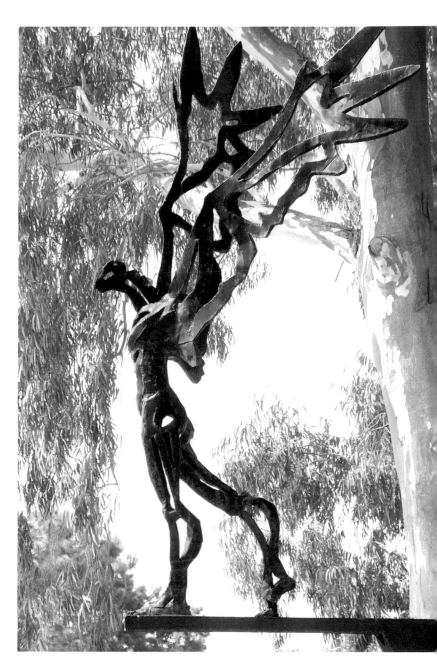

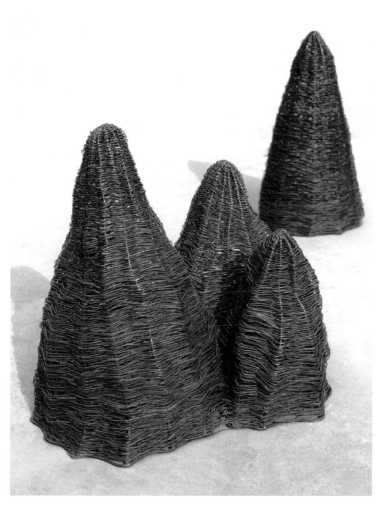

▲ Matilde Grau, *Paisatge Teixit*, 2000. Iron, 20 × 59 × 20 inches (50 × 150 × 50 cm).

► Marta Martínez, *Paso*, 2003. Pierced iron sheet and oxyacetylene welding, 32 × 14½ × 4 inches (81 × 37 × 10 cm).

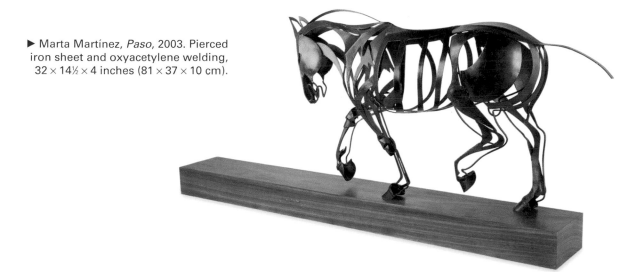

► Josep Cerdá,
*Sallammbo*, 1992.
Iron with patina,
87 × 24 × 18 inches
(220 × 60 × 45 cm).

►► Another view
of the sculpture by
Josep Cerdá with
the doors open.

▲ Ares, *Al Crit Lliure del Vent*, 2000. Forged
iron and wood, 44 × 12 × 6 inches (110 × 30 × 15

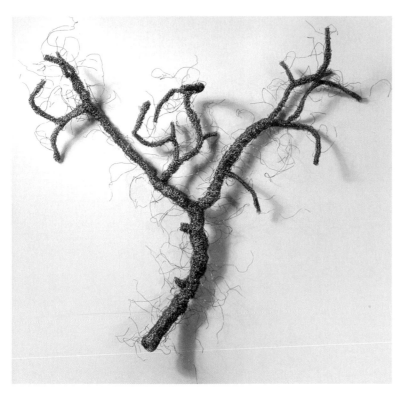

▲ Matilde Grau, *Branca Teixida I*, 2003.
Woven brass (various sizes).

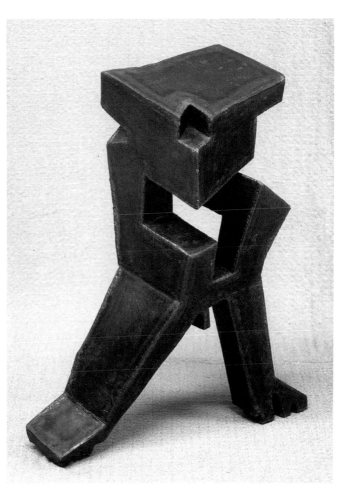

► Ares, *Noli me Tangere*, 1996. Iron sheet and
oxyacetylene welding, 25 × 12 × 20 inches (90 × 30 × 50

► Eduardo
Chillida, *Ikaraundi,*
1957, Chillida Leku
(Hernani, Spain).
Forged iron,
13 × 27 × 60 inches
(32 × 68 × 150 cm).

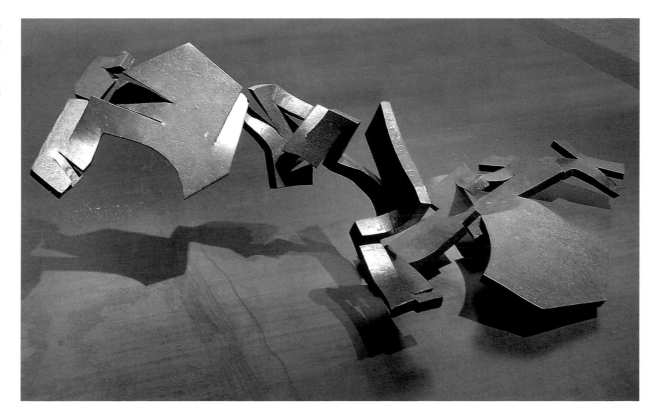

ow that you have learned about using tools and machines and have gone over the different metal working techniques, we are going to graphically demonstrate some of the processes for fabricating metal objects, from the very functional to the most sculptural. On the following pages we show how to make these objects, step by step, using the different techniques that have been explained. The object of this section is to clearly demonstrate how the pieces are constructed using a combination of the different techniques, and in some cases different metals. There are many ways to approach a project—these are only a small sampling. These approaches are an example of the wide range of creative and functional possibilities of the materials and some of the basic techniques for transforming them. We are not offering models to be copied, but a series of steps so the readers can develop their own personal creative processes.

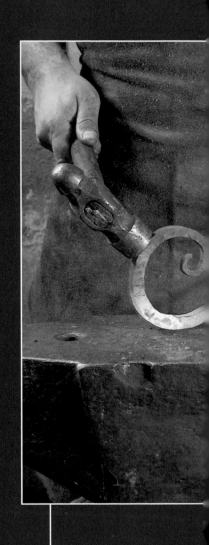

# Step by
# *Step*

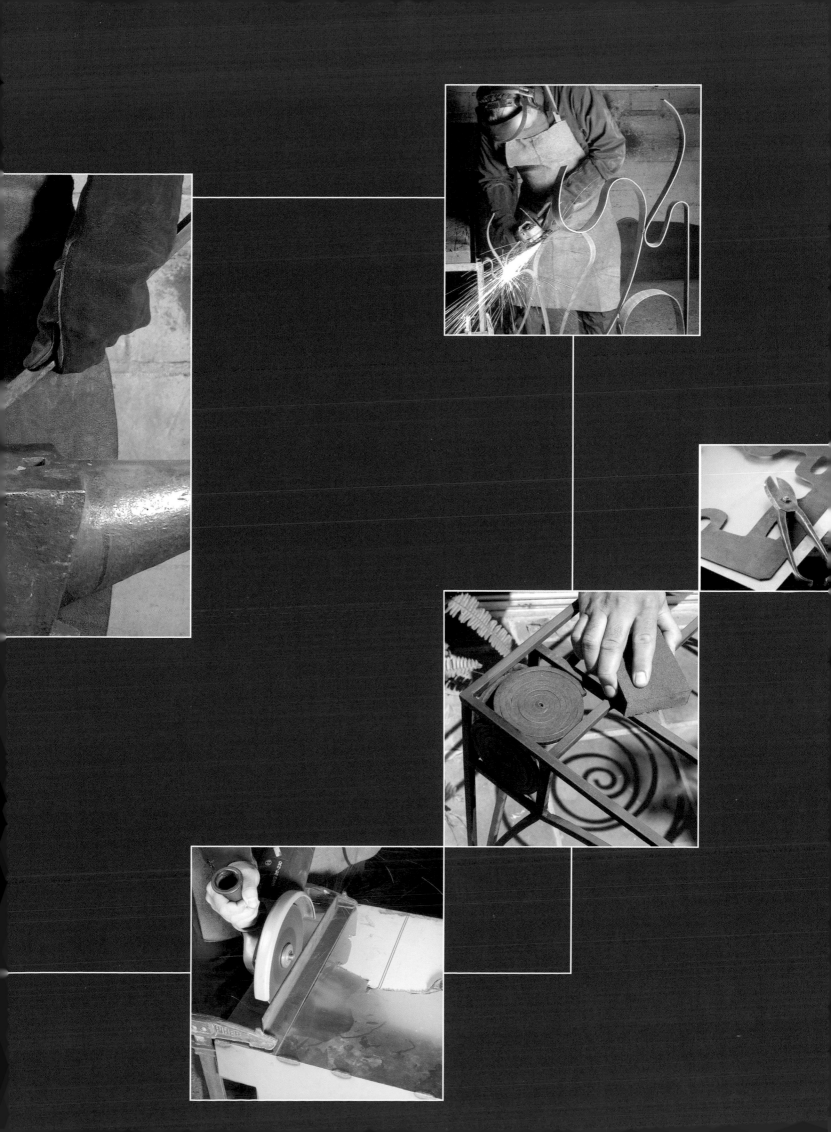

# Constructing a Trunk

*T*wo materials are combined in the construction of the following trunk: steel and aluminum. The techniques used are plasma cutting and joining with rivets, which, at the end of the process, will result in a creative and practical chest.

The fabrication of the trunk consists of four phases: in the first, the frame is constructed with steel angles; in the second, the hinges are made for the lid; in the third, the borders for decorating the chest are cut out; and finally, in the fourth phase, the steel and aluminum panels are attached to the frame to conclude the assembly of the trunk.

▲ **1.** A drawing on paper helps to finalize the idea and estimate the materials that are required.

**Making the Frame of the Trunk**

▲ **2.** Following the previous sketch, the steel angles are cut to the required sizes with 45° angles on the ends.

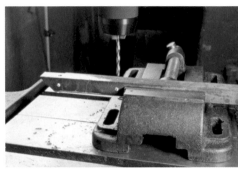

▲ **3.** Next, holes are drilled in the steel angles using a drill press. These holes were designed to be equidistant and equal in all the angles, and will be used later for inserting the rivets. This operation is carried out before assembling the structure, since it is easier to handle the individual steel angle parts now than to work with the completed frame later.

▼ **4.** The edges of the mitered steel angles are beveled with a handheld grinder where the weld will be made. The beveled area will hold the weld bead and ensure a solid joint at the corners. These are tack welded to hold them together while holding them at 90° in a corner vise so the steel parts will form a perfect right angle.

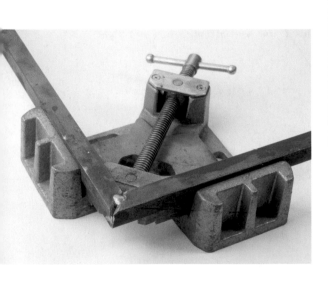

▲ **5.** After all the angles have been tack welded together, all the joints are welded with continuous wire, also known as MIG welding. It is important to wear protective clothing and equipment when doing this.

▲ **6.** To finish the construction of the frame, the welds are smoothed with a grinder to even out the surfaces of the angle iron.

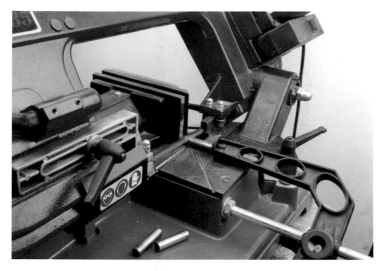

## Constructing the Hinges

◄ **7.** We select a tube approximately 0.40 inch (1 cm) in diameter whose inside diameter accommodates a round rod that is slightly smaller, and cut four pieces about 2 inches (5 cm) long on a band saw to use for making the hinges. The stop is used on the saw to ensure that all four pieces are of the same length. Then two pieces of the rod are cut twice as long as the tubes, that is, 4 inches (10 cm).

▶ **8.** Two tubes and a rod are used to make each hinge. A hole is drilled in one of the tubes, where it is welded after inserting the rod and lining it up with the end; then the weld is smoothed with the grinder.

▶ **9.** The piece with the rod is then welded to the base of the framework and the other to the lid of the trunk, carefully aligning the two structures. The hinge parts with the rods should both face the same direction so the lid can be attached later.

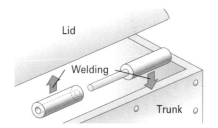

Lid

Welding

Trunk

▲ **10.** The two structures that form the base and the lid of the trunk should be aligned and held in place with clamps when welding the hinges. They are placed on the line separating the lid and the base and then welded to them. The second hinge is then welded at the same distance from the opposite end to match the first one.

▶ **11.** The framework of the trunk is painted with black polyurethane paint, since at this stage the entire interior surface can be reached. Since this object is meant for use in interior spaces, it is not necessary to apply a coat of primer before painting it.

## Creating the Panel Border

▼ **12.** To create the panel border, the design is traced from a template cut from of a sheet of chipboard sized to fit the framework of the trunk.

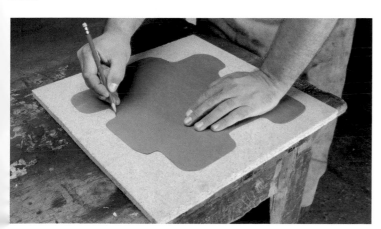

◄ **13.** Here the template is being made. First, holes are drilled at each corner of the drawing. These allow the blade of the jigsaw to be inserted so the cutting can be done as comfortably as possible.

◀ **14.** Next, the edges of the opening are smoothed with a wood file. It is important that the surface that will be in contact with the plasma torch be as smooth as possible.

▼ **15.** The template is placed on a piece of sheet metal, in this case the same size as the ends of the trunk, and it is held in place with locking pliers. Then the outline of the border is cut out with the plasma machine, carefully following the template. It is a good idea to wear safety glasses and an apron for this step.

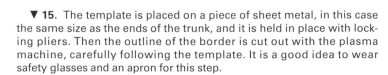

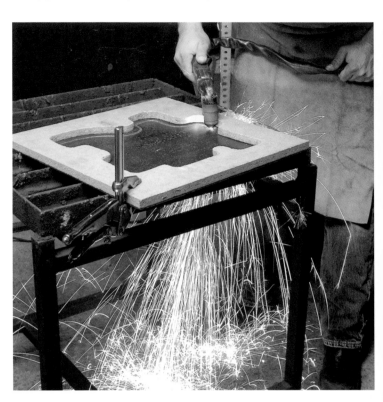

◀ **16.** The plasma cut metal compared with the template.

▼ **17.** After making sure that the cutout is correct, the burrs made by the plasma cutter are removed using a power grinder with a grinding wheel. A transparent protective face shield should be used for this step.

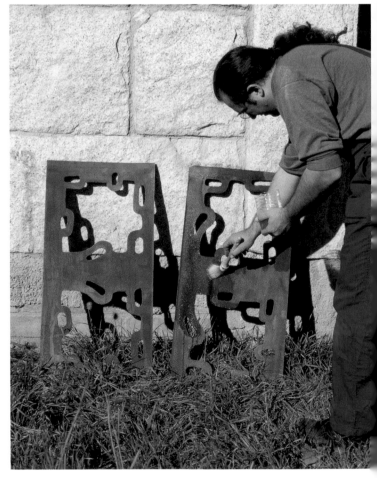

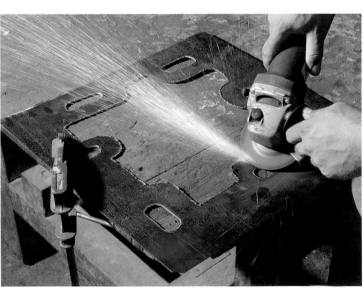

▶ **18.** After repeating the same procedure for the other sides of the trunk—another small one and three long ones—the panels are oxidized with a saltwater solution. This is made by mixing a container of water with a heaping tablespoon of table salt. The solution is applied with a brush, but it could also be sprayed on. The oxidizing process will be accelerated if it is done outdoors.

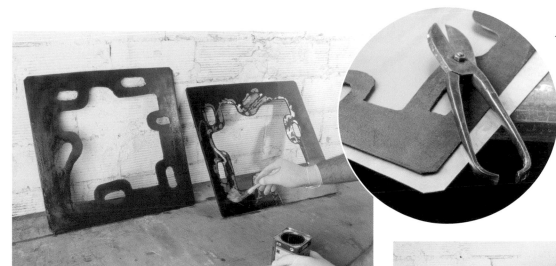

◀ **20.** Next, six pieces of aluminum sheet are cut to the same size as the steel panels. The corners of the steel and aluminum panels are trimmed off with tin snips. This will allow them to fit the frame structure, which has some welds on the inside corners of the steel angles that are difficult to eliminate.

▲ **19.** A protective varnish treatment is applied to the entire surface of each steel panel before attaching them to the framework with rivets.

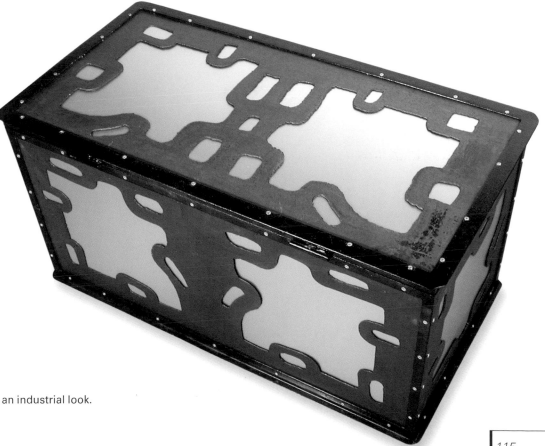

▶ **21.** To attach the panels to the framework, they are first held in place with clamps and holes are drilled in them with a power drill. These holes must line up with those in the steel framework. Be very careful when drilling the aluminum because it will scratch very easily.

▲ **22.** The steel and aluminum panels are riveted to the framework of the trunk and to the lid using a pop riveter. Finally, the lid is put in place.

▶ **23.** Here is the finished trunk. The rivets give it an industrial look.

# Constructing a Wrought Iron Gate

*N*ext we will fabricate a gate using steel strips. The important part of this exercise is seeing the potential for twisting, forming, and folding some metal shapes without having to treat them first with high temperatures. We also make use of a full-size drawing as a guide for making the gate. Very graceful forms can be made using scroll wrenches with the help of jigs for leverage. To avoid working with excessively long strips, we will make the gate with pieces and later weld them together using the coated electrode process. The design of this gate is inspired by the Catalan Modernist tradition.

► **1.** It is a good idea to make several sketches of the gate to find the one that best matches the original idea and the place it is designed for.

◄ **2.** The gate idea is transferred to paper, in this case as a pencil drawing.

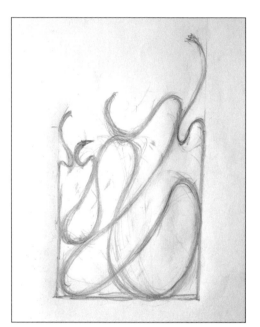

◄ **3.** The forms of the gate are drawn full size on the floor with chalk. You could also draw on a sheet of wood or metal if you do not have enough space.

▼ **4.** The full-size drawing lets you evaluate the forms as they are drawn.

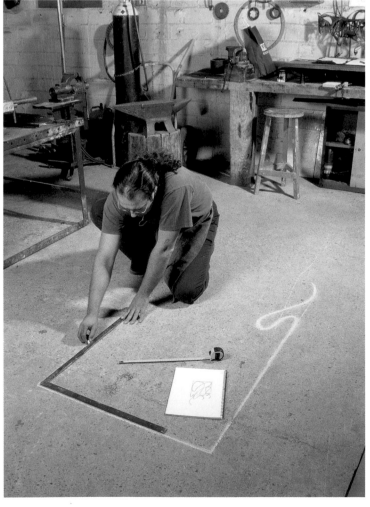

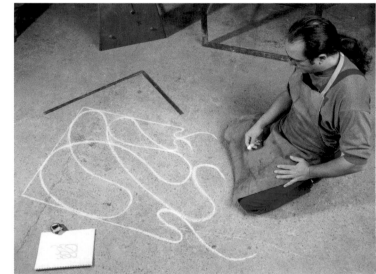

▲ **5.** Begin with a steel strip and bend it to a 90° angle in a circular bender, to create the base and one side of the gate.

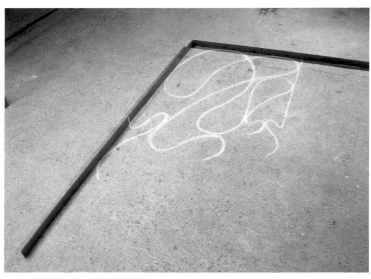

▲ **6.** The bent strip is laid on the drawing on the floor to mark the edges and check that the angle is correct.

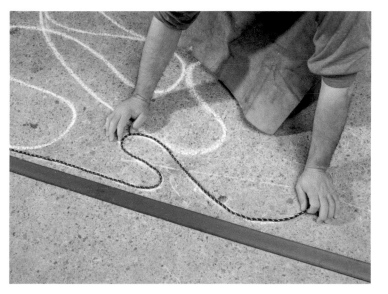

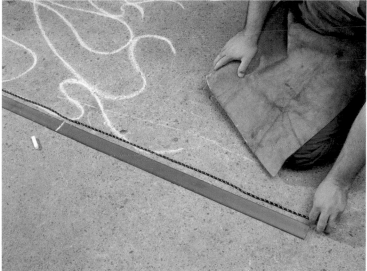

▲ **7.** A string is laid on the line drawing to determine how long a strip is needed to make the shape on the gate.

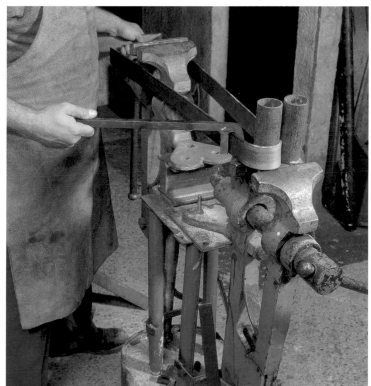

▲ **8.** The string is straightened and the length is marked on the steel strip at the point where the shape of the curves will begin.

▶ **9.** At this point, the cold forming is begun, using a jig made from two pieces of pipe held in a post vise. Pressure is applied to the strip using a scroll wrench and the jig at the point that was marked with chalk to make the curve.

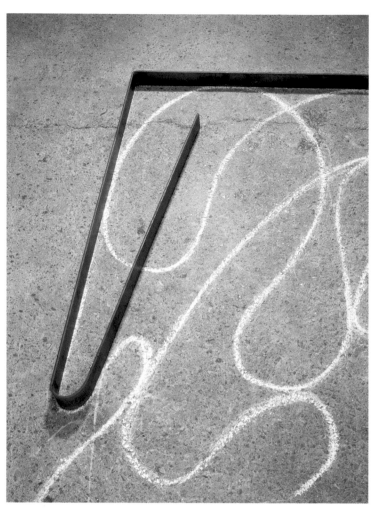

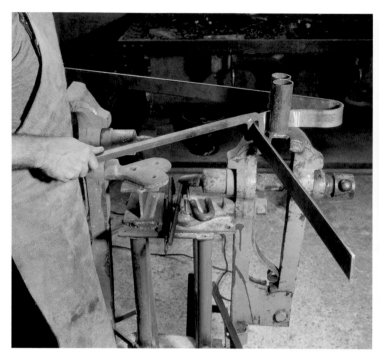

◄ **10.** When you suspect you have created the correct curve, it is laid over the one in the drawing for comparison. If it does not line up, it can be corrected by eye as many times as is needed.

▲ **11.** More curved forms are created on the jig using the scroll wrench. The chalk marks on the strip indicate the starting points of the curves or formed areas that must be corrected.

◄ **12.** Differences between the piece and the drawing often appear during the forming process. At this is time you can decide whether to correct the piece to match the drawing or to keep the new shape. This process is the basis of a dialogue between the form and the material.

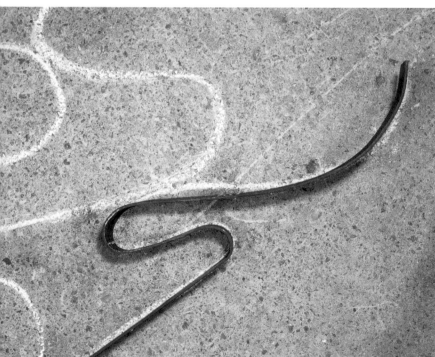

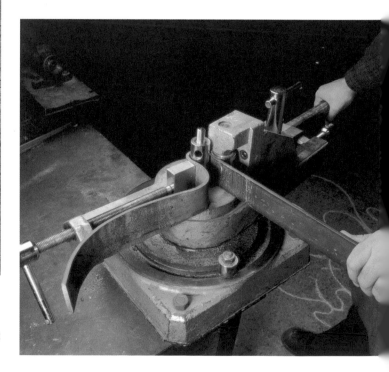

► **13.** The circular bender can be very useful for making very tight and precise curves.

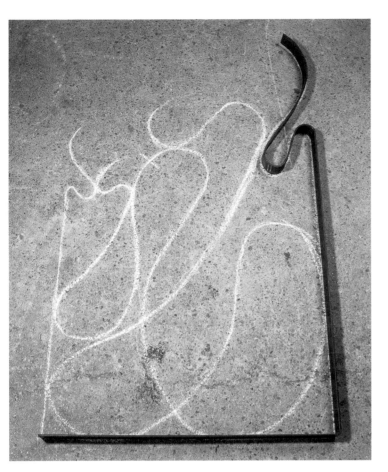

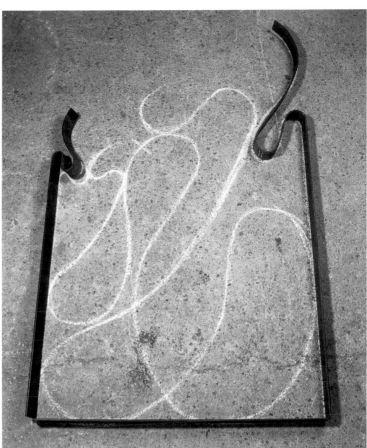

▲ ▼ **14.** In this sequence of photographs you can observe how the different parts of the gate are formed little by little, following the process described here.

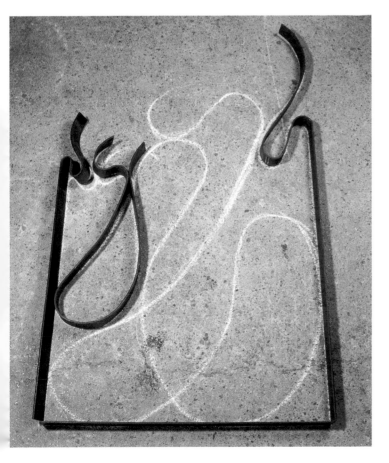

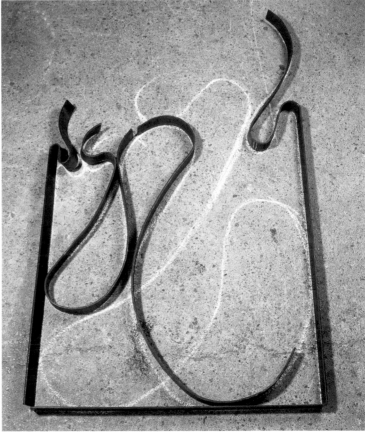

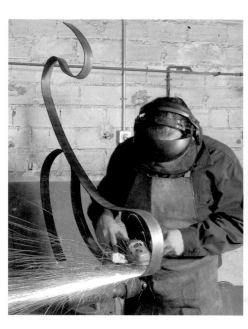

◄ **15.** After all the parts have been formed, they are welded together. In this case we have used coated electrodes, but it also could have been welded using the MIG process.

► **16.** The weld beads joining the parts of the gate are smoothed with a grinder before they are all assembled. It is easier to handle them and reach tight areas with the tools this way. The parts should be held in a bench vise to avoid accidents caused by movements of the parts.

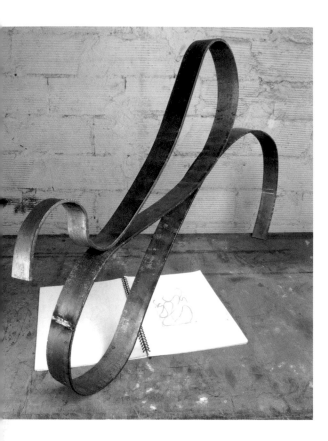

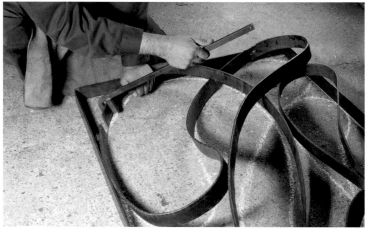

► **17.** To complete the assembly of the parts of the gate, they are interwoven and placed on the reference drawing. If necessary, the ends can be made to meet by using the scroll wrench. Interweaving the different parts adds volume and a sense of movement to the gate.

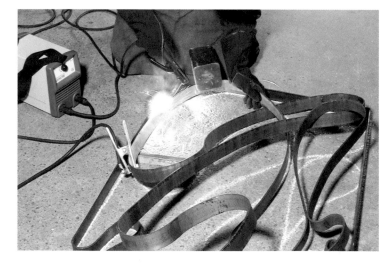

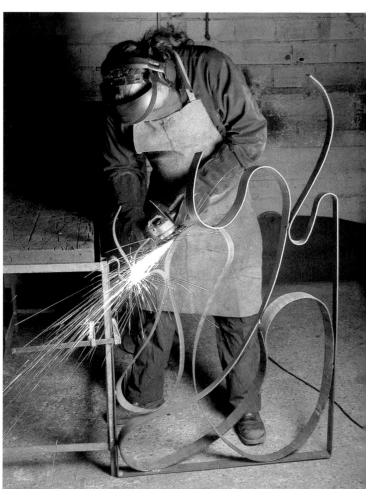

▲ **18.** After the parts have been adjusted, they are welded together with coated electrodes. In this case, a very heavy piece of steel helps immobilize the parts of the gate as they are welded.

► **19.** After all the necessary welds have been made to hold each part in its place and give it its shape, they are smoothed using a handheld grinder with a grinding disk to remove sharp edges and corners that could cause injuries to anyone using the gate after it has been installed.

▲ **20.** The wrought iron gate is then given two light coats of primer to ensure that the final coat of paint will adhere well and be durable. The last coat of paint is a special color that imitates the color of hand-wrought iron.

▼ **21.** This is a detail of a hinge that can be made for hanging the gate on a wall.

Welded to the gate

Wall

▶ **22.** Here is the gate hung at the Ca la Maria farmhouse (Llagostera, Spain).

# Stainless Steel Coffee Table

*T*he following project is the construction of a stainless steel coffee table shaped like a cube and with a matte finish.

The important part of this exercise, along with working with stainless steel, is understanding the techniques of bending, cutting with a grinding tool, and the use of TIG welding. The effort required for constructing the cube is optimized and the number of welds for joining the edges is reduced. Another technique demonstrated here is that of welding in a manner that minimizes the risk of causing the sheet metal to warp from the heat of the weld beads.

Protective safety gear is worn while carrying out the different phases of the work to avoid injury to the eyes, hands, and other parts of the body.

▲ **1.** A simple line sketch is enough to record the basic idea.

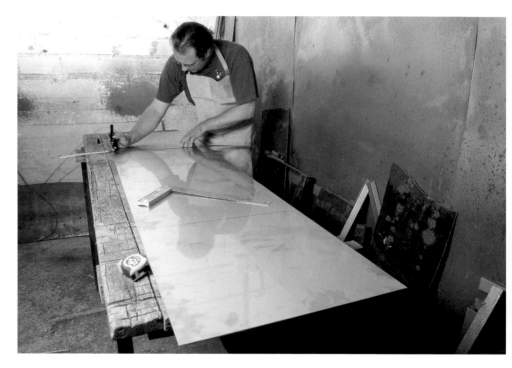

▶ **2.** The divisions for each side of the cube are marked on an 80 × 20-inch (200 × 50-cm) sheet of 0.080-inch (2-mm) stainless steel using a steel ruler and a permanent marker.

▼ **3.** A grinder with a cutting disk will be used to score the lines where the bends will be made in this especially hard 0.080-inch (2-mm) thick sheet metal. The cutting disk will be guided along the edge of a steel angle to keep the line perfectly straight. We begin with the large sheet that will form the four sides of the cube.

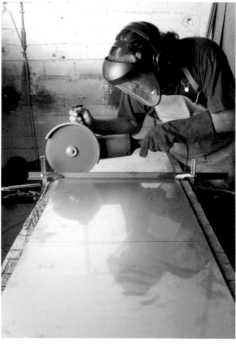

◀ **4.** The line where the bend will be made is scored with the grinder and cutting disk, making several passes with the grinder while using the bar as a guide.

▼ **5.** The groove is achieved by making several passes applying only light pressure, otherwise the metal could be cut through. The same operation is repeated wherever the sheet metal is to be bent.

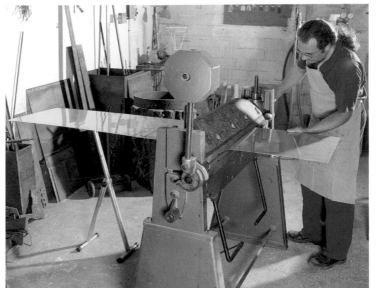

◄ **6.** Next, the folds of the cube are made. The metal sheet is placed between the bars of the leaf brake and held in place by lowering the lever on the side of the machine.

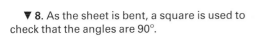

◄ **7.** The forming bar is raised, applying bending pressure to the sheet metal.

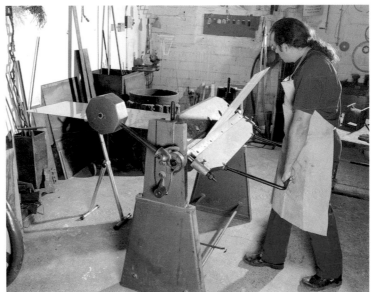

▼ **8.** As the sheet is bent, a square is used to check that the angles are 90°.

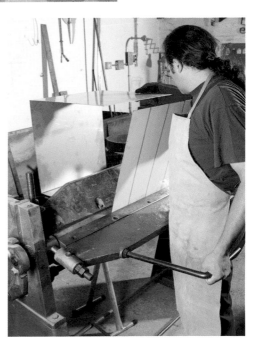

►► **9.** All the sides of the cube are folded until the two ends come together. The folding bars must be separated and the sheet metal forced a little to remove it from the machine.

▼ **10.** The sides of the cube are immediately tack-welded. The sides of the stainless steel sheet, and the top piece, are held together with clamps while the welds are made. The protective plastic sheet is removed from these areas so that it will not burn.

◄ **11.** The tack welds, made using a TIG welding machine, are about ¾ inch (2 cm) long and spaced about 4¼ to 5 inches (8 to 10 cm) apart.

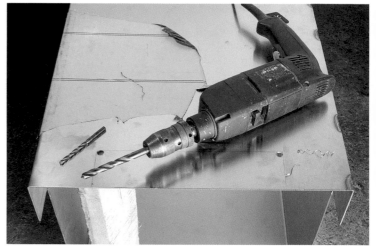

▲ **12.** After the whole cube has been tacked together, the legs are cut out. Two holes are drilled at the inside corners of the space between the legs. Because of the hardness of the material, a small diameter hole is made first, then another of a larger diameter is drilled in the same place; this way the power drill is not overstressed.

◄ **13.** A cut is made between the two drilled holes, using a steel bar as a guide. The bar should be held fast with two clamps to ensure a straight cut.

▼ **14.** This is how the drilled holes align the cuts made by the grinder. Next, the burrs made by the cutting wheel must be removed and the crooked cut adjusted. The scrap piece of sheet metal can be used to complete the table legs.

▼ **15.** The piece of sheet metal is bent to shape and used to complete the legs of the cube. The sheet metal sides are attached with a few tack welds. A small clamp is required to hold the metal for welding.

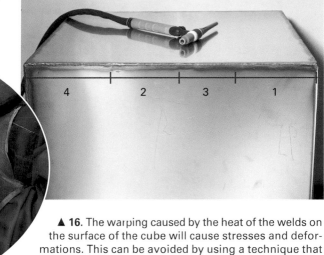

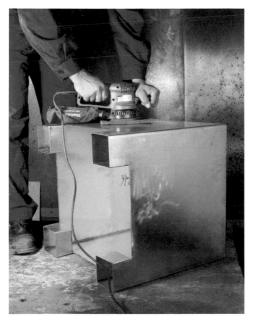

▲ **16.** The warping caused by the heat of the welds on the surface of the cube will cause stresses and deformations. This can be avoided by using a technique that consists of alternating the order of the welds, as indicated by the numbers, to spread out and counteract the stresses.

▼ **17.** The weld bead is smoothed using a grinder equipped with a medium 60 to 80 grit abrasive flap disk until the entire surface is smooth.

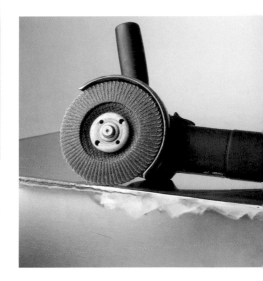

▲ **18.** The protective plastic is removed and all the surfaces of the cube are polished using an orbital sander and different grades of abrasive disks. The surface of the cube is then rubbed with a scouring pad with the help of the same orbital sander.

▶ **19.** The texture made by the tools and finished with the scouring pad adds personality to this 20 × 20 × 20-inch (50 × 50 × 50-cm) coffee table.

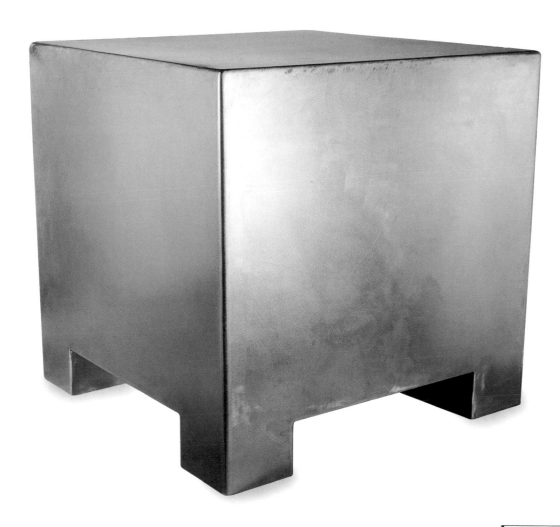

# Wrought Iron Door Knocker

*I*n this exercise we make a wrought iron door knocker in the shape of a snake. It consists of different phases that allow us to combine some basic forging processes.

First, we make the tail of the snake by drawing out, flattening, chamfering, and scrolling a metal bar. Next the body is made by twisting the bar, and the head is created using the techniques of upsetting and chamfering. Then, the neck and the mouth of the snake are detailed with a cut in the head and by bending the bar.

Finally, the nails and back plate for attaching the door knocker to the door are forged. The process concludes with the application of oil to create a blackened patina.

This step-by-step exercise is a sincere homage to the artisan blacksmiths, who through their work made countless anonymous contributions to the enrichment of the popular imagination over the centuries.

◄ **1.** These sorts of sketches show the combination of forged forms that the door knocker might have.

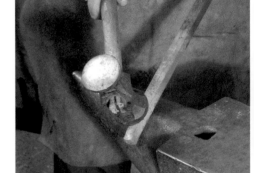

► **2.** The forging process begins by heating a square bar in the coals until it has a light cherry red color.

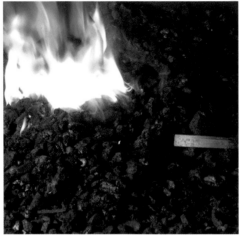

▲ **3.** The drawing out process is used to make the tail of the knocker. This consists of striking the heated bar with a mallet against the round horn of the anvil. This operation must be done several times to draw out the metal, alternating with heating the bar in the coals when it cools off.

▼ **4.** The section of the drawn out bar is evened by chamfering it. This is done by striking the heated bar on the face of the anvil and forming a point at the end of it.

▼ **5.** The part of the bar destined to be the body of the snake is flattened by striking it with the peen of a hammer to push the mass of the iron to the sides.

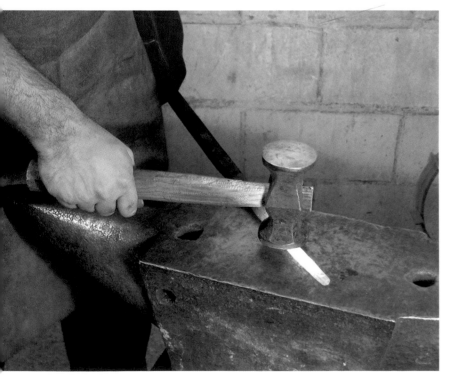

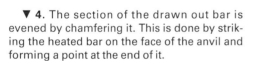

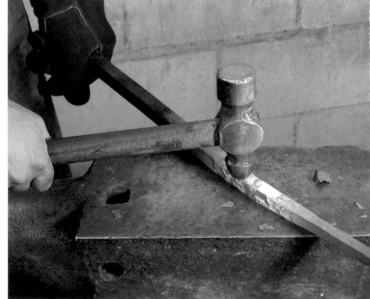

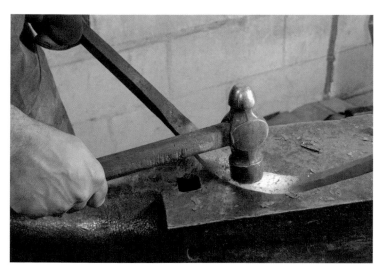

▲ 6. The section of the square bar becomes rectangular as it is struck with the flat head of the hammer. This piece will later be twisted into the body of the snake.

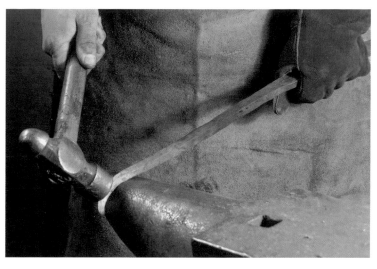

▲ 7. Now we begin to form the tail by bending the pointed end of the previously heated bar, hammering it against the point of the round horn of the anvil.

►►8. We continue by alternating shaping the point against the face and the horn of the anvil until the tail of the snake has the desired curve.

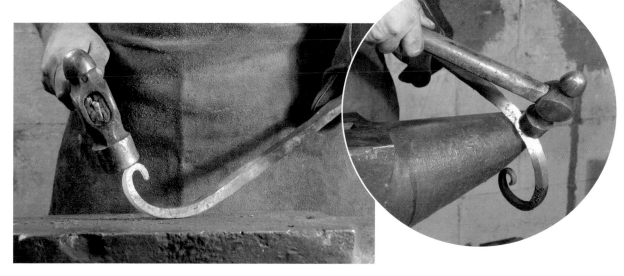

►9. The hammering should be done lightly for the final adjustments of the curve.

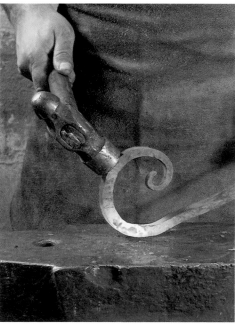

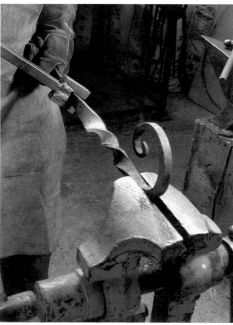

◄ 10. The previously flattened rectangular section is twisted to create the body of the snake. The tail is held in the leg vise and the bar is twisted with a scroll wrench.

▼ **11.** Work on the snake's head begins by upsetting the end of the bar. To do this the flat end of the bar is heated in the coals until it is light orange and then struck against the face of the anvil.

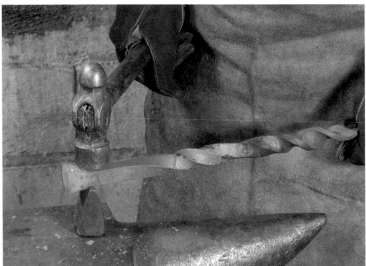

◀ **12.** The snake's neck is drawn out so it will be thinner than the body and the head. To do this, the four sides of the bar are hammered against a bottom fuller with a rounded edge.

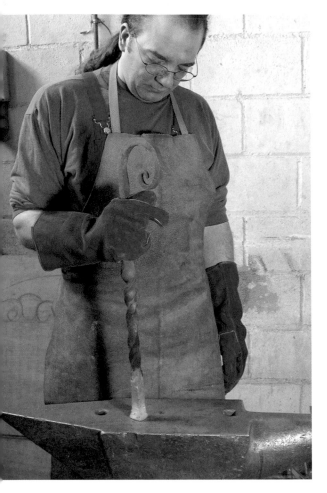

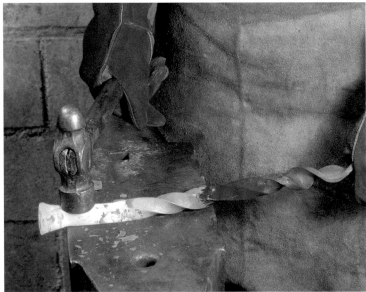

◀ **13.** Now the neck is drawn out, placing the upset end off the anvil face so it will not become damaged.

▼ **14.** The upset end of the bar is hammered into a bevel to make the head of the snake.

▼ **15.** Then, the neck is bent with the help of a U-shaped jig held in the leg vise.

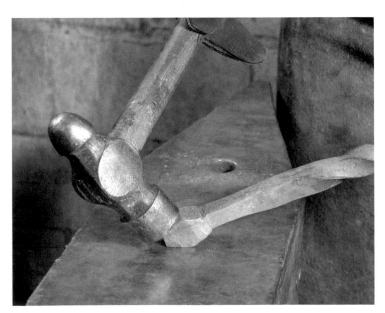

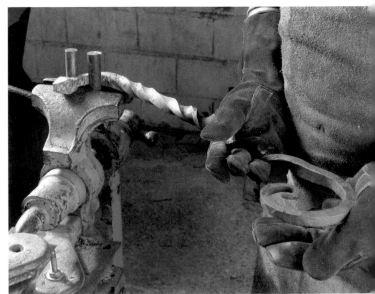

▼ **16.** Here is the snake, made by chamfering and scrolling the tail, flattening and twisting the body, drawing out and bending the neck, and finally, upsetting and chamfering the head.

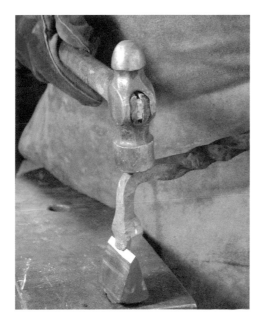

▶ **17.** Using a grinder, a cut is made in the head to make the mouth.

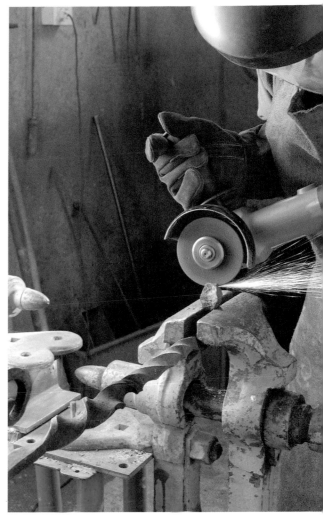

▶ **18.** The area of the cut in the head is heated in the forge, then it is placed on a hardie and hammered to open the mouth. Special care should be taken when heating this area, since introducing the entire head into the coals risks melting the narrower of the two parts created by the cut. The piece must be constantly watched and moved around during the heating process.

▼ **19.** Now we begin forging the nails, marking a heated round bar on the bottom fuller.

▼ **20.** The body of each nail is drawn out and chamfered following previously made marks.

▼ **21.** The place where the nail is to be cut is marked on the hardie.

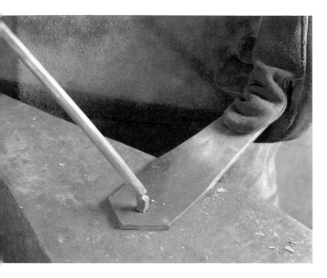

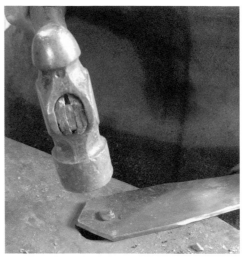

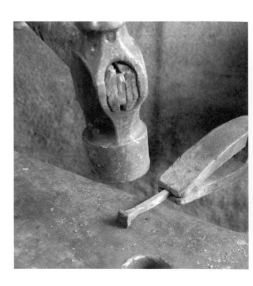

▲ **22.** The nail part is introduced into a nail-header and the bar is bent until it breaks off at the cut mark.

▲ **23.** The red-hot bar is hammered to make the head of the nail.

▲ **24.** The sides of the head are retouched to give it the desired shape. As many nails as are needed can be made in this manner.

► **25.** Here is a nail-header and some finished nails.

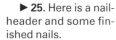

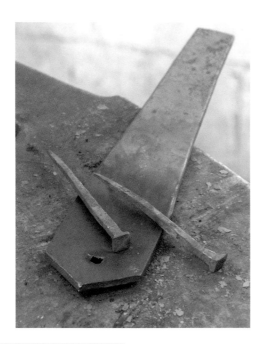

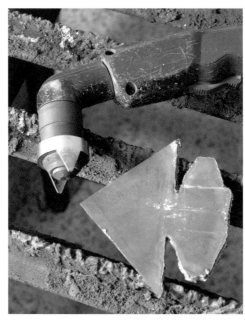

◄ **26.** To make the piece that will attach the door knocker assembly to the door, the sheet metal part on which the forged snake will be mounted is cut out with a plasma torch.

◄ **27.** The plate is heated and it is given a texture by hammering it with a ball peen against the anvil.

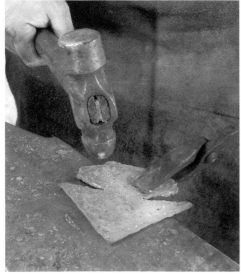

► **28.** The brackets, needed for attaching the knocker to the back plate, are bent over the square horn of the anvil.

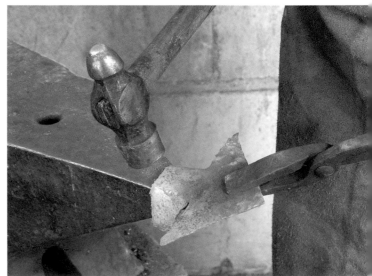

**◄ 29.** The back plate is retouched, flattening any warped areas it might have.

**◄ 30.** The knocker is attached to the back plate with a forged round pin. Previously, where allowed on the twisted body of the snake, a hole was made for inserting the pin. Holes were also made in the back plate for nailing it to the door.

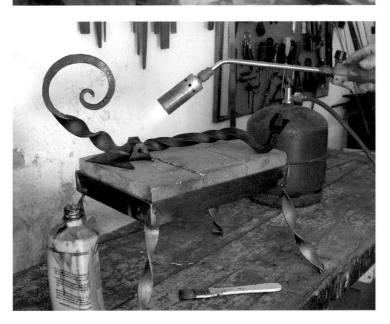

**▲ 31.** For the finish, the piece is slightly heated with a torch, and then linseed oil is applied with a brush so that it darkens the piece as the oil burns. It is a good idea to wipe off the excess oil with newsprint between applications to avoid dripping and changes in the piece's color. The darker you want the patina, the more applications will be required. At the end of this process, after the piece is completely cool, the patina is evened by buffing the knocker with a rag dipped in oil or by applying a coat of wax.

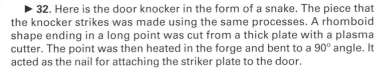

**► 32.** Here is the door knocker in the form of a snake. The piece that the knocker strikes was made using the same processes. A rhomboid shape ending in a long point was cut from a thick plate with a plasma cutter. The point was then heated in the forge and bent to a 90° angle. It acted as the nail for attaching the striker plate to the door.

# A Brass Tray with Open Design Work

*T*o make this tray we are going to use a 0.60-inch (1.5-mm) thick sheet of brass, selected from the scrap pile in a sheet metal shop. This way, we find a use for metals that had been previously destined for other purposes. The objectives of this exercise are to use a pattern for transferring the design to the sheet of brass, and to plan the forming techniques to keep the soldering to a minimum, only what is absolutely necessary, to prevent this thin sheet of metal from warping from the effect of the heat.

▲ **1.** A few sketches will help define the image of the tray and to decide the measurements and the shape that the pattern should have.

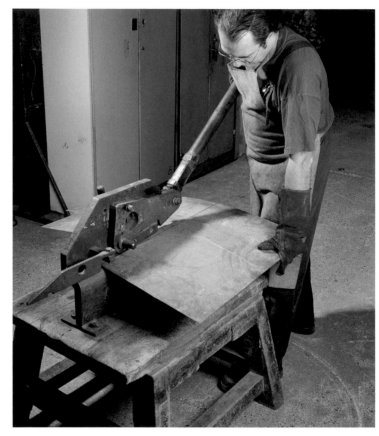

◄ **2.** The sheet of brass is cut according to the measurements of the sketch using a power shear to make it easier to work with the metal.

◄ **3.** The metal is polished with an orbital sander fitted with a fine-grain disk. The goal is to clean it up as much as possible before the construction process begins.

◄ **4.** The orbital sander and a scouring pad are used to clean up the area previously sanded to eliminate the marks left by the procedure.

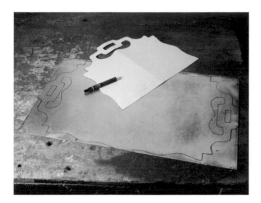

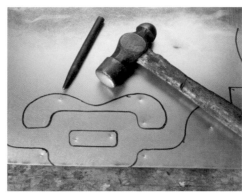

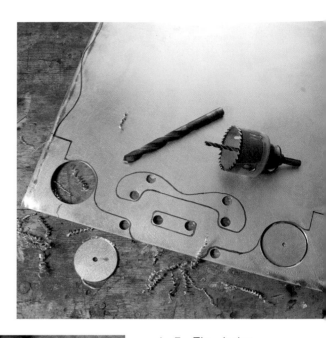

▲ **5.** Once the surface is polished, the general outline of the design is transferred to the brass using a heavy paper pattern. Since this is a symmetrical design, only half of the pattern is needed.

▲ **6.** The holes' centers are marked with a hammer and a center punch, where the tray's open work will be created. Next, using a drill bit with a diameter somewhat larger than the jig saw, the holes are made in the required places.

▲ **7.** The holes made on the sheet metal are used to insert the blade of the jig saw and to remove the piece of metal. Some have been made with a hole cutter to better define some rounded areas.

▶ **8.** The outside of the tray is cut with an electric shear, which is ideal for curves made on a thin sheet of metal. The hole made with the cutter makes room for cutting with this tool.

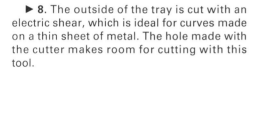

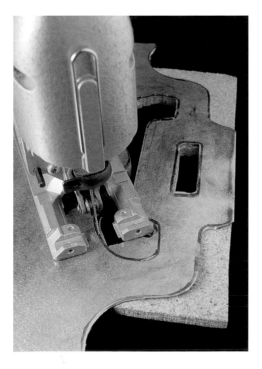

◀ **9.** The jig saw can be used to cut the inside edges of the open design work. The technique used is the same as that covered in the section for cutting with a saw. Remember to remove the material from the spaces when making curved cuts.

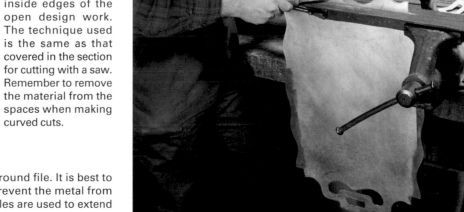

▶ **10.** The tray's outline is defined with a half round file. It is best to work as close to the bench vise as possible to prevent the metal from bending from the filing. To do this, two steel angles are used to extend the grip of the vise on the metal.

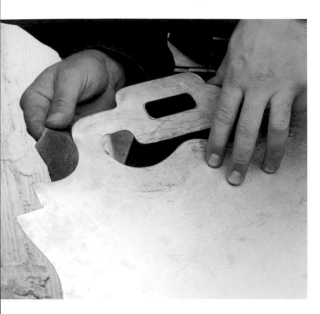

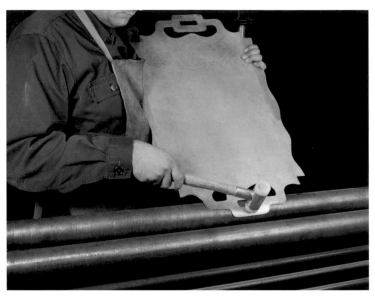

◄ **12.** To eliminate the crease caused by the rolling mill at the beginning of the rolling process, the edges of the handles are placed on rolls and gently tapped with a nylon hammer.

▲ **11.** Scratches and burrs caused by the filing are removed with emery paper. This gives the material a pleasant feel.

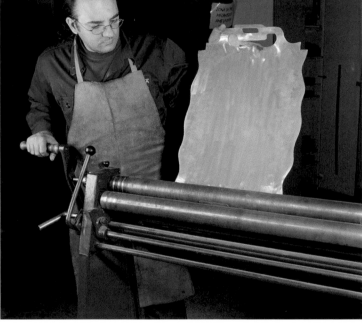

◄ **13.** The curved edge of the tray is placed between the two rollers, and the lever is turned until the entire surface of the handle is curved. The same procedure is followed for the other handle.

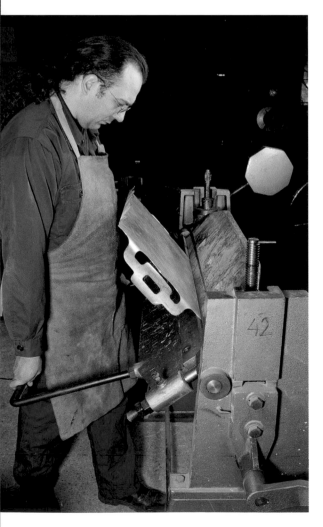

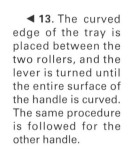

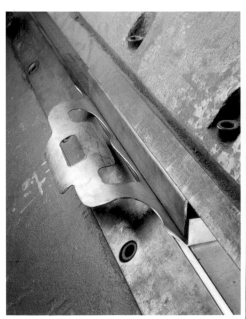

◄ **14.** After rolling the handles, the long sides are bent on the leaf break. After the side of the tray has been placed between the bars of the machine, the bar that will create the fold is raised.

▶ **15.** To fold the sides where the handles are located, a piece with a 90° angle is used as a wedge. It will be held between the bars of the bending machine above the height of the folded sides, while applying pressure on the tray's base.

► **16.** When all the sides of the tray have been folded, they are welded together with oxyacetylene and brass rod. This procedure requires the use of an oxidizing flame with excess oxygen, to prevent as much as possible the volatilization of the zinc, which is a component of the brass alloy.

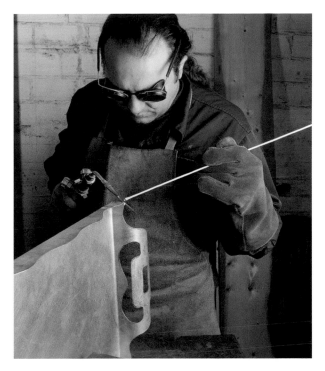

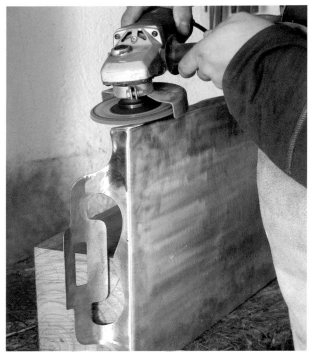

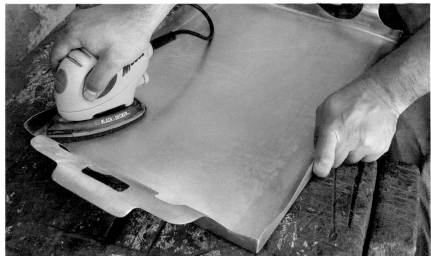

▲ **17.** Then, the welded joints are sanded with a hand-held grinder fitted with a fine-grit abrasive flap disk. The goal is to even out the surfaces by sanding only on the welded area. The tray is held in the vertical position by placing a weight on one of its sides. This will help prevent the marks and warping that could occur on the bench vise.

◄ **18.** To create the matte finish, a special orbital sanding tool is used to reach every corner of the piece. First, it is sanded with medium-grit sandpaper, then again with a finer grit, and finally with steel wool and a scouring pad, which will provide the matte finish.

▼ **19.** Final look of the brass tray where the soft matte finish can be appreciated.

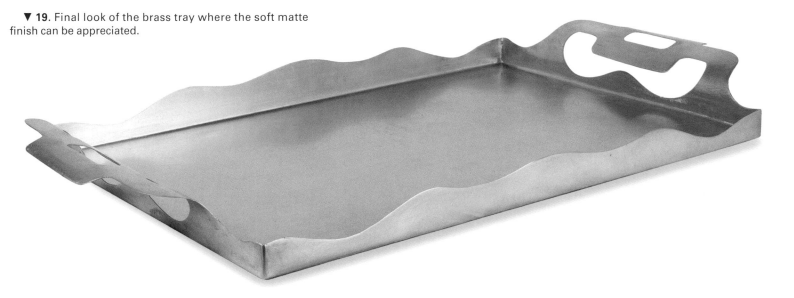

# Iron Garden Table

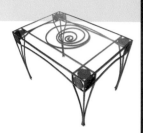

*I*n this exercise we make a wrought iron table that has been created by combining forging and cold forming techniques.

The material to begin the project will be iron bars obtained from recycling an old grid, which will be used to make the framework of the table.

The main decorative element on the table will be a spiral, which will be placed on the table top. It will also be accompanied by 12 rolled spirals that will be placed at the joints where the legs and the table top meet. The table top will be made of transparent glass, which will let us see the table's structure and iron work. The finish will consist of a varnished natural oxide. The construction of this table will be used to explore metalworking techniques in depth, resulting in a very useful object with an artistic flair.

▲ **1.** The project begins by making a design. In this case the process has evolved from an idea to drawings produced with the help of a drawing program like Autocad, although any program like Freehand or Archicad could be used.

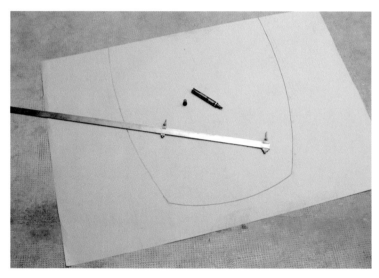

▲ **2.** Then, the full-size drawing of the table design is transferred to a sheet of heavy paper. A beam compass and a marker are used for this.

▼ **3.** The rods from an old grid are taken apart by cutting them at their welded points with a grinder fitted with a cutting disk.

▼ **4.** A square rod is placed over a U-shaped stake and hammered to make the curved rods of the framework of the table. These blows must be executed gently to arrive at the desired shape little by little and without going too far.

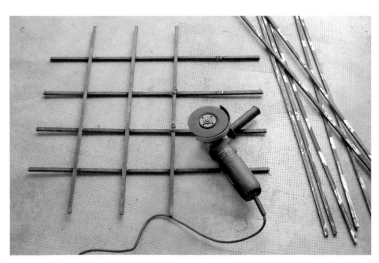

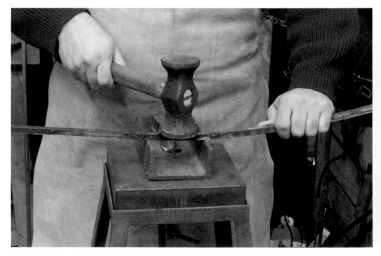

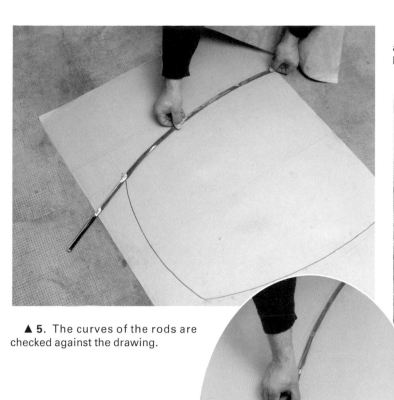

▲ **5.** The curves of the rods are checked against the drawing.

▶ **7.** The curves and edges of the rods are checked again comparing them with the pattern to correct any deviations if necessary. The same procedure is followed for the rest of the rods.

▼ **6.** The end of the rod is bent while heating part of it with the oxyacetylene torch. This way it will bend at a particular point using the bench vise, which holds the end, as a lever.

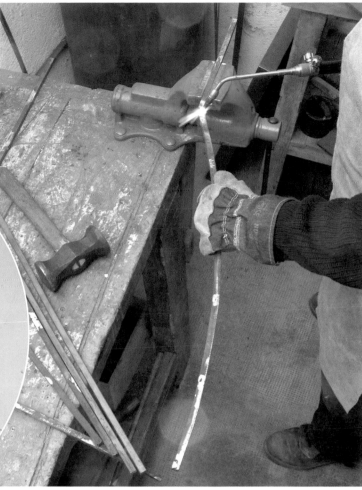

▼ **8.** Now, the pieces of the table leg structure are placed over the pattern to check how they fit before we proceed to weld them together.

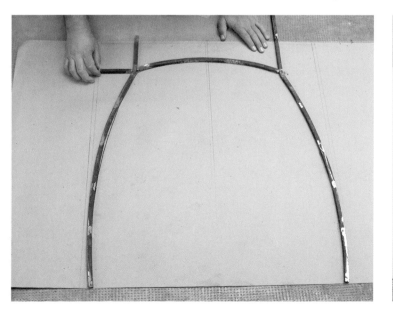

▼ **9.** The rods are welded using the coated electrode welding method. The weights placed on the rods prevent them from moving as a result of the tension and dilation produced by the welding operation.

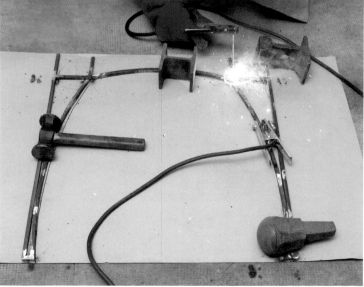

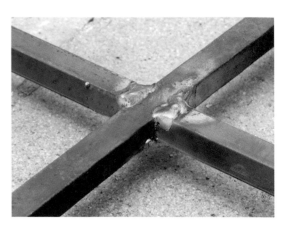

▲ ▲ ▲ **10.** In the top structure, which will support the glass top, some rods are notched. The joints are created by making a series of small consecutive cuts, with a grinder, for example, without cutting the rod all the way through.

▼ **11.** Once the top structure is assembled according to the design, it is welded and the welded surface is smoothed with a grinder and a de-burring disk. It is important to use the proper safety gear during this process as protection against the metal particles that may be projected during the grinding.

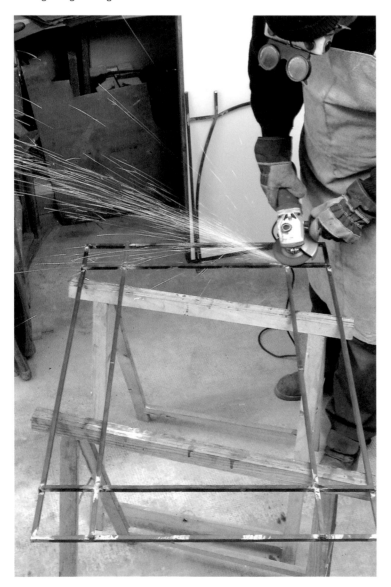

◀ **12.** Details of the bevels created to accommodate the filler metal that will connect the legs to the frame of the table top.

◀ **13.** The structure is turned over and the legs are placed on the table top structure. A magnetic steel set square (in red) will help maintain the 90° angle between them while they are being attached with a tack weld.

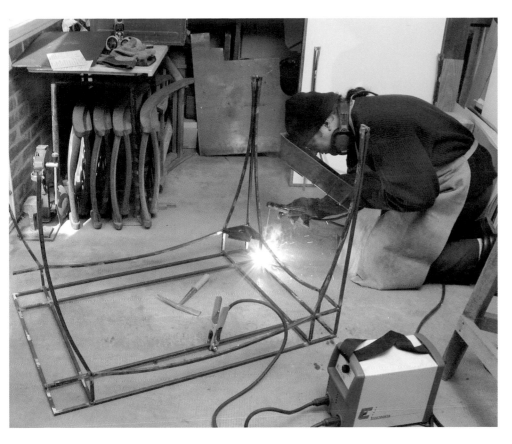

◄ **14.** After checking the angles, we continue to make the welds.

▼ **15.** Now we are going to construct the spiral motif that will be placed in the center of the table-top structure. To begin this process, we need to make a metal pattern with the design of the spiral, which is drawn on a sheet of metal.

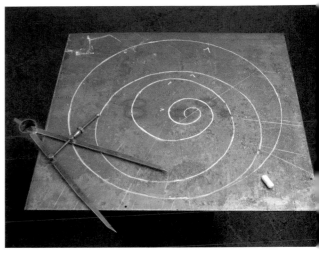

▼ **16.** A steel band is bent into a curve with the help of the vise and a scroll wrench, constructing the spiral in parts.

▼ **17.** The curves of the metal bar are checked by comparing them with the drawing of the spiral made on the metal surface.

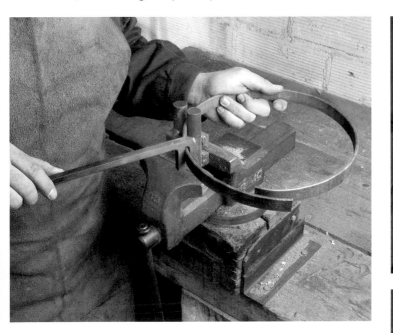

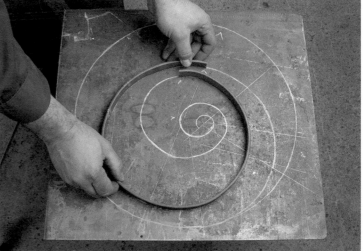

► **18.** Spiral sections cut and compared against the drawing. They have not been welded yet because they will be attached to the metal surface as the pieces that will make up the spirals are forged.

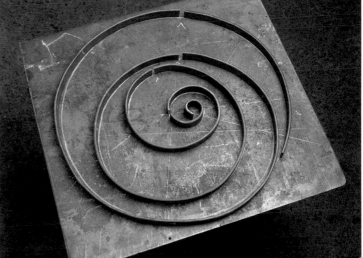

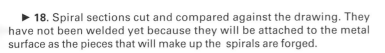

139

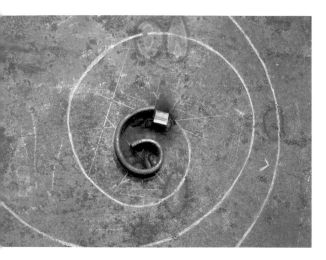

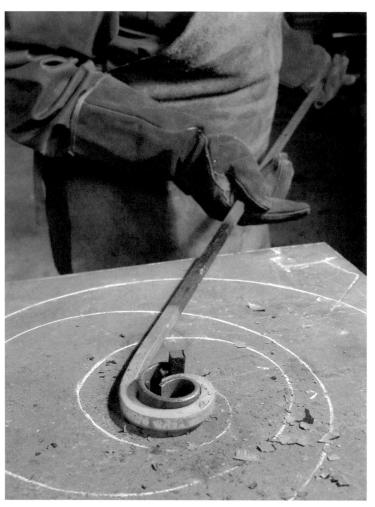

◄ **20.** After the end of the rod has been heated, it is inserted in the pattern and the forging of the spiral begins.

▲ **19.** Now the first part of the spiral on the pattern is tack welded to the metal plate. Also, at this point, a square stopper is attached to help hold the rod as it is being forged.

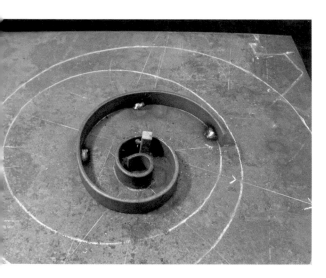

◄ **21.** When that section of the rod has been shaped, the next piece of the pattern is added by welding it the same way with a few tack welds.

▼ **22.** Only the section of the rod that is to be bent is heated, then it is placed in the metal patern and the spiral forming continues.

▼ **23.** The procedure is repeated and as the metal cools off, it is heated again in the forge.

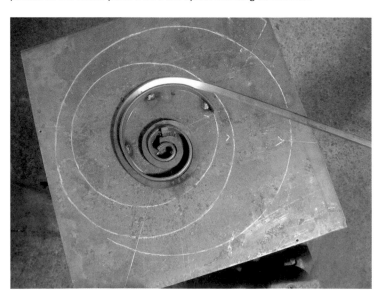

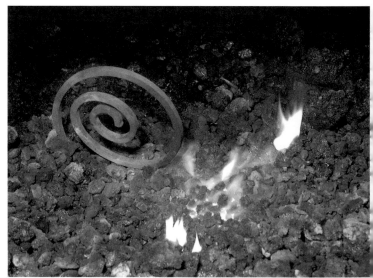

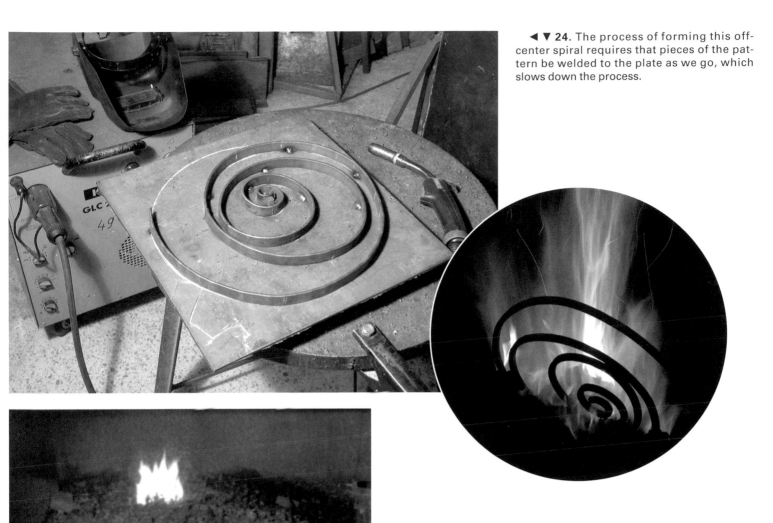

◀ ▼ **24.** The process of forming this off-center spiral requires that pieces of the pattern be welded to the plate as we go, which slows down the process.

◀ ▼ **25.** The desired shape of the spiral is finally achieved after tack welding each part of the pattern, little by little, and heating and bending the metal bar.

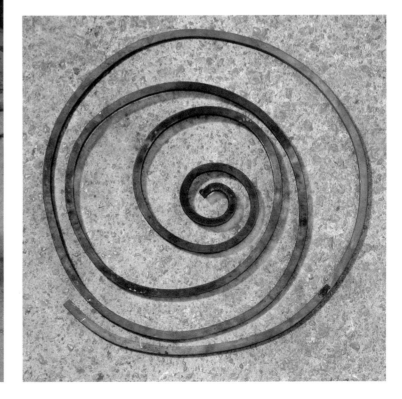

**◄ 26.** And now we will make the 12 spiral pieces that will be placed where the table's legs and top meet. The process begins by bending the end of a square rod on a bench vise. This will help hold the spiral as it is being formed.

**► 27.** Once the rod is securely attached, the process begins by rolling the first spiral with the hammer.

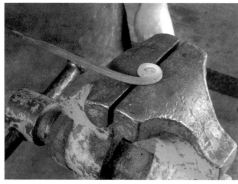

**▲ ▲ ▲ 28.** Then the iron is heated in the forge and continuously bent on the vise until the desired spiral shape is achieved.

With a levering motion we create the desired curvature, using the hammer to adjust the form of the spiral.

**◄ 29.** Toward the end of the coiling process, a pair of blacksmith tongs are used to hold the spiral by the piece that was bent at the beginning. The same procedure is followed to make the remaining 11 spiral pieces.

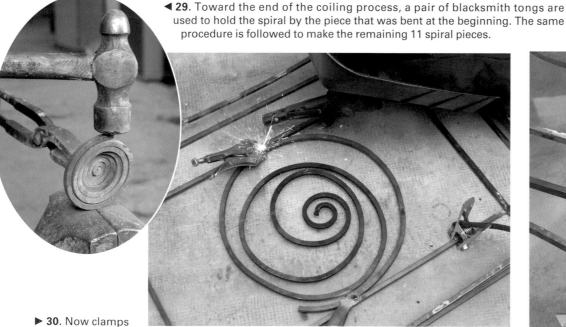

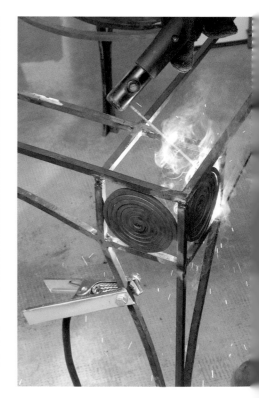

**► 30.** Now clamps are used to hold the large spiral in the center of the table-top structure, following the design, and it is attached by arc welding.

**► 31.** Now the 12 small spiral pieces, which fit perfectly into the square spaces reserved for them, are attached. The welding, which is easier due to the perfect fit, is always done from the inside of the table's structure to prevent the welds from ruining the geometrical shape of the forms.

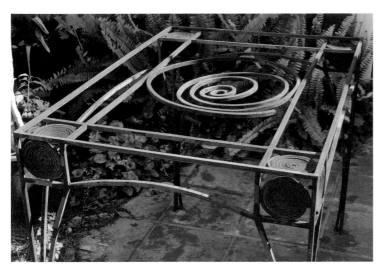

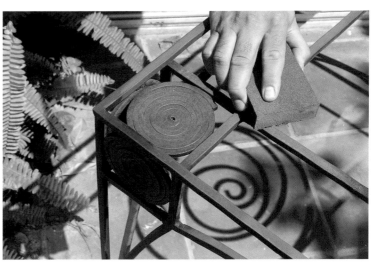

▲ **32.** For the finish of the table we chose the uniform look offered by the natural oxidation of iron. To create this, the table is soaked in water for several nights, to keep the water from quickly evaporating from the heat of the sun, until the desired tone or combination of tones is achieved.

▲ **33.** Before the protective layer of varnish is applied to the table, the oxidation that does not adhere well to the metal must be removed with emery paper. In this case, the emery paper is attached to a sponge, which makes it easier to handle. When this operation is finished, a couple of coats of colorless and transparent varnish for metals are applied followed by a coat of colorless wax. This varnishing and waxing process must be repeated once in a while if the table is kept outdoors, exposed to the elements.

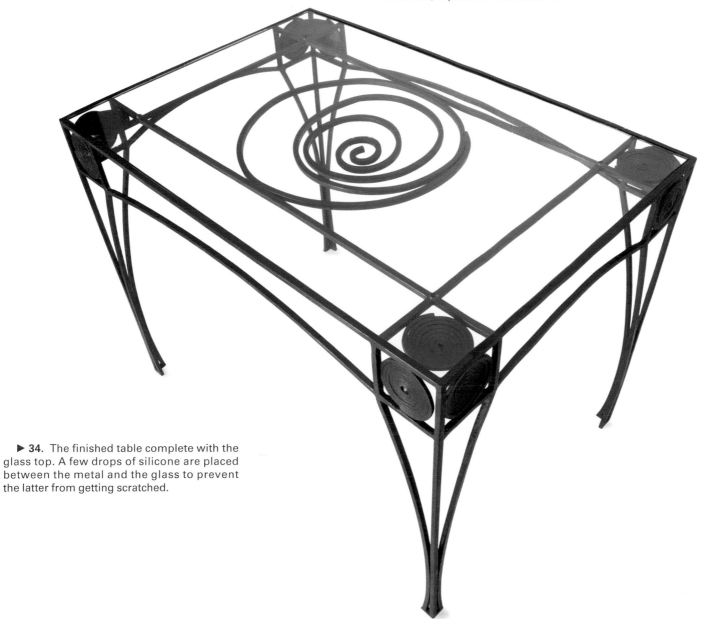

▶ **34.** The finished table complete with the glass top. A few drops of silicone are placed between the metal and the glass to prevent the latter from getting scratched.

# A Sheet Copper Jewelry Box

*N*ext, *we make a jewelry box using copper sheet and stainless steel, combining the techniques of hollow forming, brazing with copper-phosphorous filler rod, and resistance welding.*

*The important aspect of this exercise, other than working with copper sheet, is forming the different geometric shapes in this material. To do this it will be necessary to first construct a few hollow pieces, which will later be used for forming. The sides of the copper box are welded together only after the shapes have been formed, to avoid the annealing that takes place as a result of the heat from the welding process.*

*The jewelry box is a conceptual exercise, which projects the idea of the box onto a sheet of copper and is complemented with a stainless steel grid cover that allows one to see through but not touch the objects.*

◄ **1.** A sketch and a pattern for the jewelry box design are made.

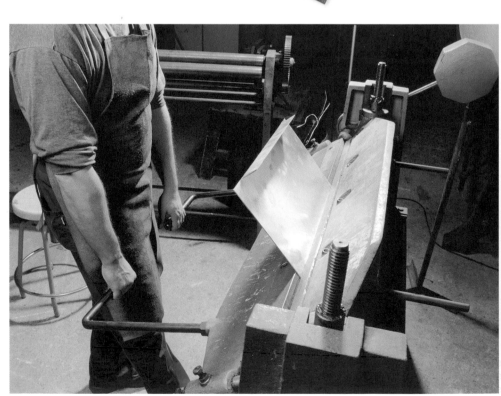

► **2.** We use commercial tubing to make the hollow forms on a copper sheet. If some of the shapes are not available, like the triangle, one is made using a sheet of steel and welding it together.

▲ **3.** A 0.040-inch (1-mm) thick sheet of copper is used cut to the dimensions of the chosen design, and the corners are removed with a power shear. These cuts must be consistent. This cut-out piece constitutes the base of the box.

► **4.** The sheet is placed in the leaf break and the two long sides are bent.

► **5.** Next, and with the help of a piece of wood the same size as the folded side of the sheet metal, the two other sides are folded.

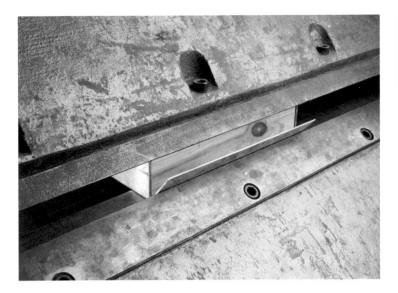

◄ **6.** Once all the sides have been folded, the shapes are marked on the piece. To do this, a template with the cut-outs of the chosen shapes is used.

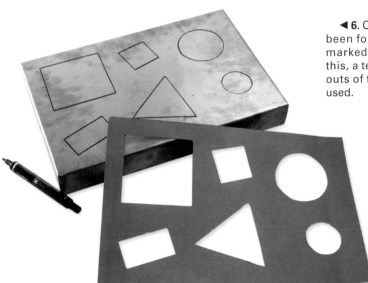

▲ **7.** The rough edges of the hollow forms are filed to prevent them from marking the underside of the metal during the forming process.

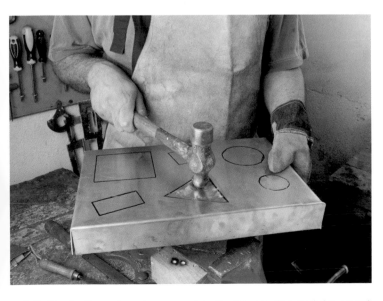

▲ **8.** The hollow piece is secured in the bench vise and the metal sheet is placed over it to coincide with the design. Then, the copper sheet is hammered with the ball peen of a hammer as the design takes shape.

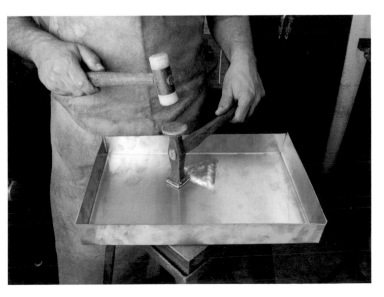

▲ **9.** To control the areas that may be deformed outside of the shape, the flat side of a planishing hammer is pounded periodically on the metal sheet placed upside down on a flat stake.

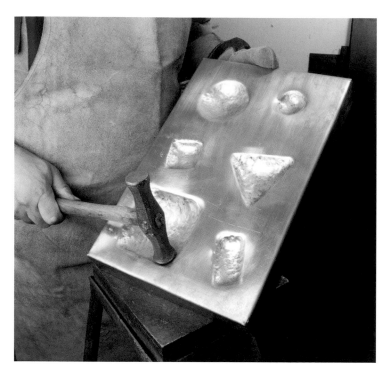

▲ **10.** After all of the hollow shapes have been formed, their outlines are adjusted by striking with the rounded face of a chamfering hammer.

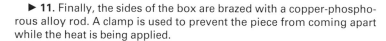

▶ **11.** Finally, the sides of the box are brazed with a copper-phosphorous alloy rod. A clamp is used to prevent the piece from coming apart while the heat is being applied.

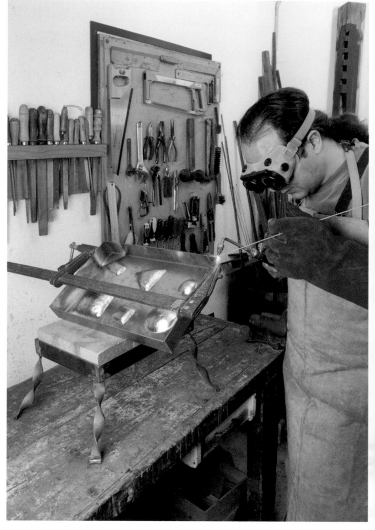

◀ **12.** When the welded joints cool off, the surface is smoothed with a grinder and a fine-grit abrasive flap disk. A piece of wood is used to prevent the piece from bending out of shape while being held at the bench vise.

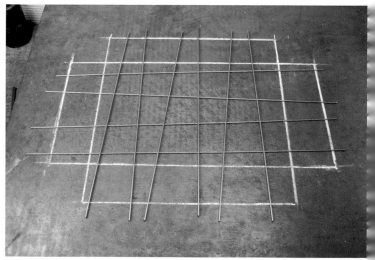

▲ **13.** To create the grid cover for the jewelry box, the unfolded design of the box is drawn on a flat surface with chalk. Next, the stainless steel rods are arranged over it to find the most pleasing pattern.

▶ **14.** The points where the rods will cross each other and where they will be welded are marked.

▼ **15.** The area where the welding will be done is flattened. To do this the rod is hammered over the horn of the anvil.

◀ ▼ **16.** To make the grid cover for the jewelry box, the stainless steel rods are resistance welded. It is a good idea to test the welding times on scraps before proceeding with the permanent welding.

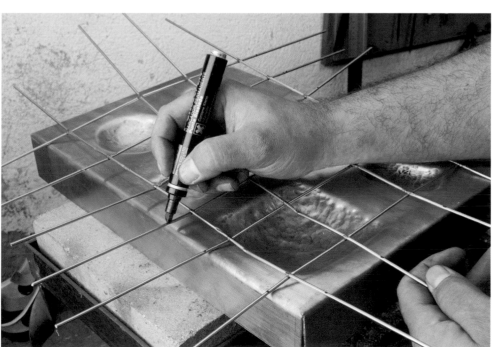

◀ **17.** After all of the rods have been welded, the grid is placed over the jewelry box and the points where the wires must be bent to form the lid are marked.

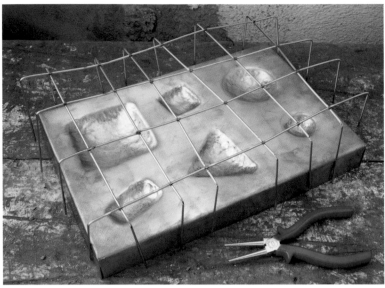

▲ **18.** The ends of the wires that form the grid cover are bent with needle nose pliers.

▶ **19.** With the grid secured to the bench, the ends are cut off with a grinder and a cutting disk to make them all even.

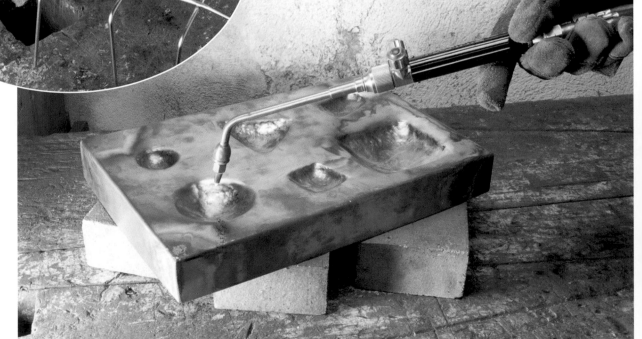

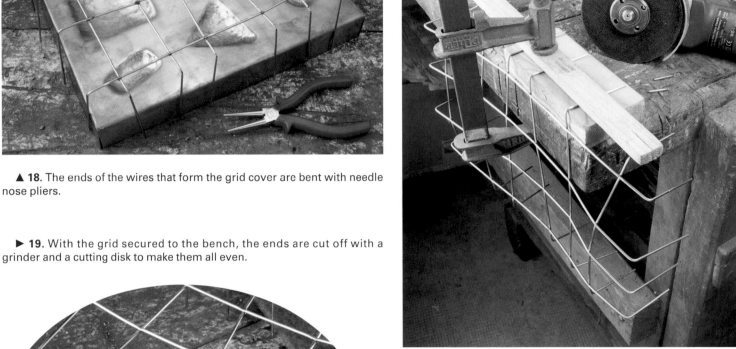

▲ **20.** The wires are rubbed with a scouring pad to create a luminescent shine on the grids.

▶ **21.** The finish of the jewelry box is applied by oxidizing the surface with the oxy-fuel torch, which creates iridescent colors.

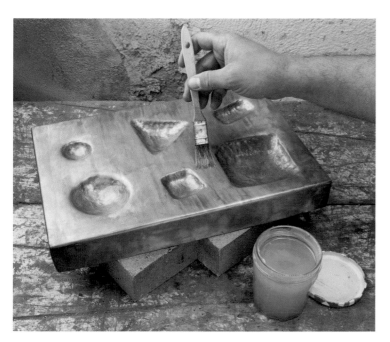

▲ **22.** A wax and colophon resin base varnish is applied to preserve the colors made by heating the surface of the jewelry box.

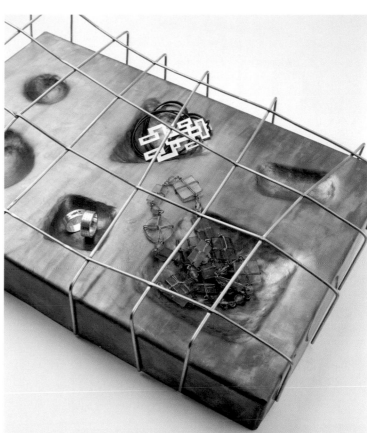

▲ ▼ **23.** The finished jewelry box with a grid top.

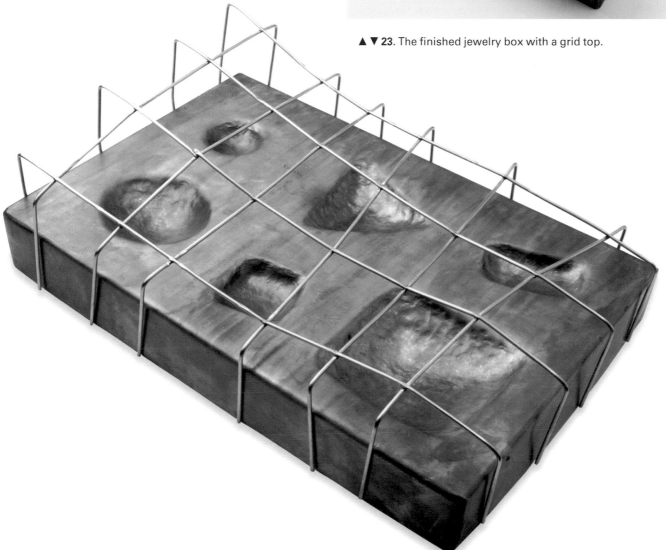

# Creating a Brass Dragon

*T*his exercise is based on a relatively simple technique: transferring the form of a dragon's head sculpted with modeling clay to a sheet of brass. First, the dragon's head is modeled with clay based on some sketches, and then templates of each part of the head are made for transferring the design to metal. The metal parts are hammered on a lead block until the desired shapes are created.

The idea is not to copy the figure exactly but to use it as a reference for creating the metal piece because modeling paste and sheet brass express themselves very differently. The creation of this dragon constitutes a purely sculptural exercise.

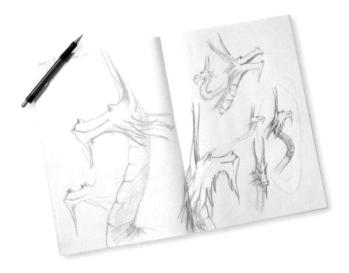

▲ **1.** Several sketches of the dragon's head in brass are made as an initial model.

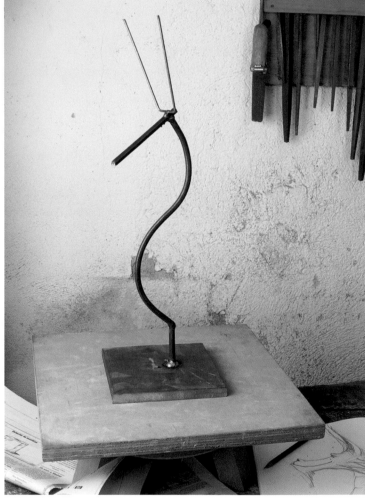

▲ **2.** To model it with clay, a metal structure is made as a support. This structure consists of steel rods formed by following the outline of the desired shape.

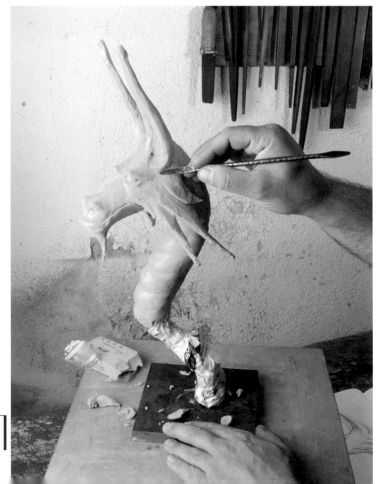

◄ **3.** To get some volume, the structure is covered with newsprint, over which the clay is applied and the figure is modeled. Next, the necessary templates are made to transfer each part of the dragon's head onto metal. We will use the dragon's ear as a model for the pattern-making process. The procedure is identical for the remaining parts.

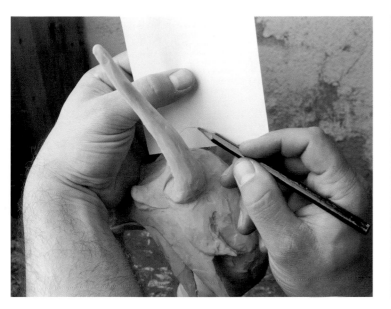

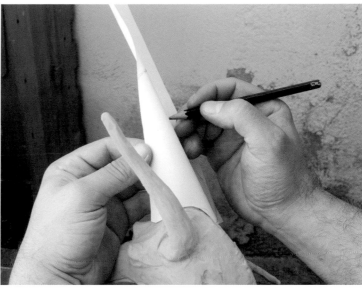

▲ **4.** A piece of paper is placed over the ear. The outline of the ear and the point where it meets the head are drawn on the paper.

▲ **5.** Once the design is cut out, it is placed over the model and we continue drawing and cutting out.

► **6.** Then, the dragon's ear is wrapped with the paper while trying to avoid wrinkling, and we continue drawing the different contours, which are successively cut out and drawn.

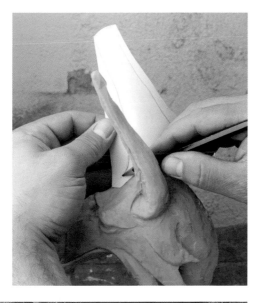

◄ **7.** At the end of the process we will have the flat and approximate model of the volume of the dragon's ear.

▼ **8.** Different phases of paper cutting and adjusting until the final shape of the pattern is achieved.

▼ **9.** The outline of the pattern is transferred to the sheet brass twice, once for each ear.

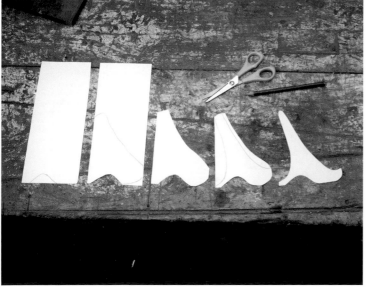

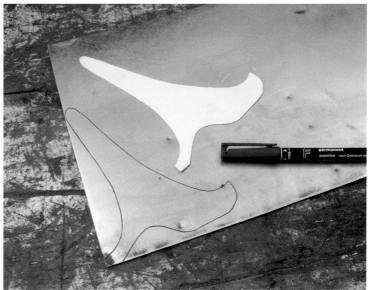

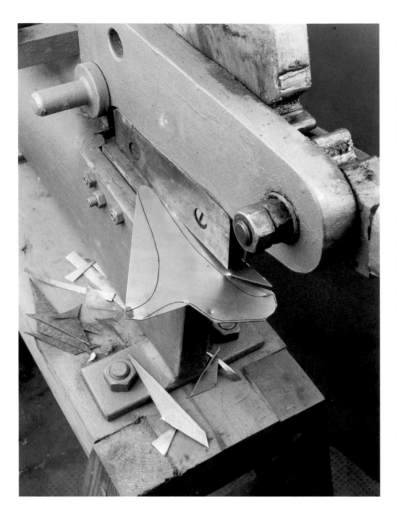

◄ **10.** Then, the dragon's ear is cut out. To begin with, excess material is removed with a power shear, cutting as close to the outline of the design as possible.

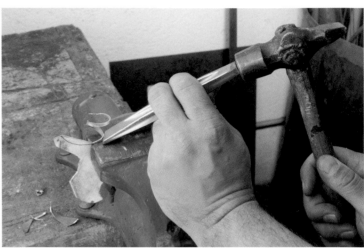

▲ **11.** The metal piece is placed in a bench vise, and the exact design of the piece is cut out with a chisel.

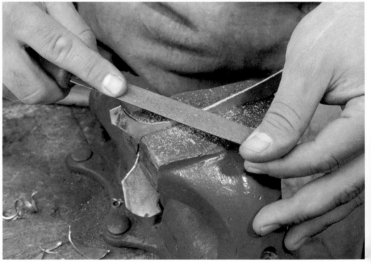

► **12.** The burrs are removed from the edges, and the form is completed with a half-round file.

▼ ▼ **13** and **14.** Now, we begin to form the dragon's ear by striking the sheet of brass placed on a lead block with a ball peen hammer. The metal expands as we continue to hammer all over the sheet of metal.

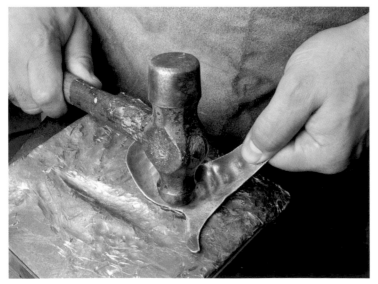

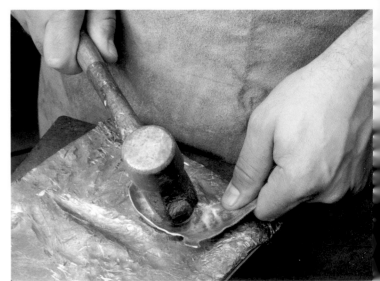

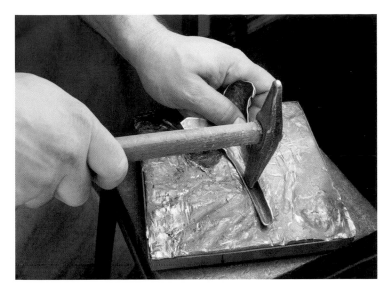

**▲ 15.** Forming is done using different hammers according to the forms that we wish to create.

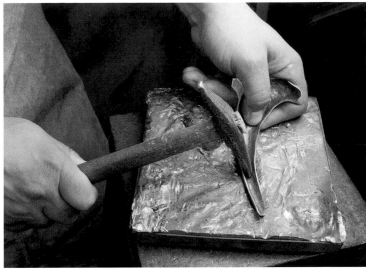

**▲ 16.** On of them was made from a welder's recycled chipping hammer.

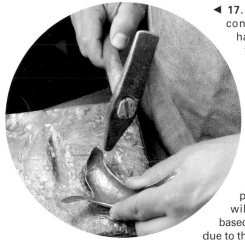

**◄ 17.** The welding hammer converted into a forming hammer causes the metal to expand in different directions depending on the side that is used (see the section on forming).

**► 18.** After the first phase of the forming process is finished, we will have the brass part based on the design; however, due to the expansion of the material from the forming, it has a greater longitudinal curvature than desired.

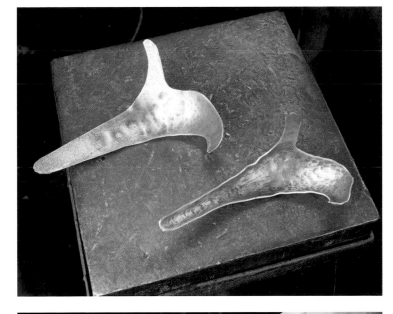

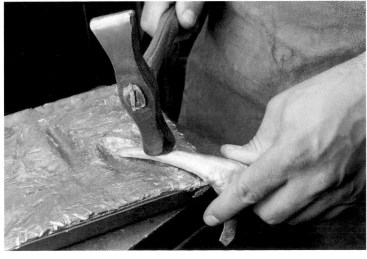

**▲ 19.** To eliminate the excessive curvature, the other side of the piece is hammered on a lead block.

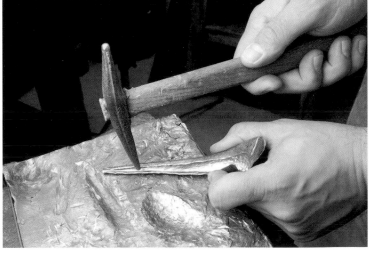

**▲ 20.** To create the final shape, the sides are hammered and closed together. We create the other ear the same way, but in the opposite direction.

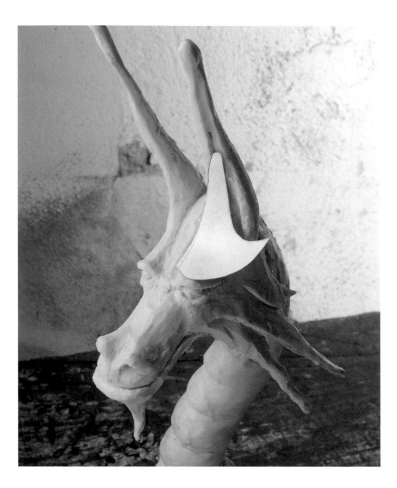

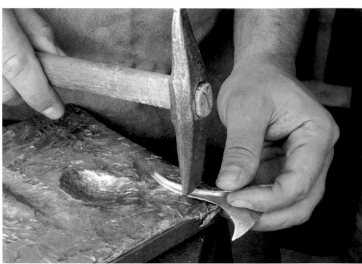

◀ **21.** Then, the pattern for creating the eyebrow is made following the same procedure as before.

▲ ▼ **22** and **23.** The part of the brow that should fit against the ear is bent and curved, always hammering on the lead block.

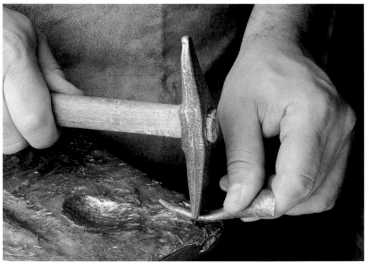

▼ **24.** The brass pieces are checked periodically against the model made with modeling clay.

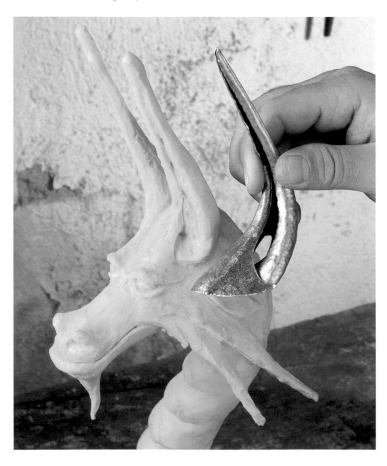

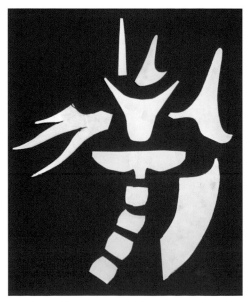

◀ **25.** All the patterns used to make the dragon.

▶ **26.** The dragon's snout is formed according to the paper pattern.

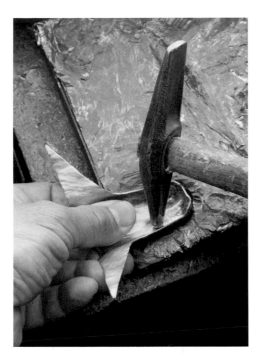

▼ **27.** The pattern and snout of the dragon. The brass sheet is stretched following the shape of the pattern until a volume similar to the snout of the dragon made in clay is achieved.

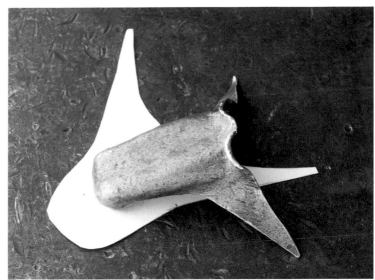

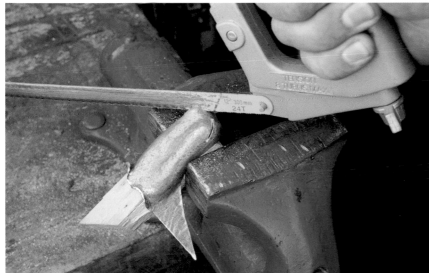

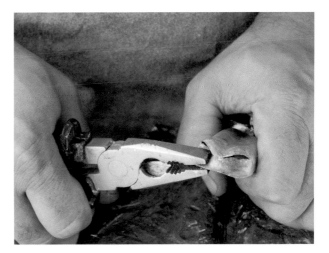

▲ **29.** The metal is bent with pliers to make the nostrils.

▲ **28.** To make the openings in the nose, the end of the snout is cut with a hacksaw. A piece of wood is placed inside the snout to prevent it from bending out of shape from the pressure from the vise.

▶ **30.** Now we join all the formed pieces together by brazing them with brass filler rods. Modeling clay is used to secure the piece that is to be brazed, because it holds the piece in place without bending it.

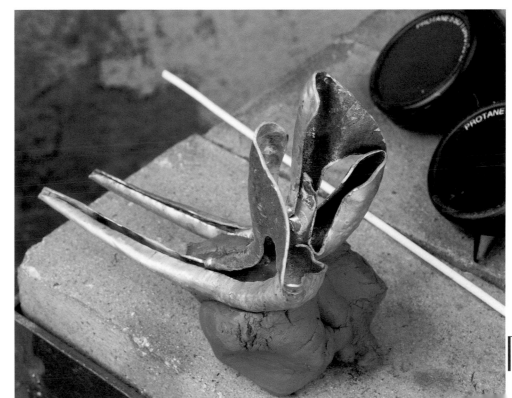

►► **31.** The lower jaw is made the same way as the upper one. Then, to design the most interesting position for the dragon's face, the pieces are arranged in different poses until we come up with the most pleasing one.

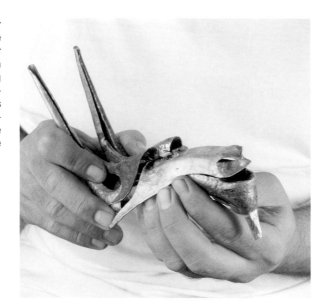

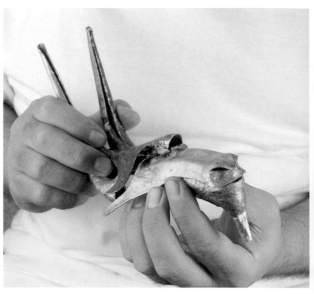

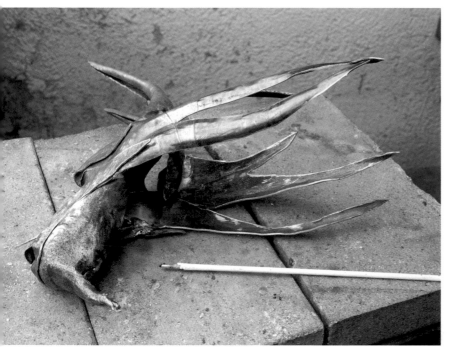

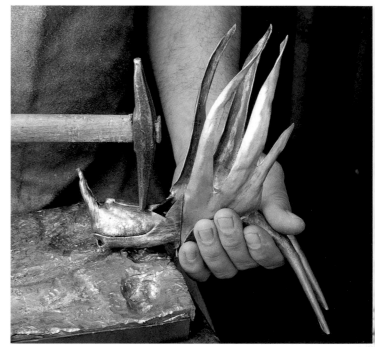

▲ **32.** The next phase for creating the head is to braze the lower part of the jaw in the chosen position. The same is done with the appendages that come out of the base of the head, also created with the corresponding patterns.

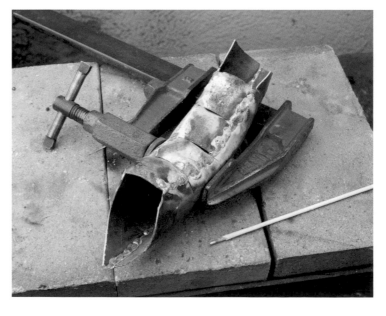

▲ **33.** Taking advantage of the annealing caused by the brazing process, we hammer those areas on the lead block to adjust the joints of the piece.

► **34.** The dragon's neck is constructed by brazing the formed pieces. A clamp is used to immobilize it so the brazing can be done comfortably.

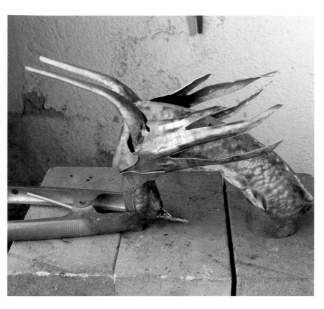

▲ **35.** It is necessary to come up with creative ways of holding the dragon when brazing the large pieces.

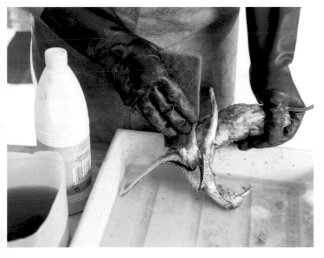

▲ **36.** To finish, the brazed areas are polished and cleaned with a scouring pad soaked with ammonia diluted with water. Rubber gloves for acids are used as well as a mask and goggles as protection against spills.

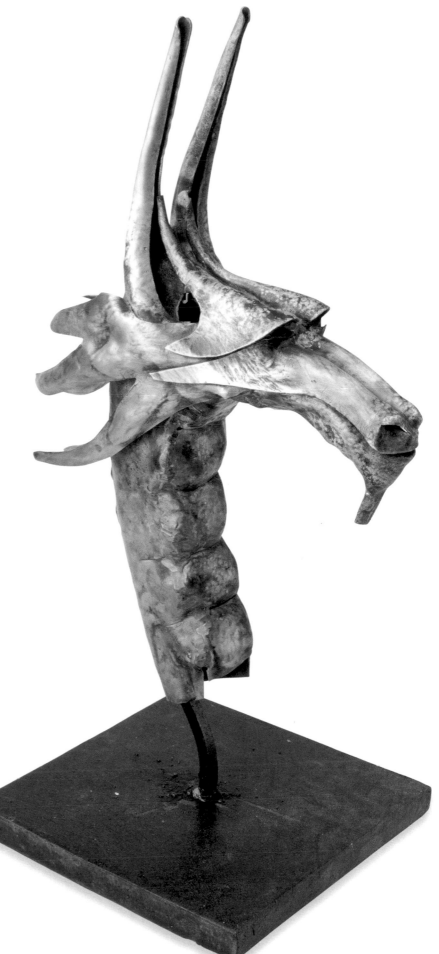

▶ **37.** The finished brass dragon. We have used a square piece of heavy carbon steel for a sturdy base. The head is brazed to a piece of square rod which in turn is attached to the base.

# Glossary

## a

**Alloy.** A combination of two or more metals like carbon steel, which is made of iron and carbon. Some alloys can have as many as seven components, like certain hardened steels made of iron, cobalt, and wolfram.

**Alumina or Aluminum Oxide.** This is formed on the surface of aluminum in contact with oxygen that is introduced or in the air, especially at high temperatures.

**Atmosphere.** A measure of pressure equivalent to 14.2 psi ($1 \text{ kg/cm}^2$).

## b

**Borax.** Hydrated sodium borate, very commonly used as a flux in the welding process. .

## c

**Cast iron.** The first product, also called pig iron, obtained from the blast furnace when smelting iron ore. This type of iron has a high carbon content and is very brittle.

**Chamfer.** A 45° angle made on two metal edges that are to be fused together to accommodate the weld bead.

## d

**Deburring.** The action of eliminating small bits of metal splinters or filings from the edges of metal using files and electric tools.

## e

**Extrusions.** Different types of bars with different sections and shapes manufactured by laminating hot steel ingots or cold forming laminated sheet steel.

## f

**Fluidity.** The capacity of movement of a substance in liquid state.

**Flux.** A substance that is used in some welding and soldering processes to facilitate the fusion of the oxides that are produced when heat is applied to some metals.

**Forming.** An operation consisting of using pressure to transform a flat sheet into a volume whose surface cannot be developed, that is, that cannot be created by changing the form of the sheet using a template.

**Fusion.** The passage of an object in a solid state to a liquid state through the application of heat.

## g

**Galvanization.** A zinc coating applied to steel to protect it from atmospheric corrosion.

## h

**Heat.** "A heat" refers to heating a piece of metal in the fire of a forge.

**Helicoidal.** Having a spiral shape. A term that is applied to drill bits.

**High-speed steel or Tool steel.** The names for the type of steel that can be worked at temperatures up to 1,112°F (600°C) without losing its hardness.

**l**

**Lamination.** The process of applying great pressure to a material by passing it through two rollers that rotate at the same speed and in opposite directions for the purpose of reducing its thickness.

**m**

**Metric.** The system used to designate threads that measure their exterior diameter in metric decimals, normally in millimeters.

**Molten puddle.** The place where the base metal and the introduced metal are simultaneously melted by heat to form a volume of material that will be the weld bead when it has cooled.

**o**

**Ore.** Part of a mineral with the richest content of the metal it contains.

**Oxidation.** This is the combination of metal with the oxygen in the air. A thin oxide layer is formed on the surface, which in many cases prevents more oxygen from entering, thus fulfilling a protective function.

**Oxy-fuel cutting.** A process for cutting steel with a flame produced by burning a mixture of oxygen with another gas, normally acetyline.

**p**

**Pantograph.** A tool that can make multiple exact reproductions, or different sized proportional copies, of an original model.

**Pyrometer.** A gauge or cones that melt that are used to measure high temperatures.

**r**

**Regulator.** A valve that reduces the high pressure of a compressed gas in a bottle or from a compressor until it is regulated to an optimal working pressure.

**s**

**Self-tapping screws.** The threads of these screws make their way into the metal of the piece that is to be joined together to form their own threads.

**Setting.** The act of alternately bending the teeth of a saw to the left and the right to optimize its cutting action.

**Slag.** Material resulting from the decomposition of a coated electrode. Its purpose is to protect the molten puddle and the weld from oxidation. The term is also applied to the mass of impurities obtained from smelting iron ore.

**Stress relief.** An operation that uses heat to improve the toughness of tempered steel at the cost of reducing its hardness, mechanical durability, and its elasticity.

**t**

**Tack welding.** The action of joining two pieces by welding them at individual points.

**Tap and die.** Tempered steel screw taps are used to create threads inside a hole, which becomes the nut. Dies are tempered steel tools used to create bolts by cutting threads on a metal rod.

**Template or pattern.** This is a piece of shaped metal, wood, or even cardboard, that can be traced to make one or several identical pieces, or that can be used for checking and comparing shapes as they are being made.

**Tin plate.** A carbon steel sheet metal that is coated with a thin protective layer of tin.

**Traction.** The action of dragging an object.

**v**

**Vacuum tension.** This is the voltage that exists in the base metal clamp and the electrode holder when no welding is being done.

**Vernier gauge or Sliding calipers.** A tool that indicates small fractions of distance by taking a measurement with moving the jaws that connect to a precision steel rule.

**Volatilization.** The phenomenum of some substances changing from a solid or liquid to a gas or steam at room temperature.

**w**

**Weld bead.** A deposit of metal that fuses together two metal parts.

**Work hardened.** The increase in the hardness and durability of a metal that is worked cold, which at the same time becomes less plastic and and more brittle.

# Bibliography
## and acknowledgments

ANDRIEUX, Jean-Yves. *Les travailleurs du fer*. Découvertes Gallimard, Evreux, 1991.

HERNÁNDEZ RIESGO, Germán. *Manual del soldador*. Asociación Española de Soldadura y Tecnología de Unión, Madrid, 2000.

HUGHES, Richard, and Michel Rowe. *The Colouring, Bronzing and Patination of Metals*, Thames and Hudson, London, 1991.

LOBJOIS, Ch. *Tecnología de la calderería, Vols*. I, II, III, and IV. Ediciones CEAC, Barcelona, 1984.

LOYEN, Frances. *Manual de platería*. Hermann Blume, Madrid, 1989.

MOHEN, Jean-Pierre. *Metalurgia prehistórica: Introducción a la paleometalurgia*. Masson, S.A., Barcelona, 1992.

PEDROLA I FONT, Antoni. *Materials, procediments i técniques pictòriques*. Publicacions de la Universitat de Barcelona, Barcelona, 1988.

SCHMIRLER, Otto. *Outils et réalisations en fer forgé*. Office du Livre du Fribourg. Frigourg (Switzerland), 1981.

SERRA SUBIRÀ, Eduard. *Materials i eines de l'escultor*. Publicacions de la Universitat de Barcelona, Barcelona, 1992.

SLOBODKIN, Louis. *Sculpture, Principles and Practice*. Dover Publications, New York, 1973.

UNTRACHT, Oppi. *Metal Techniques for Craftsmen*. Doubleday, New York, 1975.

V.V.A.A. *Guía práctica de la forja artística*. Editorial de los Oficios, Leon (Spain), 1997.

V.V.A.A. *Tecnología del metal 1.1*. Bruño - Edebé, Barcelona, 1976.

VITIELO, Luigi. *Orfebrería moderna (técnica-práctica)*. Ediciones Omega, Barcelona, 1989.

To Parramón Ediciones, S.A., for coming up with a much needed book collection devoted to arts and crafts. I wish to express my most heartfelt gratitude to editors María Fernanda Canal and Tomàs Ubach for putting so much confidence in my work and to the entire team of professional collaborators of Parramón Ediciones for their excellent work.

To the sculptor Matilde Grau for believing in me and for encouraging me to create this book, and for keeping a permanent smile; and to Carles Codina for putting me in touch with Parramón Ediciones.

To Joan Soto, of course!, for the spice that he adds to his profession, for his professional experience, and the confidence that he exudes, for his complicity, for so many things!

To Antonio Rodríguez of Soldabarna, S.A., for all his help, for contributing material, and for stopping by so often.

To Justo Lebrero Estadella, from the company Justo Estadella, makers of polishing compound, for his good disposition, documentation and expertise lent to the book in the section devoted to patinas. And to Phillippa Beveridge for her help in the construction of the iron table.

To Enric Rosàs and to Industrial Llobera, S.A., for their contribution to this book with their professional expertise in subjects such as important technical advice, rust-removing agents, steel wool, soldering rods, industrial gas tanks, and so many other things!

To Josep Cerdà and to Josep Roy, Dean and Associate Dean of the Facultat de Belles Arts de la Unversitat de Barcelona, for letting me use the school for photographing some of the step by step exercises.

To Martí Rosàs and to Mari Hernández, of Restaurante Ca la María de Llagostera (Girona), for letting me rearrange some of the areas of their masía for the step by step exercise of the iron grating, and for the pastries filled with lemon cream with chocolate sauce.

To Ester Rosàs and to Javier Ares for being there whenever they were needed.

To Jordi Sánchez, the master of the printmaking studio of the Universitat de Barcelona, for his disposition and enduring spirit.

To Rafael Cuartielles, master of the metalworking studio and artist, for his exquisite knowledge, his teachings of metalworking techniques, and his great ability to introduce people to the poetry of objects. For so many good moments!

To the sculptors Jordi Torras, Gemma López, Marta Martínez, Beth Fornas, Nerea Aixàs, Josep Cerdà, and Matilde Grau for letting me dignify the entire book with images of their work without hesitation.

To Clavelina Río and to José Ares, my parents, for always supporting my decisions, and for looking after my daughter so many times.

To Marta Rosàs, my North, and to Ia, our daughter, for all the days and nights and all the patience, and all the support, may you always be as happy as you are now!

To all, my most humble gratitude.

**Ares**
Parramón Ediciones, S.A., on its part wishes to thank the Museu Cau Ferrat, of Sitges, for letting us use the Pablo Gargallo photograph, which is shown in the Gallery.